Culture in Action

A public art
program of
Sculpture Chicago
curated by
Mary Jane Jacob

BAY PRESS, SEATTLE

Essays by
Mary Jane Jacob
Michael Brenson
Eva M. Olson

Culture in Action, a program of Sculpture Chicago, has been made possible with major support from the Lila Wallace-Reader's Digest Fund and The National Endowment for the Arts

CORPORATE SPONSOR:
AT & T

ADDITIONAL
CONTRIBUTORS:
The Andy Warhol
Foundation for the Visual
Arts, Inc.
Chicago Foundation
for Women
The John D. and Catherine
T. MacArthur Foundation
The Nathan Cummings
Foundation
Polk Bros. Foundation
Prince Charitable Trusts
The Rockefeller Foundation
Sara Lee Foundation

Checkers Simon & Rosner
Illinois Bell,
an Ameritech Company
Refco, Inc.

City of Chicago Department
of Cultural Affairs
Illinois Arts Council,
a state agency

Anonymous
Anne and William J. Hokin
Inaugural Sponsors:
Charles R. Gardner,
Helyn D. Goldenberg,
Robert A. Wislow

GENEROUS IN-KIND
SUPPORT PROVIDED BY:
American Airlines
The Blackstone Hotel
Business Volunteers
for the Arts
Chicago Dock and Canal
Trust
Deborah Gordon Public
Relations
George Kaltezas
Near North Insurance
Brokerage
Randolph Street Gallery
The School of The Art
Institute of Chicago
Sheraton Chicago Hotel
and Towers
Sidley & Austin
University of Illinois at
Chicago
U.S. Equities Realty, Inc.
Wapanucka Oolitic
Limestone
Zenith Electronics
Corporation
Zolla-Lieberman Gallery

ADDITIONAL
PUBLICATION SUPPORT:
Chicago Transit Authority
LaSalle National Bank

Contents

Acknowledgments

We would like to acknowledge the numerous individuals and organizations who played an active role in "Culture in Action," and without whom this ambitious program would not have become a reality.

Our first debt of gratitude is to the artists for their dedication and determined efforts throughout what may have occasionally seemed like an eternal process. A special thanks to the Board of Directors of Sculpture Chicago and its Co-Chairs Charles R. Gardner, Helyn D. Goldenberg, and Robert A. Wislow for their vision and support. We are most grateful to board member Jack Guthman at Sidley & Austin for his invaluable guidance and direction, especially during the Suzanne Lacy project. Board member Sam Budwig, our Site Committee Chairman, was a wonderful source of energy and ideas during the planning phase of the program. With regard to the book, we wish to thank the author Michael Brenson for his moving words and inspiring presence; John McWilliams for his compelling images; Publications Manager Terry Ann R. Neff for her patience, humor, and tact over the months of book conception and production; Cheryl Towler Weese for her design; and Sally Brunsman and Kim Barnett of Bay Press for their timely participation in copublishing the book.

Many people guided Sculpture Chicago through the research and implementation of "Culture in Action." Following are some of the friends, colleagues, foundation staff members, City of Chicago officials, consultants, teachers, technicians, artists, and volunteers who worked tirelessly behind the scenes. For their assistance during the planning phase of "Culture in Action," we want to acknowledge the efforts of Carol Adams, Gerald Adelmann, Connie Baldwin, Chuck Brashears, Susan Cahan, Alex Campos, Mary Ellen Carroll, Diane Chandler, Mel Chin, Chris DerDerian, Amy Gabbert, James Grossman, Lori Grove, Doris Hebel, Lynelle Hemphill, Paulo Herkenhoff, Ian Hunter, Alfredo Jaar, Mary Janzen, Donna Jernigan, Ronald Jones, Narelle Jubelin, Irwin Kale, Barbara Kirshenblatt-Gimblett, Robbin Lockett, Evelyn McGee, Kathryn McKee, Cheryl McWorter, Vince Michael, Phyllis Rabineau, Esther and Alan Saks, Gary Sangster, Patrick Shaw, Federica Thiene, Judith Vismara, Susan Wink, Wishbone Restaurant, and Theodore Zernich.

For their work on behalf of the artists and Sculpture Chicago throughout the program, we want to thank Max Abrams, Rolando Acosta, Paul Adams, William Adelman, Sandra Andel, Patrick Arden, Joan Arenberg, Eric Bailey, L.D. Barron, Chris Bayard, Carol Becker, Jack Becker, Phil Berkman, Robert Berman, Joyce Bollinger, Victoria Boomgarten, Commissioner Joseph Boyle, Virginia Boyle, Valerie Brodar, Lynne Brown, John Cartland, Gery Chico, Carole Cirignani, Arlene Coco, Kevin Coffey, Angela Coleman, Dwight Conquergood, Lisa Corrin, Carlos Cortez, Toby Craiger, Andrew Cross, William Cummings, Hugh DesMarais, Tony DiBiase, Amina Dickerson, Thomas and Frannie Dittmer, Brian Eaton, Anne Edgar, Connie Esler, Aleli Estrada, Joyce Fernandes, Adam Finkel, Stanley Freehling and The Arts Club of Chicago, James Frost, Patricia Fuller, Selwyn Garraway, Claire Geall, Phylis Geller, Daryl Gerber, Camille Gerstel, Lucy Gomez, Inmaculada Guiu, Miriam Gusevich, Sandra Guthman, Juana Guzman, Suzanne Gylfe, Joan Harris, Hazel Harvey, Jethro Head, Sharon Higgins, Bette Cerf Hill, Rhona Hoffman, Will Hokin, Karen Indeck, Mary Ann Johnson, Deputy Commissioner Ron Johnson, Phil Kalinowski, Rebecca Keller, Judith Russi Kirshner, Chris Kolker, Luisa Kreisberg, Iris Krieg, Bert Kubli, Susan Larson, Mike Lash, Anthony Law, Jim Law, Alan Leder, Kim Lero, Russell Lewis, Roberta Lieberman, William Lieberman, Lucia Woods Lindley, Olga Lopez, Ed Maldonado, Faye Strope Manker, Mary Marcinkowski, Paula Pia Martinez, Beatrice Cummings Mayer, Alderman Ted Mazola, Mary McCall, Therese McMahon, Endale Hapte Michal, Denise Miller-Clark, Andrew Moss, Paris Murray, Walter Netsch, Bridget O'Keefe, Nilda Ruiz Pauley, Jerry Pearlman, Antonio Pedroso, Antonio Perez, Sarah Peters, Marianne Philbin, Mike Piper, Nancy Pletos, Nick Rabkin, Elvia Rodriguez, Kelly Jo Rogers, Jane Saks, Yolanda Santiago, Charles Dare Scheips, Ruth Schnitzer, Charles Schrank, Tom Senft, Kim Sherman, Joan Shigekawa, Marie Shurkus, Gary Sieland, Ann Smith, Elizabeth Smith, Janet Carl Smith, Mary Cele Smith, Treasure Smith, Connie Springborn, Ted Stanuga, Robin Starbuck, David Steele, Peter Stellas, Dorie Sternberg, Jim Stoller, JoAnne Stone-Geier, Peter Taub, John Taylor, Encarnacion Teruel, Paul Teruel, Amy Theobald, Keith Thomas, Commissioner Charles Thurow, Carlos Tortolero, David Vermilya, John Vinci, Liz Walters, Commissioner Lois Weisberg, Dennis Wile, Connie Wolf, Tomas Ybarra-Frausto, Barbara Yergin, Elliot Zashin, Victor Zamudio-Taylor, and Russell Zavacki.

Eva M. Olson
Executive Director

Mary Jane Jacob
Program Director

To the staff of Sculpture Chicago – Karen Paluzzi, Rebecca DesMarais, Stephanie Dodoo, Jessica Rath, Ktalia Simon, and Giorgia Wolfson – and interns Nyame Brown, Julia Bunnage, Steph Halpern, Jason Meadows, and Claudia Sohn and the countless members of the "Culture in Action" team who staffed buses and handed out balloons and made it all work, our heartfelt thanks for an incredible job.

We also want to recognize the major sponsorship of the Lila Wallace-Reader's Digest Fund and the National Endowment for the Arts. **Without their support and the support of our other funders, "Culture in Action" would have remained an idea without fulfillment.**

Who is the audience for
How can public
when there are

public art?

art represent the public

many publics?

NEW ART, NEW AUDIENCES: EXPERIMENTS IN PUBLIC ART

Eva M. Olson, Executive Director, Sculpture Chicago

This book documents an ambitious investigation in urban artmaking that took place throughout the city of Chicago over a two-year period. Conducted by Sculpture Chicago in collaboration with fourteen artists, their community partners, and countless individuals who believed in this program and worked hard to make it happen, "Culture in Action" marked a significant moment in the history of this continually evolving organization.

Sculpture Chicago is committed to defining a new form of public art

Sculpture Chicago is a unique entity, difficult to define in conventional institutional terms. Neither museum nor gallery, it is not limited to a single established location. Originally conceived as a "museum without walls," Sculpture Chicago has maintained its role as a forum for artists to create new works and to educate the public about the creative process. Founded in 1983, Sculpture Chicago has grown from a neighborhood exhibition featuring Chicago-area sculptors making works in public view to its current experimental format. Because of its unusual organizational structure, it can move into realms of public art that are usually inaccessible to museums and larger cultural institutions. **In its place outside museum practice, Sculpture Chicago is committed to defining a new form of public art, one that places equal emphasis on artist and audience, one that reduces the gap between them and attempts to foster dialogue through communal action.** It can remake itself to suit the needs of a particular project, and can explore current issues in public artmaking more freely because of its lack of administrative constraints.

Throughout Sculpture Chicago's relatively brief history, its uniqueness and ability to test the boundaries of public art have remained paramount. Founding chairman Robert A. Wislow has stated that one of the principal benefits in establishing Sculpture Chicago lay in the fact that it was "absolutely different from anything being done in Chicago in the arts at the time." Although its approach to arts education has changed over the past eleven years, Sculpture Chicago has always conceived of itself as an organization in service to artists. With each successive program it has broadened its mission to encompass more of the city's numerous audiences. Forging a fundamental link between art and education, Sculpture Chicago has dedicated itself, in its most recent programs, to commissioning public art that can be relevant to the lives of Chicago residents.

The open-air accessibility of the biennial juried exhibitions staged from 1983 to 1989 – in which artists created works under tents during the summer – brought large audiences into newly developed areas of the South Loop. In its 1989 exhibition, Sculpture Chicago took a major leap forward when, in addition to its emerging artists' forum, works by Vito Acconci, Richard Deacon, Richard Serra, and Judith Shea were sited at Equitable Plaza on Michigan Avenue. Several pieces from this exhibition were placed permanently in the city: Shea's *Endless Model* in the lobby of the NBC Tower; Acconci's *Floor Clock* (see below) in Ogden Plaza, a revitalized riverfront area; and in front of the Chicago Historical Society, a work by Sheila Klein titled *Commemorative Ground Ring*.

Then, in 1991, Sculpture Chicago commissioned Pritzker Park (see pages 12, 13, and 15), the first public park in the city's Loop. A collaboration with the City of Chicago Department of Planning and Economic Development, this initiative resulted in a 33,000-square-foot permanent environmental work of art that functions as a haven of green space, as well as a reading garden intended to complement the nearby Harold Washington Library Center. Designed by artist Ronald Jones, who was inspired by the Prairie-style landscape architecture of Jens Jensen and a painting by René Magritte titled *The Banquet* (The Art Institute of Chicago), the park combines Chicago references of artistic, architectural, and historical nature while making a plea for a reconsideration of our civic and social responsibility (through the use of a quotation borrowed from the nineteenth-century poet Henry Abbey, "What do we plant?").

With Pritzker Park, Sculpture Chicago set a precedent for spearheading innovative art projects and bringing them into existence through partnerships with other organizations in the city.

With "Culture in Action," Sculpture Chicago made another important programmatic change by moving away from its downtown locations to engage a new public through projects that took place in multiple communities throughout the city. This program tested the territory of public interaction and participation and the actions of the artist as an expression of intervention. It resulted in projects that unfolded over an extended period

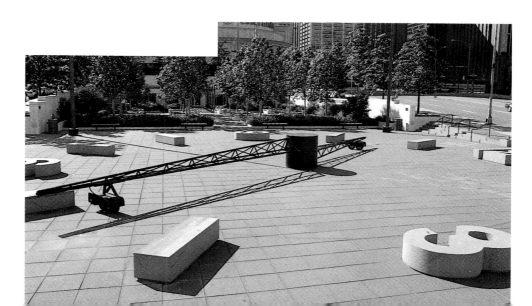

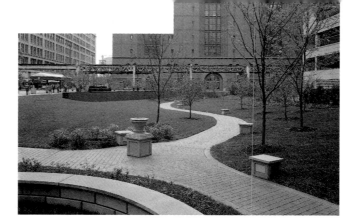

of time rather than objects existing in space. In this way, the program allowed Sculpture Chicago to challenge the notion of what "sculpture" can be, even as it debated the parameters of audience and the place for art in society. As Haha artist Laurie Palmer noted, "Culture in Action" was concerned with "spaces of discourse" and the active continuum of sculptural and cultural space.

"Culture in Action" presented a series of experiments in the urban laboratory of Chicago. The city served as a locus in which artists could explore pressing social and political issues, a canvas on which they could layer the concerns of individual communities.

The logistics of accomplishing the projects were very difficult. Bridging art and life was sometimes more complex than anyone could have imagined: for example, in the case of gaining permission from various private and public owners to place 100 rock monuments on sidewalks in front of buildings in the Loop for Suzanne Lacy's project "Full Circle," or the process of mobilizing 500 participants and literally "orchestrating chaos" for the parade organized by Daniel J. Martinez and VinZula Kara. Numerous partnerships were formed and dissolved over the course of "Culture in Action," all of which became interlocking pieces of the puzzle.

IVY GROWS ON THIS WALL

TREES CONFIGURED SO AS TO REPLICATE PAINTING FROM THIS VIEW

"Culture in Action" addressed populations not usually served by museums – and rarely by Sculpture Chicago – offering them shared authority and a voice in the creation of artworks. This program rejected the museum notion that a large audience equals success by dealing directly and intensively with eight different, specific audiences. It subverted the notion of museum "outreach" by positioning the projects directly in communities, offering a multiplicity of experiences to diverse audiences. It is the quality of these experiences that is paramount, and the idea of resonance and continuation through collective memory that brings value to each project. The projects served as a conduit between a particular community and the more diverse audiences that make up the general public; through the ripple effects of each project, the ideas born and generated by artist-community interaction will, it is hoped, filter into the larger culture.

Throughout the program, its organizers believed that discourse and dialogue around the issues of public artmaking were as important as the projects themselves. The process itself was challenged and explored from planning to final stages. A series of roundtable discussions began in December 1992 as the projects were moving from planning to implementation. Participants in these discussions were as varied as the projects themselves: local community leaders, critics, art patrons, international curators, community partners – all came together to discuss the nature of community-based art and the problems and questions that surround its manifestation. **Ultimately, "Culture in Action" was not designed to provide answers, but to raise questions; not an attempt to limit the definition of "audience" or "public" or "sculpture," but to extend those definitions. During the process of debate and evaluation, problems of critical language as well as problems of interpretation arose - evidence of the need to develop new methods and new language to mirror new ways of making art.**

FLOWERING TREES DIFFER FROM THOSE AT SANDBOX

BIRD BATH

NO SCULPTURE SITED WITHIN MAINSTREET VIEW

FILL IN

ALL TREES SURROUNDING SANDBOX ARE TO BE FLOWERING ONLY!

EVERGREEN WALL SURROUNDS PARK

* SHRUBS SET IN PRAIRIE SCHOOL STYLE
* FLOWERING TREES SURROUND SANDBOX AND IN WEST CORNER IN FRONT OF COUNCIL RING –

MEADOW (FUTURE SCULPTURE SITE)

BIRD BATH

BIRDBATH

FLOWERING PLANTS

ENTRANCE CENTERED ON SUBWAY STOPS

N ——→

Transformation was a persistent theme – for the artists, their counterparts in communities, and Sculpture Chicago itself. As Iñigo Manglano-Ovalle said: "Artists don't kick-start culture; it's a shared process." He has noted the series of "productive collisions" that occurred – the learning process that transformed everyone involved. At its best moments, "Culture in Action" became a mutually empowering endeavor. "Culture in Action" reflected a moment in public art in which it became possible to talk about audiences, community-based art, and the role of the art institution in new ways. It may not immediately be possible to define the transformation that took place, but clearly the organization has changed forever, and the experience of working in this way will continue to inform and shape future programs. For Sculpture Chicago, "Culture in Action" is not a destination, but a direction.

Sculpture Chicago's next program will evolve out of equal urgency and responsibility to address pressing issues in the field and in the world. The resonance of "Culture in Action" will be felt as its eight projects evolve or disappear on their own. There is a strong desire to follow each project in a longitudinal, social science-type study, but for Sculpture Chicago to remain true to its mission, the work must be allowed to thrive on its own terms. At this point Sculpture Chicago must continue to explore alternative forms of public art practice. There are other communities, other audiences. The goals are to integrate art and culture, to make art a real part of people's lives, to push the boundaries of public art, to be audience-driven, and, above all, relevant.

a public art that places equal emphasis on artist and audience

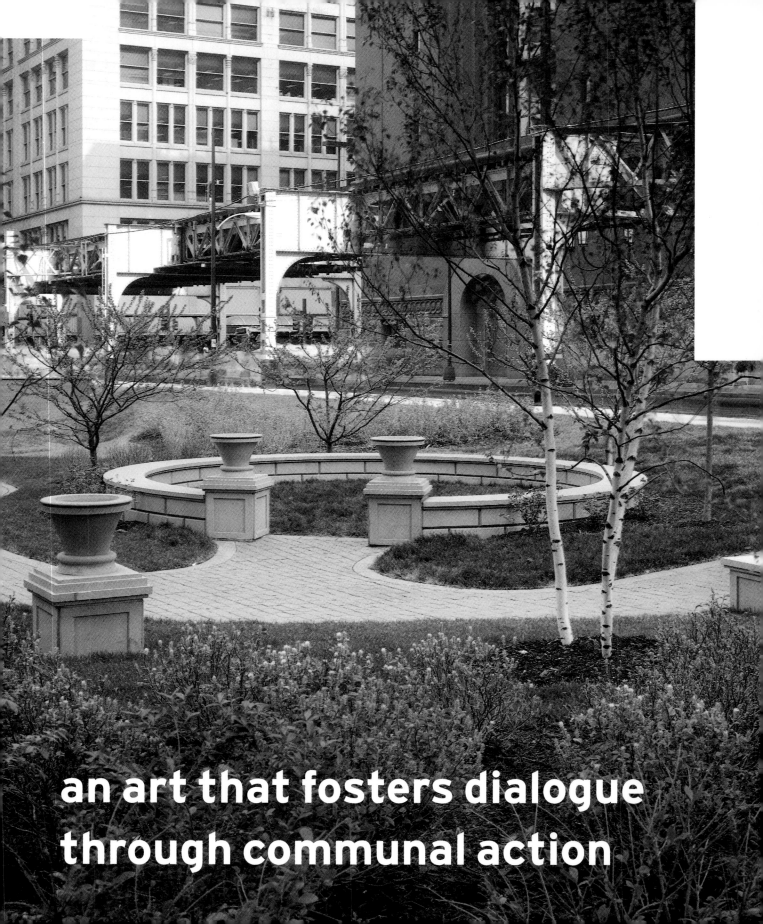

an art that fosters dialogue
through communal action

HEALING IN TIME

Michael Brenson

INTRODUCTION. The first question to ask about "Culture in Action" is how to approach it. What attitude, what state of mind, is needed in order for its emotional, intellectual, and artistic substance to reveal itself?

Giving yourself to "Culture in Action" means feeling the discomfort of irresolution and allowing it to become a condition while your responses evolve.

Giving yourself to the eight community-based or community-oriented, site-specific projects in "Culture in Action" is every bit as important as giving yourself to the pictorial and imaginative processes of an old or modern master. If you are going to appreciate the intelligence, commitment, and complexity of Matisse, let's say, you are going to have to put aside a lot of assumptions – about his immediate accessibility perhaps, or the easy pleasure of his work, or about the potential for genuine courage in an art of political disengagement. If you do give yourself to Matisse's work and enter the process of discovery it makes available, it will lead you beyond most assumptions and preconceptions you brought to it. The questions and answers you have at the end of your exploration and investigation are likely to be very different from the ones you had when your assumptions and preconceptions mediated your response to the work.

The same is true with "Culture in Action," but knowing how to give yourself to it may be far more difficult. For one thing, the object can seem so mundane, so familiar, so fully integrated in everyday life, that it may not be clear where a particular project begins and ends, or even what or where "the work" is. The primary content of a project may be hard to define. The rules of interaction between the art and its audiences may seem so loose, so fluid, that they can be determined only by the dynamics of the situation. As a result of all this unknowing, it is almost never apparent upon encountering the art by what, and by whose, standards the success or failure of a project, or of the entire program for that matter, can be measured.

Even for critics and artists steeped in community-based, site-specific art, giving yourself to "Culture in Action" means, almost inevitably, throwing yourself into the water and learning to swim. It means feeling the discomfort of irresolution and allowing it to become a condition while your responses evolve. It also means hearing the clamor of long-held artistic and

political questions – about quality and community-based art, perhaps, or about the social value of community-based art, or about the effectiveness with which an alternative arts organization such as Sculpture Chicago, with its largely corporate board, can make a commitment to voices and audiences with no previous access to institutional power. It means listening to these reservations and then being able, for a while at least, to put them aside. Without a willingness to relinquish control and follow the projects where they lead – into the thoughts and realities of communities, into the hopes of the artists, into the artistic possibilities of these collaborations – the richness of these projects, and their real strengths and weaknesses, cannot emerge.

"Culture in Action" demands an extraordinary commitment not only from its artists and from the communities with which they collaborated, but also from anyone determined to engage the projects in a fair and thorough manner.

The projects unfolded over an extended period of time, and the way they appeared at the end of September 1993 was in most cases very different from the way they appeared the previous May, when "Culture in Action" was inaugurated as a public event. In addition, the projects developed in parts of Chicago that were not only distant from one another, but also, in most instances, far from any convenient tourist base downtown. Staying with the projects over months meant traveling all over the city and returning again and again to the kinds of neighborhoods most art museums have become fortresses against. It meant trusting the unfamiliar, trusting process, and trusting fluctuations of response toward some or many of the projects that could be more chronic and disorienting than those aroused over several months by any traditional sculpture and painting.

In these and many other respects, "Culture in Action" is fundamentally different from its two most important predecessors, Kasper König and Klaus Bussmann's 1987 "Skulptur Projekte" in Münster, Germany, and Mary Jane Jacob's 1991 "Places With a Past: New Site-Specific Art at Charleston's Spoleto Festival." Both these ambitious undertakings – "Skulptur Projekte" invited more than sixty artists, "Places With a Past" twenty-three – reflected the sea change in art in public places that took place during the years of bitter controversy over Richard Serra's "Tilted Arc," the 120-foot-long and 12-foot-tall bend of steel that was installed in Federal Plaza in Lower Manhattan in 1981 and removed in 1989. The three-day public hearing about this work in 1985 revealed and reinforced a wall between the array of art professionals testifying in favor of the work and members of the general public who wanted it removed.[1] For many artists working in the realm of public art, the breach those hearings exposed between art insiders and audiences with little or no interest in modern and contemporary art remains an open wound.[2]

In 1989 the art critic Arlene Raven published an anthology called *Art in the Public Interest*, which documented the growing dissatisfaction among artists with the materialism and self-absorption of the institutionalized art world in the 1980s and the growing need among more and more artists to make socially responsible art that would help bridge the gap between art and life. Essays in the

book discuss some of the works that have become canonical in the realm of collaborative community-based public art, including Suzanne Lacy's *Crystal Quilt*, in which 400 women gathered together in a ritual celebrating themselves and aging; the devotional and healing Names Project AIDS Memorial Quilt in which each of its ever-growing bed of panels (there are now 25,000) commemorates someone who died of AIDS; and the Los Angeles Poverty Department (LAPD), a theater troupe made up of homeless men and women that was founded in 1985 by John Malpede. The book includes an article on a watershed in the history of public art in Chicago, the display of David Nelson's satiric painting of the late Chicago Mayor Harold Washington in the student exhibition of The School of The Art Institute of Chicago in May 1988, which set off reactions that underlined the divisions between the school and many segments of the city.[3]

Both "Skulptur Projekte" and "Places With a Past" come out of museum thinking but they also move away from museums in the force with which they challenge artists to conceive of installations that engage and comment upon the history and social dynamics of place. Both argue for the need to root public art in the physical, historical, and emotional texture of its site in such a way that voices shaping the past and present of the site also shape the work. "Skulptur Projekte" and "Places With a Past" responded to the pressure that was building in public art, and in contemporary art in general, to listen to forgotten histories and to voices outside institutional power, and to develop the kind of poetry and punch that could affirm the possibilities and importance of socially responsible artistic statements.

But the allure of these experimental festivals still depended upon the romantic images of their cities. Münster has a strong medieval past. Charleston is one of the architectural jewels of the South. "Skulptur Projekte" and "Places With a Past" led visitors all through these cities, through ordinary and working-class neighborhoods but also to the kinds of historic sites that draw people from around the world. In addition, while Münster and Charleston inspired installations so dependent upon their sites that they were unimaginable in another location, a number of the artists, including Donald Judd, Claes Oldenburg, and Richard Deacon, in Münster, and Chris Burden, Christian Boltanski, and Cindy Sherman, in Charleston, produced work that would have been just as successful in a New York gallery or museum.

None of the artists in "Culture in Action" is known as an object-maker. All are known for collaborations.

"Skulptur Projekte" and "Places With a Past" raised as many questions as they answered. Who were these projects really for? Many art-world visitors came through and art critics wrote about them, but what were their effects on the people who lived with the works, whose lives were formed by the histories with which the artists were concerned? The artists in these exhibitions were moving toward audiences outside galleries and museums, and often they had contact with them while conceiving and making the works, but did the show really touch them? Was the gap between the art public and the nonart public, art and life, that many artists in these exhibitions were trying to bridge, really closing? While "Skulptur Projekte" and, to a far greater degree, "Places With a Past," essentially rejected the notion of a permanent public-art monument imposing an artist's view on a public site, and while they pointed eloquently toward the kind of intimate relationship between artist and place that is now characteristic of the most influential public art in the United States and Europe, the success of these two endeavors still depended, to some degree, upon the tourist and museum experience.

"Culture in Action" does not. It is smaller, more intense, and less conducive to a hit-and-run approach. None of the artists in "Culture in Action" is known as an object-maker. All are known for collaborations. All are activists. Almost all belong to the tradition of socially based community or interactive art that includes the Russian Constructivists, Joseph Beuys, the Situationists, Allan Kaprow, and Christo – a tradition that has never been fully at home in galleries and museums. With the exception of Lacy's quarried limestone blocks commemorating 100 Chicago women, which were arranged around the Loop, all the projects unfolded in working-class or poor areas that hardly anyone outside Chicago would think of when picturing the greatness of this city.

"Culture in Action" had a grittiness that made it extremely difficult for visitors to encounter its projects without experiencing the social and economic realities and the humanity of the communities with whom the artists worked.

One of the most important and telling aspects of "Culture in Action" was its reversal of power relations. In this program, the insiders were not members of the gallery and museum worlds but communities whose members tend to feel that museums like The Art Institute of Chicago and the Museum of Contemporary Art have nothing to do with them. Encountering the artistic collaborations in neighborhoods, members of the gallery and museum worlds were the outsiders. To experience the eight projects, people affiliated with the institutionalized art world had to understand something of the foreignness that residents of these neighborhoods may feel in art institutions.[4]

In the Art Institute, what Latinos in West Town, African-Americans on the South Side, or Mexican-Americans on Maxwell Street feel about the paintings and sculptures on the walls and floors is essentially irrelevant to the standards by which the institute appreciates and judges its work. In "Culture in Action," museum standards are essentially irrelevant to judging the success or failure of the chocolate bar, the hydroponic garden, the block party, the parade, the ecology class, or the paint chart, to cite some of the objects, events, or situations that resulted from the artist-community collaborations. The shoe was on the other foot. In order to stand on solid ground in experiencing and evaluating the projects, the communities had to be entered, their voices heard, power shared.

"Culture in Action" has an idealism that has always characterized the most ambitious socially based art. It was driven by a belief in people and a faith in the ability of art to deal with social crisis. Each artist in the program is aware of how violently fragmented America has become and how seriously the social contract among its citizens has been broken. Each artist believes in the power of art to break down walls and build trust. To resist "Culture in Action" before understanding what it has to offer is to reinforce the same kinds of defensive-reactive attitudes that have made community-based, site-specific art an increasingly urgent matter. A program that is so much about the outlook for trust and respect must be trusted and respected before it is judged.

What I want to do in this essay is articulate what "Culture in Action" had to offer and why it has the ability to deepen the way everyone thinks about the multiplicity of audiences that make up the American public, as well as, therefore, about the enormous and complex field of public art. **I want to explain why "Culture in Action" has the ability to deepen the understanding of art. To assume that because many of these projects take place in communities with little connection to galleries and museums, and because they produce very little that looks like art, that "Culture in Action" has nothing to do with gallery and museum art, would be a serious mistake. It has as much to do with the essence of art now as anything in a gallery or museum. It is precisely in the areas of ambitious and responsible artistic community involvement where you are now likely to find art and artists with the kind of mission and responsibility that has driven so much of the work that has made twentieth-century art a vital human and spiritual matter.**

THE OBJECT AND TIME. One way to approach the differences between museum art and "Culture in Action" is through the object. A great painting is an extraordinary concentration and orchestration of artistic, philosophical, religious, psychological, social, and political impulses and information. The greater the artist, the more each color, line, and gesture becomes both a current and a river of thought and feeling. Great paintings condense moments, reconcile polarities, sustain faith in the inexhaustible potential of the creative act. As a result, they become, inevitably, emblems of possibility and power.

This distillation and compression create an extraordinary pressure within the work, that can make a painting seem complete, self-contained, inviolable. To audiences who love painting, the experience this kind of concentration and coherence offers can be not only profound and poetic but also ecstatic, even mystical. Spirit is incarnated in matter. People and events seem locked into and yet liberated from their moment. The human capacity for revelation is manifest. Not only does an invisible, spiritual world seem to exist, but it seems accessible, within the reach of anyone who can recognize the life of spirit in matter.

Painting points toward the promise of healing. Modernism argues implicitly that any kind of personal and historical drama can be illuminated or transformed. A Manet, a Degas, a Picasso, a Malevich, a Miró, a Pollock, a Bacon, makes it possible to believe that no anxiety or doubt is unfaceable and no conflict purely destructive, and that all trauma carries within it the potential for greater understanding and truth.

Modernist painting encourages viewers to assume that reality can always be seen, shaped, ordered, created. This, too, helps explain why painting is almost inevitably an emblem of power.

But painting also has the weaknesses of its strengths. At its best, it is so contained, so intact, that it becomes not only a conduit – from longing to light, muteness to eloquence, everyday life to a spiritual realm – but also a wall. It has become so much an emblem of power that it

can only function to a limited degree as an interrogation of power. Its illuminated coherence encourages people to take refuge inside it. Its capacity to evoke an experience of transcendence allows it to become for many people a release from the world around them. It is precisely the blend of spirituality and control that makes it so desirable to collectors who want to partake of its talismanic vitality – and so essential to a market system that has had no trouble converting a charmed and empowering pictorial presence into a coveted commodity.

What art of such internal pressure can do to only a limited degree is lead outside itself into social and political situations. No matter how much a painting may be about someone or something outside painting, it always pulls attention back into itself and holds it there. Titian's portraits of the rich and famous of sixteenth-century Venice are unforgettable because they are great paintings, and the imagination of the paint is more memorable in the end than the particular representatives of religious or secular power. Van Gogh's mesmerizing paintings of Arles and Cézanne's of Aix-en-Provence have inspired generations of people to visit these places, but it is almost impossible then to stop seeing them through these paintings, and through these artists' eyes.

A painting concentrates and distills; a "Culture in Action" project expands and flows.

And it is into the world outside art that an increasing number of artists, overwhelmed by the social and political conflicts around them, want to go. **All the art in "Culture in Action" is intended to lead away from the object into the lives of real people, real neighborhoods.** All the art is designed to challenge institutional power by fighting stereotypes, by building bridges between people pitted against one another, by empowering the kinds of audiences that do not feel comfortable in art museums, by underlining the richness of culture in the housing project and street. "Culture in Action" is intended to develop the ability of art to respond directly to social situations and appeal to a sense of collective responsibility as a means to personal redemption and power.

The imagery of its eight projects functions very differently than the imagery in a painting. Not primarily as a repository, although the "We Got It!" chocolate bar, the paint chart mapping American public housing, the hydroponic garden, the granite floor, and the limestone rocks bearing plaques honoring women may eventually become that. The chocolate bar, the paint chart, the garden, the granite floor, and the limestone rocks are successful only within the context of this program in so far as they lead away from themselves, toward actual people and real-life situations. A painting concentrates and distills; a "Culture in Action" project expands and flows.

The differences between museum art and "Culture in Action" are just as profound in their attitudes toward sound. In most art museums, as in most cathedrals (except, of course, during Mass), silence is golden. For the artists in "Culture in Action," silence is less a condition of respect and prayer than a symbol of repression whose rule must be broken.[5] A painting may orchestrate many different voices but they are felt and seen rather than heard, and, as a result, it is easy for viewers to tone them down or tune them out. The "Culture in Action"

projects depend upon and conjure up a myriad of actual conversations. They are generated by and they generate speech. In the rambunctious noise of the parade organized by Daniel J. Martinez and VinZula Kara, and in the pounding and restrained cadences of the block party organized by Iñigo Manglano-Ovalle, the models were not museums but street art, and the currents of sound were such that silence seemed not only jolted but broken. **A multifaceted Cubist painting offers a private experience of spatial dynamism. These artists ask visitors to experience the multifaceted, unrestrainable dynamism of the real world.**

Art that does not result in the kind of object in which a viewer is encouraged to dwell has the potential to throw the idea of ownership into question. However successful it may be in building a social bridge, no project in "Culture in Action" encourages a sense that conflicting viewpoints can be distilled into a seamless whole. No project allows anyone to say for sure: I have the work, it is mine, this is where it is. "Culture in Action" does not encourage a sense of control. None of the projects has the dense and sometimes wondrous consistency of a painting. All of them are ephemeral and unframed. One morning or evening the parade and the block party were there. Then they were gone, and all the people who participated in or observed them were left with were memories of the marching bands and video images and words and the pressure to interpret what the sounds and sights of the block party and parade meant. The images generated by "Culture in Action," such as the paint chart, the chocolate bar, and the hydroponic garden, point toward realities without getting in the way of experiencing them. The process of engaging the "Culture in Action" projects offers visitors an experience of embeddedness in the world around them that no painting of those communities could offer to anywhere near the same degree. Paintings, no matter how ebullient and gregarious they may be, are essentially centripetal. The art in "Culture in Action" is centrifugal.

At the heart of the difference between the aims and functions of art as object and art as non- or anti-object is a radically different approach to time.

Nothing is more important to the magic of a great painting than the sense of the concentration – and sacralization – of time. Time seems gathered, poured, molded into canvas or wood with paint. It is held there. It seems to be held there in a way that is totally distinct from its absolute refusal to be frozen, even for an instant, in daily life. Power over time is something human beings are not permitted in their lives, but in a painting it seems possible to hold time and feel that it is responsive, even obedient, to the human hand. The consent of time is one reason a painting can seem like a blessed event.

"Culture in Action" secularizes time. It does not try to stop time. It does not in any way encourage the belief that time can be organized into a unified narrative framework, or that the "fall into time" is a Biblical curse, or even a fall, or any mark of human frailty and sin. On the contrary, its projects deliver themselves to the disorderly flow of time, and ask everyone exploring the pro-

jects to consider flux home. The immersion in time means a different kind of participation than the kind encouraged by a painting. Building on historical precedents such as Russian Constructivism, and reflecting the growing public dissatisfaction with the limits of art institutions and the struggle within many of them to question and expand their understanding of the public, the projects require visitors to get out of the gallery and into the city, into real rather than pictorial space. They also all but demand an emotional and intellectual interaction with many different kinds of situations and people.

The rewards of trusting rather than resisting the call of real time and space in "Culture in Action" are enormous and surprising. While the immersion in everyday existence may seem to offer no myth, no poetry, no ritual, no sense of access to a privileged realm of feeling and experience, there is a powerful lyricism in the projects of Haha and Daniel J. Martinez, and for many of the artists in "Culture in Action," including Lacy, Martinez, and Manglano-Ovalle, ritual is essential to their ability to focus attention on social issues. A number of the projects offer a sense of initiation. It can come at any stage in the discovery of the work. It is not likely to come all at once, like a revelation so consuming that the work remains a personal landmark forever. Once a project does seem to reveal itself to you, however, the sense of recognition and intimacy is likely to remain for every bit as long as it does after it is generated by a painting.

Anyone who meets the temporal demands of these projects will be stretched into several worlds. In order to understand the paint chart that Kate Ericson and Mel Ziegler developed with the Ogden Courts Residents Group, it is helpful to visit the Ogden Courts housing development on the South Side of Chicago and speak with a member of that group.[6] It then begins to become possible to comprehend the realities of the Chicago housing developments and the heroism and humanity of ordinary citizens, such as Arrie Martin, a leader of the group, who struggles each day to build hope in young people and make life in Ogden Courts better.[7]

After visiting Ogden Courts, it is easier to grasp the real and symbolic importance of paint in the residents' lives. Many of the apartments were painted once, more than twenty years ago, and never again – although many residents have asked the Chicago Housing Authority to repaint, and although cracking paint can be a health hazard. It is the responsibility of the CHA to maintain the buildings. Developing a paint chart and naming the colors after events in the history of public housing – of which not only inner-city housing but also the White House, shown on the cover of the chart, is part – and naming colors after individuals in the developments (for example, "Arrie's Dazzle Blue"), are political acts exposing the role of institutional indifference in the widespread stigmatization of public housing and in the stereotyping of its residents as unknowing, uncommitted people.

Only by visiting Ogden Courts is it possible to sense the distance between its residents and the artists. There are roughly sixty-five apartments and four hundred African-American residents in Ogden Courts, and ninety-five percent of its households are run by single mothers. Ericson and Ziegler are white and live on the East Coast. The paint chart is the evidence of a small bridge across race and class that can continue to grow as the chart finds its way into True Value Hardware Stores across the United States, or into some other public arena, and the information on it is spread.[8]

Experiencing the different realities that began to communicate in the paint chart is one of the sparks that can bring the project to life.[9] This experience opens up other layers. If the search for a bridge across race and class is part of the content of the work, so are the previous attitudes of Ogden Courts toward white artists from the East and toward Sculpture Chicago, which prior to "Culture in Action" was widely seen in African-American and Mexican-American neighborhoods as a white downtown organization that was not interested in the rest of Chicago. So are the assumptions about the housing project and the people in it that Ericson and Ziegler brought with them. So will be the responses to the paint chart once it becomes public. In so many ways, the paint chart expands outward, unfolding in many directions, flowing into personal, social, and political worlds.

In short, the involvement in real time and space opens up the projects in "Culture in Action." And the importance of this kind of involvement to an understanding of the projects raises with particular urgency one of the most fundamental of all contemporary art issues: responsibility.

And into art. The paint chart speaks to the history of Conceptual Art, including the photographs and installations of Gordon Matta-Clark, who was passionately interested in the ordinary American house and in the social conditions of the people who lived in it. It also needs to be understood in the context of the careers of Ericson and Ziegler, who were once house painters, Ericson for more than fifteen years. Much of their work has been an attempt to empower ordinary people and explore the conventions and meanings of house painting, and ways in which a culture develops and spreads ideas about house and home. They have worked with individual homes and their residents in suburbs and in small cities like Charleston, where they participated in "Places With a Past." For "Culture in Action," they conceived a project that could benefit tenants in the urban environment of Chicago's South Side and at the same time suggest the vast and complex story of American public housing as a whole.

In short, the involvement in real time and space opens up the projects in "Culture in Action." And the importance of this kind of involvement to an understanding of the projects raises with particular urgency one of the most fundamental of all contemporary art issues: responsibility. This is not an easy issue for museums to tackle. They are now so dependent for support upon dealers, collectors, patrons, and artists that hardly any major museum can risk asking the questions: **to whom and to what are we really responsible, and how does our dependence upon these various, and sometimes competing, interests affect the ways in which art is defined, artists are recognized, and institutions are seen?**

The blockbuster shows that big museums still covet for their ability to generate crowds, publicity, and money mediate against commitments to reflection and time. Such exhibitions almost obliterate the question: what does it mean to approach responsibly an artist such as, let's say, Matisse? When exhibition becomes spectacle, it is easy for viewers to rationalize their fifteen to twenty seconds with a painting and one to two hours in a major show. Well, they kind of knew Matisse anyway, and after all they did respond to some works, and they can always see other works of his in museums near their homes and in books. It is not hard to come away from a blockbuster and toss aside the nagging sense of frustration over not being able to deal with its challenges.

"Culture in Action" is different.

Although many of its projects promise pleasure, none promises a quick high. Many of them all but demand to be understood in context, which means visiting their sites, listening to their multiple voices, and approaching them from several sides. Because "Culture in Action" confronts visitors not with a work on a wall or floor but with real-life situations and real people, it is harder to brush off the discomfort of not being able to grasp fully its challenges. Its projects apply considerable pressure to think about what responsibility – of the artist, critic, audience, and participant - now means.

Iñigo Manglano-Ovalle's "Tele-Vecindario: A Street-Level Video Project" is an example of the highly developed sense of responsibility and extraordinary commitment of time that successful community-based art requires. Manglano-Ovalle lives in the community with which he worked, which meant that he was constantly around the youths he was collaborating with, and constantly in a position of discussing their project with other members of the community. The stakes for which he was playing were so high that his project had to merge art with life. If his video project succeeded, the young people he worked with would see themselves more constructively and the community would see itself more in communal terms. If his community felt he had not been responsible first and foremost to its needs rather than to his own, or to someone else's needs if it felt exploited or betrayed by him, he would be marginalized within it.

Manglano-Ovalle's August 28 video block party was the culmination of months of collaboration between the artist and a group of twelve-to-fifteen mostly Latino teenagers in his West Town neighborhood. All were between sixteen and eighteen years old. Some were former gang members. All understood the power of the electronic media to control the way they are seen by constructing stereotypical and often unflattering images of them and then spreading them through American culture as a whole.

Manglano-Ovalle spoke with these young people, met them after school, respected their suspicion, learned what was necessary to gain their respect.[10] He enlisted the cooperation of a dynamic community leader: Nilda Ruiz Pauley, a teacher and the coordinator of the School-Within-a-School program at nearby Wells High School. He arranged for video equipment to be made available to the students and brought in local video professionals like Maria Suarez and Paul Teruel to work with them on videos about themselves and their neighborhood, and to help them form the Street-Level Video group. Over several months, the members of Street-Level Video shot and edited a score of videos about themselves, their families, their friends, their daily lives. The videos documented street codes and gang codes. They asked questions about old age and youth, race and gender – access and ownership. "Is this my neighborhood or your neighborhood?" some young people ask the viewer in one video. "Is this my reality or your reality?"

The videos changed a great deal in the months leading up to the block party. Many of the early videos zeroed in on someone, got an expression, a response, a statement, and moved on to someone else. When the young people asked questions of others, there was rarely a follow-up. These videos tended to move fast and cut sharply, suggesting lives of great speed, little distance, short attention spans. Then Street-Level Video began to make slower videos that were more responsive to older

people and respectful of the gravity of harsh events, such as gang killings. By the time of the block party, everyone in the community seemed to be acknowledged not only in the content of the videos but also in their rhythms.

Like all the artists in "Culture in Action," Manglano-Ovalle wanted to open doors, build contacts, establish conversations. "What I was trying to do was create an event that focused on the potential for discussion and discourse and dialogue in the street," he said. "The main issue at the very beginning was there wasn't any dialogue and discourse on the street. But it was as well about discourse and dialogue between generations, as well as between youth. Then it folds and unfolds and keeps going, so now it's between streets and the different loops of communities that come in."[11]

All over the world, from prehistory to the present, there have been images believed to have the power to purify body and mind.

The block party featured seventy-one monitors showing forty-six videos. The monitors were in the street, behind fences, in yards, on steps, in doorways. They made the street seem like one giant living room. As it became night, the screens animated and haunted the darkening pavement with the voices and faces of community residents. One video showed, over and over, in close-up and slow motion, people counting money – both acknowledging and questioning the kind of business done on the street all the time. "Rest in Peace" was a video installation in an empty lot that commemorated, through the fairly rapid succession of testimonies juxtaposed with still images of flowers, the loss of young people to gang violence.

The videos mapping the faces and hearts of the neighborhood offered a journey through space and time. They encouraged everyone who saw them to look at people, places, social structures, and also economic and political situations – like gentrification, which threatens the community from the outside, just as street violence, turf wars, and social fragmentation threaten it from within. At one point on Erie Street, videos symbolically formed a barricade that ended the block party in front of a sign announcing the construction of four new luxury apartments, each with two-and-a-half baths, "Euro kitchen," and marble foyer, each with a $234,000 price tag. One video, standing on a crate, replayed the words, "Our community is not for sale."

This video block party did indeed inspire community feeling. The day before the event, Manglano-Ovalle met with members of different gangs. Thirty assigned themselves to the protection of the monitors and people. Normally, Pauley says, there are hundreds of police at block parties. None were present and none were needed. Outsiders who would not normally visit West Town moved through the block party in complete safety. The party brought together people from a mixed but mostly Latino neighborhood and the institutionalized art world and put them in a shared and welcoming space in which they could begin to relate to each other as individuals.

Some of the video equipment has been given to the Street-Level Video crew. One hope is to use the videos at community centers and in local high schools and involve at least one of the original participants in the discussions. Pauley has no doubt about the positive effects of the block party and videos on the youthful video crew. "They've taken ownership," she says, "and people see them a little differently."

"Our kids don't see a future in this community," she says, "and that bothers me tremendously. And if people like Iñigo and if money for community artists can float into a project and give our kids a concept of a tomorrow, I'm 100 percent for it, because our kids don't see a tomorrow."

"Iñigo has become part of the community," Pauley says. "Now a lot of them will come to him and he will support them."[12]

An art object cannot do what Manglano-Ovalle's "Tele-Vecindario: A Street-Level Video Project" did. A painting can be an inexhaustible world that inspires a profound sense of pleasure, poetry, meditation, and prayer. It cannot easily inspire young people to seek control of their lives and communicate with others, and it is no longer a world that engages audiences as different as the usual ones for Sculpture Chicago and the residents of West Town. **An art object can suggest the spiritual possibilities of human beings through its illumination and transformation of matter. The community-based art in "Culture in Action" can not only expose the energy and depth of ordinary people but also help these people develop their human potential in individual and communal acts. A successful painting can live on in the mind as personal landmark and cultural beacon. Successful community-based art keeps unfolding in the mind in the ways it allows real voices to be heard and the dignity and dilemmas of real communities to be felt and real dialogues across race and class to develop. Community-based art will never replace museum art. But museum art cannot substitute for what community-based art can do. If community-based art offers a different experience of time than a museum object, it also offers a different experi- ence of space.** One consequence of the current polarization of American life is that people feel no distance between themselves and others. People different from us can seem to be impinging upon us, to be leaning against us, to be giving us no air. The gap between us and them is experienced, paradoxically, as an absence of space. Giving yourself to "Culture in Action" means entering the gap between Ericson and Ziegler and the Ogden Courts residents, or between West Town and downtown Chicago. The gap seems inhabitable. It becomes space. The experience of elastic, unstable, unboundable time can encourage people to feel an abundance of space and air. From Egyptian statuary, Etruscan tomb painting, and Byzantine mosaics; to Chinese landscapes, Indonesian Buddhas, and Indian miniatures; through Picasso, Giacometti, Pollock, and Serra, the spatial imagination has been essential to aesthetic experience.

The community-based art in "Culture in Action" works toward a new kind of space, one that encourages a sense of place outside the gallery and museum, in unexplored neighborhoods of the heart, and in the unfamiliar storefront, marketplace, park, and street.

HEALING. Healing has always been one of the functions of art. All over the world, from prehistory to the present, there have been images believed to have the power to purify body and mind. In many African countries, images have been used to drive away evil spirits. In many European countries, images were seen as having the ability to relieve physical misfortune. "The stories about divine statues performing miraculous cures belong to the repertory of all religions," wrote the art historian Moshe Barasch.[13] "They also abound in Greek literature in antiquity."

With the development of modernism, Western art became more systematically involved with healing than ever before. Beginning in the mid-nineteenth century with Romanticism, Realism, and Impressionism, much of the most influential Western art has been a response to conflict and crisis. The sensitive, compassionate individual cut off from the impersonal conformity of the group; human beings cut off from nature; members of different classes, genders, and races cut off from one another in a world structured on inequality and power – these kinds of ruptures are staples of the modern experience. Modernist painting and sculpture reflect the shocks of modern life, sometimes lamenting them, sometimes celebrating them, sometimes deploring and exalting them together, almost always trying to relieve the experience of shock through the healing power of materials and images.

So many of the enduring images of the late nineteenth century are both endorsements of the modernity of disjunctiveness and convulsion, and struggles to harmonize and heal. In his paintings of water, trees, and hills, Monet accommodated an acute awareness of flux and uncertainty within his Edenic images of peace and bloom. In the tumultuously organic shapes and rhythms of his Provençal landscapes, van Gogh imagined a community of spirits bound by caring, respect, and love. At roughly the same time on the other side of the Atlantic, Winslow Homer composed genre scenes, portraits, and landscapes in which the differences among Americans and within nature were speaking in an independent yet integrated pictorial manner.

Responding to crisis, acknowledging its ability to stimulate creativity and change and at the same time struggling to overcome the danger and loss that accompany it, is part of the fabric of modernism.[14]

Modernist painting and sculpture argue implicitly that there is no trauma or crisis, no personal, social, or spiritual illness or upheaval, that cannot be faced in art, and that cannot, through art, become a source of revelation and strength.

In its vibrantly broken spaces, Cubism, inspired by Cézanne, met the artistic challenge of fragmentation and, in the process, embraced the modern reality of multiple points of view. Responding in his own way to the modern condition of crisis, Matisse, who discovered painting during an appendicitis attack when he was twenty years old, attempted, through color and light, to "relieve," to "alleviate,"

to "heal."[15] Surrealism saw disjunctiveness and incongruity as sources of the marvelous. Abstract Expressionists offered vast contemplative or cathartic spaces in which they believed personal and collective trauma could be transformed through imaginative participation.

In the 1960s, everything changed. The social conflicts discerned by early modernists such as Courbet and Manet no longer simmered more or less beneath the surface, but burst into the open. Inequalities resulting from institutionalized attitudes about race, gender, and class exploded into debate, violence, and action. Social tensions could no longer be contained within any existing social framework; it was no longer enough for artists to substantiate and explore social conflict within the confines of the frame and the pedestal. As the crises of the cities and the environment intensified, art moved into the street, into the landscape, and, in '80s public art endeavors such as "Skulptur Projekte" and "Places With a Past," into prisons, dungeons, churches, garages, universities, and city halls.

The healing power of images now seems limited. Most of the responses of modernist painting and sculpture to dislocation, displacement, and injustice – and to the denial and defensiveness of institutional thinking – found their homes in living rooms, galleries, and museums. The museums with which modernist painting is identified are now establishment institutions whose curatorial decisions inevitably defend the social and economic interests of their well-heeled and mostly white corporate boards of trustees. The increasing isolation of modernist painting and sculpture from the texture of the world in which they were created has reinforced the view that modernism is now itself both a symptom and a victim of the fragmentation and divisiveness many modernist artists tried, in their own ways, to heal.

Modernist painting and sculpture will always offer an aesthetic experience of a profound and indispensable kind, but it is one that can now do very little to respond effectively to the social and political challenges and traumas of American life. Its dialogues and reconciliations are essentially private and metaphorical, and they now have limited potential to speak to those citizens of multicultural America whose artistic traditions approach objects not as worlds in themselves but as instruments of performances and other rituals that take place outside institutions. The greatness of an early modernist such as Manet lay in his ability to locate social divisions, to build into his compositional structures a consciousness of them, and at the same time to organize them into a magisterial moment in which the fault lines of French society seem to emerge on their own and yet any tendency toward futility is conquered by the luminosity and synthesizing potential of paint. The challenge for contemporary artists inspired by Manet may be to use art to bring all the audiences Manet was aware of into actual conversation.

Certainly images whose homes are galleries and museums can do very little to respond to the present crisis of infrastructure in America. Largely as a result of the greed, egotism, and carelessness in Reagan's and Bush's America, the social fabric was torn up in the '80s. Not only do many roads and bridges and buildings in America now need to be repaired, so do roads and bridges between people.[16] Building human and societal infrastructure is a goal of community-based art. While in their rejection of the present and longing for a new start, modernist avant-garde painters and sculptors struggled again and again to return to the childhood of painting, the origins of culture, the

birth of civilization, "Culture in Action" is concerned with actual youth, the foundation of the future. The projects of Iñigo Manglano-Ovalle, Mark Dion, and Bob Peters are shaped by adolescents. The parade organized by Daniel J. Martinez and VinZula Kara featured young people, and the youngest, from Cardenas Elementary School, marched near the front. The Ogden Courts Residents Group is using its participation in the paint chart project to apply for grants that will help it establish a program to support and reward good students.

The tradition in which the "Culture in Action" artists are rooted is one that does not seek to heal through the art image but by bridging the gap between art and life.[17] The Russian Constructivists, whose revolutionary program included making everything art, and who felt, with the poet Vladimir Vladimirovich Mayakovsky, that "The streets are our brushes, the squares our palettes,"[18] are part of this tradition. So is Marcel Duchamp, who proved that almost any everyday object, from a urinal to a bicycle wheel, or even his life, could be art. So are the Situationists, whose visual and verbal outbursts in public places helped make absurdity, appropriation, and the use of the spectacle against what they saw as the spectacular nature of industrial life, into avant-garde strategies that challenged the museum and all other forms of institutional power. So is Christo, who made negotiating and collaborating with the public a basic part of his grand, transitory, ceremonial performances. And Allan Kaprow, whose "Happenings" transformed into performances the performance aspect of Pollock's dancing and tossing gestures in his "drip" paintings, and who has argued that even in the most common everyday act, like brushing one's teeth, it is possible to find the visual and intellectual surprises and questions that help define an aesthetic event.[19] For "Culture in Action," the most prophetic voice in this tradition is Joseph Beuys.[20] He believed art had not only the ability but also the obligation to help heal an enormous wound. For him, the wound was in Germany, as a result of the sickness of its Nazi past; it was in Cold War Europe, divided by the Berlin Wall; and it was in societal thinking, fractured and shriveled by the tendency to see everything in categories and compartments instead of as an interconnected whole. "Beuys's vision of social change, like that of many other artists during the 1960's," wrote the curator Ann Temkin, "centered on repairing a divided world and a divided self."[21] "As he engaged the country's Nazi past in various ways," Temkin writes, "Beuys framed his work as a form of homeopathic therapy: 'the Art Pill.'"[22]

For Beuys art had to be a way of life, not a profession. In his concept of "social sculpture," everything was sculpture, everything was art, and every aspect of life could be approached creatively, with a sense of inventiveness and ritual. "The social order is a living being," Beuys said.[23] Art had to be brought to the people and made by the people if society had any chance for structural change. "Everyone is an artist," he said, in one of his best-known statements.[24] "I am really convinced that humankind will not survive without having realized the social body, the social order, into an artwork. They will not survive," Beuys said.[25] Beuys fought against polarizations such as science and art, East and West, warm and cold, solid and fluid, rational and intuitive, animal and human. He also fought against any reductive view of an artist's life and career. He was a politician, helping to form the Green Party. He was a teacher who performed on blackboards and worked to make classrooms, in effect, into galleries. He was a maker of objects that could seem prehistoric

and yet forever unfinished. In his "Actions," he was actor in and director of ritualistic public performances in which people would see him with living or dead props in situations that encouraged a deeply felt experience about political, environmental, and human issues.

In almost everything he did, Beuys encouraged a freshness of response, a skepticism about all systems, a consciousness of the human connection to nature, and an awareness of the importance of ritual and myth in everyday life. Believing that empathy builds bridges and carries with it the potential to heal powerlessness and neglect, he worked toward what the curator Bernice Rose called "empathetic healing."[26] Empathy for other people was not enough. "Empathetic imagination has its roots in nature," Rose wrote. "If we can leave behind our own identities to identify with the other – the suffering of the animal in nature – then we have sensitized ourselves so we can be social beings."[27]

For Beuys, art had to combine the gentleness of healing with an activist toughness. "I am no longer interested in covering up maladies and wrongs," Beuys said. "I consider it my democratic duty to shake things up and to teach larger numbers of people."[28] Art had a human and social mission. In 1985, the year before he died, Beuys described his art as an attempt to find "the only way of overcoming all the surviving racist machinations, terrible sins, and indescribable darkness without losing sight of them even for a moment."[29]

Beuys's view of art as life, and life as art, leads to a notion of time very close to that in "Culture in Action." If art is life, then there is really no beginning or end to it. There is no frame around it. Nothing about it is fixed. Art, like life, is chaos, then it comes together, then it dissolves again, then it comes together in a new manner, then it breaks apart....

Nothing is stopped for long, everything shifts back and forth between disorder and order, everything is open-ended and unstable. Every artistic event, however finished it may seem, is incomplete since it always flows out and back into a ceaselessly fluid and infinitely complex social, intellectual, and spiritual network.

If "Culture in Action" is informed by a sense of time that reflects Beuys's vision, it is also informed by a Beuysian belief in the importance of trust, empathy, and ritual, and a Beuysian faith in the role of art in survival. In their projects, the artists in "Culture in Action" are determined to use art to heal social ills such as racism, sexism, and many other forms of injustice. Like the art of Beuys, "Culture in Action" is concerned with crossing barriers, building bridges, breaking down walls - creating dialogues that get people normally cut off from one another to sit down together and listen.

A number of the projects in "Culture in Action" suggest a commitment to art as education. In "The Chicago Urban Ecology Action Group," Mark Dion developed a classroom situation for twelve high school juniors from two magnet schools – Providence-St. Mel, a mostly African-American school on the West Side, and Lincoln Park, in mostly white north Chicago. The group traveled to Belize, in

Central America, during the Christmas break in 1992, then met regularly for eight months to discuss ecological issues, including the relationship between the ecology of the rain forest and the ecology of the city. Students of different economic classes worked together. The project also created a bridge between ecology, identified mostly with affluent whites, and the inner city, whose residents are rarely given the opportunity of experiencing the grandeur and lushness of tropical nature. Dion enabled the students to recognize themselves in and yet respect the otherness of nature. He showed them that the field of ecology is applicable to anyone and anything. He also showed them that art, which like ecology is a field that tends to be identified with an affluent white elite, can touch just about anyone and enrich the experience of anything, from a classroom to a rain forest.[30]

In "Naming Others: Manufacturing Yourself," Bob Peters set out to explore that emotional, psychological, and political realm of words that wound. With responses to surveys given to visitors to Chicago at the Urban Life Center on the South Side, he created a lexicon of hundreds of words used to describe men, women, whites, blacks, gays, and foreigners. He then built these words, as well as his assimilation of the respondents' survey comments on what it felt like to be involved in name-calling, into a telephone survey. Callers were led on a six-to-twenty-minute journey in which they were asked to relate themselves to many different naming classifications – or, as Peters says, to "locate themselves in abusive language."[31] The results clarify the dehumanizing impact of this kind of language and the way such words as fag, dyke, kike, wop, spic, and nigger reinforce social and psychological barriers by covering up feelings of anxiety, fear, impotence, anger, and neglect. Such words not only defend people who use them against those different from them; they also defend people against aspects of themselves with which they are uncomfortable.

But Peters has something of Beuys's distrust of all ideological systems and wariness of viewing anything in overly simple terms, and he came away from his project respectful of the richness and inventiveness of figurative language. Fascinated by the phrase "Red Sea pedestrians" that one respondent used to describe Jews, he emphasized that naming others can also be a testimony to the wit and inventiveness of the imagination.[32] He also believes banning abusive language would not protect differences among people, but on the contrary make it harder for those differences to be expressed and explored. In addition, since offensive naming is a potential source of access to essential pockets of pain and creation within the namer, declaring such naming taboo risks cutting off access to some of the deepest recesses of the self. From Peters's project it is clear that names given to others – to the other – are repositories of cultural meaning so filled with energy, both creative and destructive, that our inability to deal with them deprives us of access to essential parts of ourselves. These abusive words can lead to sickness, or they can lead to health, or they can lead to a greater understanding of ways in which sickness and health can be intertwined. One way to heal the personal and collective wounds they expose is to examine them fearlessly – which is what Peters says he intends to do in his university classes and and speaking engagements. "Naming Others: Manufacturing Yourself" encourages communication among the many components of the self, as well as among the many different components of society.[33]

Every project in "Culture in Action" fights neglect and indifference and works for an environment that fosters the kind of respect and trust that make dialogue and healing possible. Every project is intended to create a climate of empathy that will encourage people to identify with people different from themselves. Every project reaches out to people outside art institutions and emphasizes the potential richness of everyday life. Every project builds a road or bridge where there may not have been one before.

Every project builds a road or bridge where there may not have been one before.

The first part of "Consequences of a Gesture" brought together members of Mexican-American and African-American communities in Chicago that do not normally speak to one another and attempted to bind them together through the ceremonial ritual of a parade. Although these communities formed the core of the parade, it was organized by Daniel J. Martinez and VinZula Kara as a multicultural event that also included Asian-Americans and whites. Just as important, it was an attempt to weave together a broad range of cultural expressions, from high school marching bands, to Dion's Chicago Urban Ecology Action Group (wielding butterfly nets), to the community-based Red Moon Theater (which performs primarily for children), to television and comic books: Martinez, marching at the head of the parade, wore a cartoon Tasmanian Devil T-shirt and a jester's hat; at different points during the parade Kara, its Pied Piper, played a melodica. At all three of its stops, the procession of around five hundred people offered unsuspecting onlookers – who had no idea where the parade came from and what it was doing in their neighborhood on a sleepy Saturday morning in mid-June – a carnivallike event in which each component was a distinct yet integrated part of an organic, cacophonous whole.

Each of the three loops for the parade was in a part of Chicago where parades do not occur. The first stop was the Mexican-American neighborhood of Harrison Park. The last stop was the African-American neighborhood of Garfield Park. In between, the parade marched along Maxwell Street, the site that oriented the parade and clarified its intent. Maxwell Street is one of the richest historic areas in Chicago. In the 1800s, it was one of the birthplaces of street blues performances. It was still drawing blues musicians from the South in the 1950s. Bo Diddley played there. It was an essential part of a neighborhood through which many immigrant groups, including Jews, Poles, and Italians, passed after arriving in the United States. It is a site of labor and civil rights struggles.

Maxwell Street was designated a market area in 1912. For years it was open every day. Now it is an underground market, run almost exclusively by African-Americans and Mexican-Americans, and open only on Sundays, when it is often packed with upwards of 5,000 people. And it is in danger of becoming one more victim of university expansion and malignant urban neglect. This bustling and blighted market area has been so consistently encroached upon by the University of Illinois campus that its future is unclear. The university opened alongside the market in 1965, and while it never attracted as many students as it expected, it continues to acquire land in the market area, and its officials talk of building research centers, parking lots, or recreational facilities there. The parade celebrated the site and exposed its participants and passers-by both to the continuing vitality of the market and to the degree to which its African-American and Mexican-American vendors depend upon it. The processional movement of its young marching bands and its third graders banging

water cans with ice cream scoops and its costumed students from Project Africa, a summer program of the Henry Suder Public School, had the effect of weaving a protective spell around it.

In the second part of his project, called "100 Victories/10,000 Tears," Martinez zeroed in on Maxwell Street and went a good deal further than he and Kara did in the parade in responding to institutional indifference or resistance to the kinds of immigrant, labor, nonwhite histories with which he and many other artists in "Culture in Action" are concerned. And to the ways in which representatives of these histories continue to be displaced. Martinez was responsible for a raised granite floor installed in July near the center of an abandoned lot west of Halsted Street in the Maxwell Street market area. It was made up of thirty-two granite slabs, each weighing eighty-five thousand pounds, that had just been torn down after being used for raised walkways and outdoor forums and four lecture centers on The University of Illinois at Chicago campus. The walkways were one of the most visible elements of a widely criticized Brutalist architectural conception. In the ways they blocked light and left students physically exposed, they came to be for Martinez and many others symbolic of the university's insensitivity both to its own community and to the communities around it. Martinez's floor is itself a forum where anyone can walk or sit, and people in the market can congregate, proclaim, or simply find peace and air.

On the fences to the north and south of the floor, Martinez placed twenty-four small signs – each resembling the brown and white signs of the university warning strangers to keep out – that refer to the convulsive labor and civil rights history of the area. "Haymarket Square/Desplaines + Randolph May 4, 1886/176 Policemen attack 20 workers 4 Die," one sign reads. "Laeger-Beer Riot/Clark St. Bridge April 21, 1855/250 Vigilantes Attack & Kill German Workers," says another. These signs suggest that a terrible pattern of initial welcome and subsequent exclusion and violence has characterized the experience of many foreigners, outsiders, and workers in Chicago. The floor is itself high-spirited and welcoming, but it is also sharp in its questioning of institutional power and in its bitterness about the ways migrant and dispossessed people, and labor and civil rights histories, are rarely given the institutional respect they deserve.

The futility, rage, wit, and defiance within the work meet in a sense of absurdity that is something of a Martinez signature. "Look + Laugh," one of the signs says, appropriating the words of Felha, an African musician and revolutionary; "Absurd in Reality Is Absurd," says another, appropriating a phrase of Kara's. A sense of absurdity acknowledges the force of conflicting emotions and in some way bridges them. The floor is a lyrical gesture of invention, insolence, and freedom. It is also a welcoming, exposing, and energizing act. It is an attempt to dramatize a history of institutional brutality and neglect. It is a plea to protect Maxwell Street and not to let the market die. It is a call to action. To one side of it stand almost 200 of the granite posts that had served as the railings on the walkways. Now they are clustered together, the chains that once connected them wrapped around them, seemingly waiting like political prisoners for release and mobilization. The placement of the floor is itself a statement of empowerment and healing in its ability to define Maxwell Street not just as a beleaguered tertiary market, but also as a privileged platform from which to view the city that now threatens its existence. The site of the floor is so remarkable – with the Sears Tower and university to the north, a housing project to the

west, an expressway to the east, abandoned industrial remnants to the south – that someone standing on it, breathing the vast open space around it, looking at the grand skyline in the distance, could feel that this officially spurned, run-down, fenced-in area is special, if not blessed.

Both the Martinez-Kara-organized parade and the Martinez floor have a strong educational dimension as well. With its procession of elementary school and high school students, the parade is a call to young people to find their own ways to develop the multicultural collaboration and political possibilities of the parade. Since the floor used material discarded by the University of Illinois to call attention to practices – and to a state of mind – that devalue the lives and histories of working-class, immigrant, or marginal people, it is a challenge to universities to look at themselves. Both projects, particularly the floor, suggest the need for the kind of educational emphasis and reform Beuys was after.

One potential form of healing of which Martinez and Kara are very much aware is ritual. The parade was a ceremony; almost anything taking place on the stage of the granite floor has the feeling of a ceremonial event. Ritual is a way of giving weight to the moment, of establishing the importance of an occasion, of making everyone shaping and experiencing the occasion into a participant in an event. The block party organized by Iñigo Manglano-Ovalle not only showed West Town the efforts of the Street-Level Video crew, it also consecrated those efforts. The ritual of the block party created a sense of confidence, energy, and togetherness. Because of the compression and concentration of emotion and experience in the parade and block party, these two rituals are likely to remain seeds of inspiration for everyone touched by them.

For an activist artist, the trick is not to allow the ritual to become so compelling, so much a world unto itself, so easily repeatable, that it pushes aside the issues that inspired it. One way to deal with this problem is the way Beuys dealt with it, by making the ritual ephemeral.

For an activist artist, the trick is not to allow the ritual to become so compelling, so much a world unto itself, so easily repeatable, that it pushes aside the issues that inspired it. One way to deal with this problem is the way Beuys dealt with it, by making the ritual ephemeral. The block party existed for six hours, then it was gone. The parade marched, then it vanished. Because these ceremonial events were so transient and expansive, they survive not only as fixed images, but also as unrealized hopes and unfinished plans. They remain in the mind as sources of pressure that can only be relieved by subsequent action. The Manglano-Ovalle and Martinez-Kara ceremonies place the responsibility for developing the healing and empowering process on the shoulders of their participants.

No artist in "Culture in Action" has been working longer than Suzanne Lacy to put ritual in the service of action. Her projects for "Culture in Action," like her previous communal projects, are highly ritualized.[34] She organizes events that attempt both to collapse time by identifying them with rituals that have recurred through the ages, and to open up time, by inspiring participants to rethink social and political structures and change their personal and political lives. Her emphasis on cycles and repetitions is intended to ground responses and actions in myth; her focus on actual conditions is intended to invest the ensuing resolve in the present and future.

All of Lacy's contributions to "Culture in Action" were clearly ceremonial and clearly political. One morning in May, Chicagoans in the Loop found 100 large, scattered chunks of limestone that seemed to have dropped overnight like a meteor shower. Affixed to each rock was a bronze plaque bearing the name of a woman who had made a significant contribution to the life of the city. The rocks were cut in an Oklahoma quarry owned by women. The honorees were selected by a coalition of Chicago women. Before the rocks appeared, there were no sculptural monuments to women in all of Chicago. Now there were 100, commemorating women living and dead, representing different races, religions, and cultures. Suddenly women could find the achievements of other women recognized in bronze; and just by noticing the names on a handful of the plaques, men had to become more aware of the role of women in Chicago's history. These women were celebrated at a ceremony in Pritzker Park, a 1991 Sculpture Chicago project designed by Ronald Jones to be both an intimate oasis of air and greenery in the Loop, and a call to community and civic responsibility. When Lacy read off the name of each living woman commemorated on a rock, it was the signal for the woman to walk down a winding path and gather with the others. The success of community-based art cannot be measured without taking into account the responses of the audiences to which the art is directed, and for many of the women honored in the heart of Chicago, this ceremony clearly created an enormous sense of pride.

The concluding event of "Culture in Action" was a September 30 dinner at the Hull-House Museum. Fourteen prominent women from around the world were brought to this late nineteenth and early twentieth century center of educational experimentation and social reform founded by Jane Addams, one of the most admired figures in Chicago history. With its nineteenth-century decor and menu, and its profusion of video equipment set up to capture every nuance of the occasion, the dinner was the most formalized of the events. It commemorated Addams, whose remarkable achievements in many fields provided the inspiration and historical context for Lacy's action; it commemorated the fourteen women; and it commemorated the importance of the evening meal as an indispensable everyday ritual traditionally prepared and perpetuated by women. By ritualizing dinner and making this dinner into an event, Lacy emphasized the importance of daily rituals and the place of women through time.

But Lacy also brought the ritual into the present. Eventually she directed the dinner discussion to the current situations of women and to possible collective action that would better the conditions of women in the future. In short, Lacy used ritual both as an empowering and healing device and as a stepping stone to action. Her art places culture in the service of political action. It puts myth in the service of history; or in Mircea Eliade's terms, it puts mythical time in the service of concrete time.[35] The primary movement in Lacy's art is not from the particular to the general, or from the secular to the religious, but the reverse. She wants to put the general in the service of the particular, the transcendent in the service of the everyday. In her tableaux spilling out into Chicago and, through the dinner guests, into foreign fields and cities, she uses ritual to heal and act.

ONE PROJECT: HAHA AND FLOOD. Haha is a collaborative group based in Chicago. Its four members – Richard House, Wendy Jacob, Laurie Palmer, and John Ploof – met as students of The School of The Art Institute of Chicago, from which Palmer and Ploof graduated in 1988, House and Jacob in 1989. They began working as a group in the summer of 1988 and became Haha in the fall of that watershed year in the history of this illustrious educational institution. That May, at the annual student exhibition, David Nelson, a graduating senior, displayed a savagely satirical portrait of the recently deceased Chicago Mayor Harold Washington wearing women's under-wear. Even as the painting was being installed, word about it began to spread among African-Americans throughout the city. Nine black aldermen marched from City Hall into the school. Two of them, Dorothy Tillman and Alan Streeter, removed the painting from the wall and threatened to burn it in the president's office. The acrimo-nious media and political attacks that followed the installation underlined the severe racial and political divisions within the city, and the degree to which highly visible institutions such as the School of the Art Institute were identified by many African-Americans with white power. It was hard to be a student at the school and not be aware of the gulf between the small, institutionalized art world and the city around it.[36]

It was "painful," House said, thinking back to that time. The distance between the school and many communities in Chicago pro-voked a need, Palmer said, to "heal the gap," to work toward greater communication, toward some sense of common ground, some situation in which people could speak to one another with trust. The group had no interest in an art world phenomenon such as Neo-Expressionism, whose big canvases, big stars and big egos had helped fuel the art market boom of the '80s Haha was repelled, Palmer says, by "individualism and competition and that whole system."[37] The group did not want to be part of any artistic development in which the artist's personality commanded more attention than the issues within his or her work. The greed and narcissism of the art world in the '80s, and its tendency to detach itself from the broad fabric of American social and political life were instrumental in leading Haha, like many other artists coming of age at the end of that decade, to pursue a socially engaged and interactive artistic direction.

For Haha, process is more important than product. The group is commit-ted to a collective identity in which the four individual voices speak with communal purpose. Its members value interdisciplinary thinking; they do not want any aspect of their work to be seen in isolation. Dialogue is crucial. Discussion and communication are so impor-tant to them, in fact, that they are often not so much means to an end as ends in themselves. The group has been striving for upbeat, educational, open-ended projects in which as many people as possible, inside and outside the art world, will feel welcome to become involved on their own terms.

The operational base for their "Culture in Action" project, "Haha and Flood: A Volunteer Network for Active Participation in Healthcare," is a storefront on a quiet side street in Rogers Park, a multira-cial, multiethnic, lower- and middle-class neighborhood in northern Chicago where all four mem-bers of Haha live. The heart and soul of the storefront, and of the project, and the lifeblood of a complex caretaking system is an unassuming yet magical hydroponic garden producing green, leafy

vegetables that are known to strengthen the immune system, for people with the HIV virus and AIDS. Hydroponics, as it is defined on one of the numerous information sheets displayed in racks alongside the vegetable garden, "is a term used to describe the many ways that plants can be raised without soil." One advantage of indoor hydroponic gardening is that it makes it possible to garden year-round and thus produce more. Another is that it produces vegetables with less bacteria than vegetables produced in soil. For people who are HIV-positive, all bacteria must be removed from food, but they cannot be removed from soil-grown vegetables without also removing some of their nutrients.

With the help of its allure, its need for tending, and also of the symbolism of the garden – even the choice of plants, such as Osaka Purple Mustard, Swiss Chard, and Red Russian Kale, reflects a will to inclusiveness – Haha brought into being a small community of people, including artists, writers, a designer, a teacher, and a chef, that decided to call itself Flood. "We liked the connection with water," explained Caroline O'Boyle, a Flood member and the project director of Career Beginnings, a program organized by Chicago's Columbia College to help disadvantaged youths. "The idea was that Flood would spread out and seek a lot of different corners. It would go in all directions at once."[38]

The storefront is at once a horticultural laboratory and a laboratory for the imagination. Behind the building is a dense, rough and tumble, vegetal free-for-all abundant with plants that have some medicinal effect, such as garlic, fennel, black radish, chamomile, peppermint, acacia, and astragalus (which can be taken after chemotherapy to strengthen the immune system). In the neglected dirt in the tree border in front of the building, Flood planted another garden that during the summer gave the block a festive, tropical, even a Mediterranean air. Its burst of tall, yellow-and-black sunflowers brought a touch of natural profusion to an urban setting largely dissociated from the exuberant vitality of summer nature. The sunflowers let passers-by know that something unexpected, inventive, even a little bit fantastic, was happening here.

The storefront is also a classroom. Along with tending and cultivating the plants, Flood meets there once a week, around the brightly lighted hydroponic garden, to discuss AIDS-related issues. The group organized public lectures about herbal remedies, alternative medicines, and AIDS. Each member of Flood, including the four Haha artists, is a volunteer in a Chicago AIDS organization, such as BE-HIV, Open Hand Chicago, and the Chicago Women's AIDS Project. Most of the vegetables, Ploof said, "are washed and put into bags and distributed to Chicago House," which runs hospicelike residences for AIDS patients.[39] "We want to work with these other organizations and not in competition with them," O'Boyle said.[40]

The hydroponic garden encourages trust and hope. It is insufficient to say that its effect is non-aggressive and nonconfrontational. The garden is extraordinarily gentle. Visitors can encounter it and feel the project is so modest and so void of drama that there is nothing to it. This is the most egoless of the eight "Culture in Action" projects, the one in which ambition is the most concealed. It applies no pressure. "We hate the word 'should,'" Ploof said. "I don't think any of us feels we can say to another person, you should do this, you must do this."

But its softness can be misleading. The project is simple but also multilayered, practical but also lyrical. It reflects a search for an artistic undertaking that can combine an openness and intimacy that seem almost innocent, with a social commitment and the most knowing use of symbol and display. The project is built around an image – the garden – that has the purpose and concreteness of good activist poetry. The project also has in abundance a quality that is shared by much of the most successful community-based art: goodness. **It points beyond self-interest and self-importance toward an ethical imperative that Haha is wagering all human beings carry inside them and want to see developed, and therefore revealed, in charitable and compassionate acts.**

The hydroponic garden could not touch so many people if it did not function on a number of metaphorical levels. For example, the thirty parallel rows of vegetables in their long, thin, eight-foot-long by one-and-a-half-inch-thick white trays, under two harsh 1,000-watt halide lights, and the troughs and tubes bringing nutrients from the plastic garbage pail-tanks to the vegetables, suggest a hospital room. For much of the six-week growth cycle, the vegetables themselves, each alone in a small rock wool bed, speak of organisms so naked and defenseless that it seems as if nothing could keep them going.

But the vegetables have been nourished by an effective nutritional system and by a group of people who tended them with great care. Crops flowered. As they did, the collective bloom of the leaves blotted out the hospital whiteness of the trays and the isolation of the young plants. The general atmosphere of the storefront is one of both clinical sterility and irrepressible growth. The cycles of the garden suggest that even in a fragile antiseptic state, caring is essential and life goes on.

Flood suggested to some of its members the power of a certain kind of communication. "It's taking ideas and giving a physical manifestation of them," O'Boyle said of the project. "I'm not of the art world but this seems to me what art is giving, a physical manifestation of thoughts and ideas that is not literally what it is."

"I feel pretty grateful to have stumbled into this project because it really opened my eyes to a lot of things I was just completely unaware of before," O'Boyle said. "For example, that you can participate in a significant way in a project that calls itself art. For people like me that has always been a very intimidating thing, like, well, you can't draw very well, Caroline, so you're not an artist, and you can't be one, and that was the message I got in first grade."[41]

The Haha and Flood project is very much part of its time. There is now a tradition of artists using gardening as a way of fighting narcissism and neglect. Since 1984 Meg Webster has been planting gardens in museum settings in an attempt to encourage a caretaking mentality, as well as a greater sense of connection to the realities of nature outside clean white gallery and museum walls. Since 1991 Mel Chin, building on the pioneering environmental artworks of Helen Mayer Harrison and Newton Harrison, has been experimenting with gardens that can make sick earth healthy. His "Revival fields" in St. Paul, Minnesota, and in Palmerton, Pennsylvania, are attempts to use plants to pull heavy metals, such as cadmium and zinc, out of the soil by drawing them into the biomass of the plants; when harvested, the plants remove the metals from the soil. When the plants are incinerated, the metal can be reclaimed from the ash. The primary aesthetic factor, for Chin, is the look of the earth when healthy fields return.

In more and more parts of America, city agencies have been using gardens to foster communal hope. In 1984 Operation Greenthumb, a program of New York City's General Services Administration, began a grand effort to transform hundreds of abandoned and often junk-filled lots in blighted areas throughout the city into community-run gardens. In a number of the gardens, artists have been selected to make sculptures or paint murals in order to reinforce the ability of the gardens to generate respect. In one of these gardens, in the Morrisania area of the South Bronx, Gail Rothschild, commissioned by Operation Greenthumb to make a sculpture for the site, also planted medicinal herbs that are freely available to the fifteen or so caretakers who keep the garden going.[42]

Haha and Flood's hydroponic garden can also be understood in relation to modernism, particularly to the beloved pictorial flowerings on the walls of The Art Institute of Chicago.

Impressionism's presence in Haha's storefront was at one time immediately suggested by the conspicuous placement, in a tiny pond (a rectangular tank) just inside the entrance, of two water hyacinths, reminiscent of Monet's *Water Lilies*.[43] Throughout Impressionism, as in this project, there was an attraction to the sidewalk and street, a feeling for the romance of many people together, an upbeat gentleness, and a feeling for the power of vegetation to communicate intimacy and hope. Just as important, the dazzling flowers and foliage of Monet and Manet, like Flood's hydroponic garden, grow not only out of a sense of enthusiasm and good will and a fascination with the bloom of the moment, but also out of an experience of uncertainty and loss. In effect, the Haha-Flood project takes plants out of the Impressionist picture frame and makes them a gathering point for real people driven by feelings of reverence and emergency that have inspired so many artists since modernism began.

STANDARDS. One of the thorniest issues raised by community-based art is the one of standards. What distinguishes a successful community-based art project from an unsuccessful one? A good one from a bad one? A trivial one from a profound one?

I am not going to pretend to offer definitive answers to these questions, which depend on as many variables as the success or failure of museum art. I do believe it is important for the entire field of contemporary art that critics, curators, and artists grapple with the possibilities and difficulties, rewards and dangers, of community-based work. I am less concerned here with providing the right answers than I am with asking the right questions.

What is clear is that no evaluation of community-based art can be made without some understanding of context. Community-based art is shaped by a particular place and particular conditions and a particular political and artistic moment. It is designed to respond to very particular situations. Unless those situations are grasped or experienced to some degree, it is very hard for any evaluation of a project to be responsible or just.

The first requirement is that the community-based art project benefit the community. The community with which the artist has collaborated must be the primary audience for the work. This community must not feel exploited by the artist; that is to say, its members must not feel that the project is serving the interests of the artist – or, for that matter, of an institution – more than it is serving them. It must be clear that for the duration of the project, no one owns the project more than they do.

Sometimes it is easy to gain a clear sense of community response. There can be little question, for instance, that Iñigo Manglano-Ovalle's project had a positive effect on West Town. The videos were forceful, intelligent, and responsive to the character and personalities of the people. The Street-Level Video crew was committed to using video to articulate the concerns and struggles – and the energy – of the community. The block party that established the videos in the life of the community encouraged a spirit of curiosity and cooperation. From the videos and the party, there could be no doubt about Manglano-Ovalle's affection and respect for his neighborhood, or about the pressure his project put on its residents to think actively and creatively about it, both as an entity with the freedom to define itself, and as a broad mix of individuals with roles to play in the larger world.

There are a number of ways to consider a project's ability to affect a community. For example, if one of the goals of Ericson and Ziegler's project has been to build bridges across disparate worlds, the community it has worked with should feel at the end of the project that it has greater control over the way it is seen. One reason the residents group from Ogden Courts cooperated with Ericson and Ziegler was that its members saw a way of countering stereotypes of public housing tenants. "They kept saying we're really tired of people thinking we're stupid, people thinking we're all drug addicts," Ziegler said.[44] The intelligence and the historical awareness built into the chart helped residents of Ogden Courts contribute to a public image of themselves that can begin to counter the negative image of housing projects that is now part of the national consciousness.

What distinguishes a successful community-based art project from an unsuccessful one? A good one from a bad one? A trivial one from a profound one?

Along with the chance to participate in a document that could help to de-stigmatize public housing, the Ogden Courts Residents Group decided to collaborate with Ericson and Ziegler because the project would give Ogden Courts some feeling of access, through the downtown arts organization Sculpture Chicago and its largely corporate board, to people in power.[45] In return for working with well-connected organizations, communities with little or no voice in the corridors of power are going to expect some contact with people of influence. This expectation must be respected not only in the short run, in other words, for as long as a project is developing, but also in the long run. With "Culture in Action," Sculpture Chicago reached deep into the city and the divergent needs and manifold perspectives of the city must continue to inform the organization's mission.

In any consideration of art for public places, it is important to make a distinction between projects that result from collaborations between artists and communities and projects conceived by artists to call attention to communities.

The more audiences an artist brings into a work, the harder its overall success may be to evaluate, since each audience has its own demands and context. How the paint chart would affect people who encounter it in stores across the United States is an important question that cannot now be answered. Will people actually order "Arrie Martin Blue," "Hull House Radiance Red," or "Cabrini Green?" Will looking at the paint chart affect the way people think about public housing? Will it lead anyone to consider the quantity and potency of social and political information that is conveyed on something as "neutral" as a paint chart?

And when the paint chart is included in Ericson and Ziegler exhibitions in galleries and museums, will viewers think more about Conceptual Art and Ericson and Ziegler's artistic career than about life in Ogden Courts? And if so, is this all right? If a community feels it genuinely benefited from a collaboration with an artist, is it then legitimate for the artifacts of their collaboration to take on a life of their own in the art world, entirely removed from the community texture that helped bring them into being?

In any consideration of art for public places, it is important to make a distinction between projects that result from collaborations between artists and communities and projects conceived by artists to call attention to communities. The Martinez-Kara-organized parade was a collaborative, community-based project that cannot be fully evaluated without considering its effect on its participants and on the neighborhood organizations that engaged in discussion with the artists in order to help make it possible. The parade was a group activity, and any consideration of its success must keep its participating communities in mind.

The granite floor, on the other hand, was architectural. Its location amidst so many abandoned lots meant that it was likely to be experienced personally, alone. It was conceived by Martinez to call attention to the plight of Maxwell Street and to the social and political context that help make that plight understandable. The floor is so much about drawing attention to Maxwell Street and to the kinds of communities that participated in the parade that its effect on the vendors and shoppers who live with the floor may not be decisive in determining its success. Since its primary audience includes outsiders whom Martinez wants to experience the human and visual drama of the market area, visitors are more free than they were with the parade to take their individual responses and run with them.

The most responsible evaluations of the floor are likely to come from those people who have experienced both it and the parade. The parade dramatized the realities of Maxwell Street and the African-American and Mexican-American communities that now give it its vitality. The floor then provided a platform, a forum, a stage, on which their stories could be analyzed, debated, celebrated, and broadcast. For those who had been at the parade, the floor was likely to have had a particularly strong poetic and metaphorical power. Martinez focused on particulars and yet

presented them in ways that enabled participants and visitors to feel and think of them as their own. His ability to call attention to the institutional threat to immigrant and minority freedom while inspiring the freedom to dream and imagine is an act of imagination. Imagination is as important to the evaluation of public art as it is to the evaluation of art in museums.

The kinds of demands facing anyone evaluating community-based art can be suggested by one of the most charismatic projects in "Culture in Action," Simon Grennan and Christopher Sperandio's collaboration with the Bakery, Confectionery and Tobacco Workers' International Union of America Local 552. Grennan and Sperandio went to art school at the University of Illinois at Chicago. They are interested in using art to support labor and to make more people aware of labor issues. For their "Culture in Action" project, they collaborated with twelve line workers at the large Nestlé plant in Franklin Park, just west of Chicago. Through the collaboration, the line workers were able to produce their own chocolate bar, deciding everything from the ingredients to the design for the wrapper – with its yellow, purple, and white colors and its American flag promoting American products – and the name: "We Got It!" Thousands of these chocolate bars were distributed to grocery stores in several sections of Chicago. In addition, a poster showing the smiling workers holding an oversize image of the chocolate bar appeared on billboards on the south and west sides of the city.

The process of discussion and production created in the workers a strong sense of pride. "They were very happy," said Jethro Head, the president of Local 552. "What they got most of all out of it was the knowledge that they can do something besides this division of labor stuff that they do everyday."[46]

One reason Head was eager to support the project was that he saw that the chocolate bar could be a way of gauging relations between union and management. Nestlé had just initiated a Total Quality Management Program that meant, in principle, giving workers more input and power over their conditions and the general functioning of the plant. For Head, the chocolate bar tested the good will of this program, and with it of management, at a point just before crucial negotiations between union and management were about to begin. If management was serious about the principles behind Total Quality Management, Head believed it would be enthusiastic about the chocolate bar idea since, at little cost, it encouraged greater knowledge and independence on the line.

At first, the company did support the idea. But it backed off at the last minute, much to the dismay of Grennan and Sperandio.[47] Only after considerable pressure from Head did management give the workers a paid week off to produce the candy. The process confirmed Head's suspicions that management was only feigning interest in giving workers more power. The chocolate bar project served as a cautionary tale that Head could relate to his union if its members ever took management's gestures of real sharing of power at face value. The project was also a way in which he could suggest to Grennan and Sperandio the pattern of raising hopes and then dashing them that he says are characteristic of management methods.

Are the pride and knowledge gained by the union workers in conceiving the product, the existence of the billboards and production of the snappy-looking chocolate bar recognizing the good work and good will of the union, and the internal role of the chocolate bar in clarifying Nestlé's management-labor relationship enough to justify calling this project a success?

Other factors need to be considered. For example, while the chocolate bar was distributed in several sections of Chicago, it was not distributed in neighborhoods around the Nestlé plant or in neighborhoods in which the line workers live. Therefore the project was not available to the people who could best have related to the workers' accomplishment and what it meant to their lives.

Furthermore, as a product, the candy bar was not a roaring success. The quality of the chocolate was, by almost all accounts, low. The Market Place Foodstore, the fancy grocery store near Lake Michigan where the project was kicked off in May, sold only about 150 "We Got It!" bars in four months. The store felt the chocolate bar was out of place there, and by September wanted Sculpture Chicago to take back the unsold boxes.

If this project were really going to improve the situations of the line workers, would the chocolate bar have to have real rather than symbolic value? Or, in order to have symbolic value, does it not have to make the public want to buy it so that people will then pay attention to the producers and remember them with respect? Without an effective product, can there be a bridge between the line workers and the general public?

Just as important is the information that is not provided by the billboard message of smiling workers or by the message on the back of the chocolate bar: "In February 1993, a Team from Bakery, Confectionery and Tobacco Workers' Union Local 552 and the Artists Simon Grennan and Christopher Sperandio designed *We Got It!* This bar is dedicated to Labor and to all people who work on the line to make the products that we buy. We are proud to present *We Got It!* Now, YOU get it!" The wrapper suggests a harmonious situation in which workers are comfortable with their jobs and no labor conflict exists. If the chocolate bar were going to encourage real awareness, would not it have had to suggest, in some way, the complex labor-management reality at the Nestlé plant?

When an object enters the real world, it must function in the real world.

A basic issue here is that the project had two primary audiences. One, the union at Nestlé, is very specific. The other, the public looking at the billboards and buying the chocolate, is general. "There's an inside-outside thing, and they really do meet at the candy bar," Sperandio said. "The public buys the bar, they read the information, they get a sense of what happens, and they take that away with them. The use the union has in terms of its negotiations with Nestlé's, in terms of some kind of rallying point or source of pride, is intangible, and they're the internal audience. The meaning that the whole thing has for them is different from the meaning that it has for the person who goes into the store."[48]

Once the chocolate bar becomes a product that functions in the world outside Nestlé's management and labor, however, then the response of the union is no longer enough to decide the success or failure of the work. Once the chocolate bar exists as a product in the larger world, the response of the union is no longer the decisive factor, even if the union was thrilled with the collaboration. When an object enters the real world, it must function in the real world. If the public response conflicts with the internal response, if the union is grateful for the chocolate bar but the public comes away from its encounter with the chocolate bar with an oversimplified and perhaps even disrespectful attitude toward those who produced it, then the success of the project is mixed at best.

The questions that can be raised about this project might actually make the chocolate bar more interesting as art. Its Warholian irony, which is that an ephemeral object as intellectually insignificant as a chocolate bar can be intricately connected to so many large human issues, is intensified by the problems, which help make the chocolate bar a repository. The questions do not diminish the impact of the chocolate bar as a work of Conceptual Art, but make it stronger.

But these questions do shake the identity of the chocolate bar. Was it first of all a Conceptual Art object, or first of all a servant of community needs? If one measure of the success of community-based art is that it functions first as community service and only secondly as a work of art, then the chocolate bar project may turn out to be, in the end, an instructive failure.

Does this mean that community-based art should not be discussed as art? Of course not. Context has come to be synonymous with political and social context, but art is part of the context of a project as well. And since one goal of this kind of art is to bridge the gap between art and life, art must, at some point, become part of the conversation.

The art world life of these projects matters. Knowledge of art and artistic thinking is part of the formation of the projects in "Culture in Action." All the artists in this program have been educated in art, and all of them want to have an effect on art. They all feel part of one or more artistic traditions, and their thinking about these traditions has been indispensable in developing their ambition and nerve in risky, open-ended, community situations. Competition with other community-based artists, and a need to go one step farther than other artists around them or working within the same traditions, can paradoxically make a community-based project more selfless and communal.

The avant-garde pressures to be inventive, to be original, to do something that was not possible before, are part of what drove the artists in "Culture in Action." Lacy is eloquent in the way she talks about "pushing the envelope of art" and "changing the vision of art." She wants the attention of the art world, or at least of those conceptual, theoretical, and feminist segments of it of which she feels a part. For her the will to become part of the debate in the art world helps free her from asking for appreciation in the communities in which she works. "Where I want my recognition is in the world of ideas,"[49] she said. It is in the art world where the efforts of these artists will be recorded and discussed and where the thinking will evolve that will enable other artists to engage communities as well as or better than they have done here.

In serious discussions of community-based projects, however, the effect of the art on the communities must not be forgotten. And, ideally, not just the effect at the time of the project or immediately after. So many of the projects, particularly those involving young people, reach into the future.

It would be helpful if there was some way of following up on the effects of these projects over the years, let's say, when the Street-Level Video crew and the Chicago Urban Ecology Action Group are adults, or when the Cardenas Elementary School students from the parade are in high school, or after Bob Peters has spent several years discussing with students the issues of abusive language.[50]

When the aim of a project is to serve a community, its success is inseparable from its aesthetic impact. The effectiveness of the Manglano- Ovalle- and Haha-inspired projects, for example, inspires confidence in the projects, in the artists, and in the community or group. This success and confidence help invest the garden and the block party with the kind of power that keeps them in the minds of everyone touched by them. The garden and the block party become images, but of a very elastic and fundamentally unframable kind. The communities are part of them; so are issues that brought the projects into being; so is the coming and going, the concentration and dispersal, of real faces, real bodies, real concerns. These images are not fixed. They are not objects. They are at once actual places and imaginative spaces that are likely to make the same hypnotic, obsessive claims on the heart and mind made by exceptional art of any kind. **"Culture in Action" leads into real life and it leads into art. Its projects create an awareness of the potential for goodness in people and the potential magic of art, and I am not sure how well contemporary art made for galleries and museums can, right now, do that.**

1. The artist Virginia Maksymowicz has written that "Disdain for the concerns of the people who were to live permanently with the sculpture was not only evident in the selection of the art, but in the hearings as well, where testifying office workers were often jeered by 'Tilted Arc's' defenders. Rather than stimulating real dialogue, Serra's sculpture resulted in an obstinate standoff between artists and the nonart public. Whether or not it was good art, it had been put in the wrong place — or at least put there in the wrong way. In terms of artist-community relationships, 'Tilted Arc' was an absolute fiasco" (Virginia Maksymowicz, "Alternative Approaches to Public Art," in W.J.T. Mitchell, ed., *Art and the Public Sphere* [Chicago: University of Chicago, 1992], p. 156).

2. There is little question that the troubled history of *Tilted Arc* is decisive in the development of public art during the last ten years. Within most advanced public art circles, the rejection is now nearly complete of the idea of large-scale sculpture, made of permanent materials, that controls the response to a public site. There is increasing resistance to a public art process in which the many audiences who live with the commissioned work are not included in the selection of the artist and in discussion of the evolution of the work. And also to a process that does not provide some just means by which a commissioned work could be removed.

But the ideological vehemence of the current reaction against *Tilted Arc* continues to create its own problems and distortions.

When Suzi Gablik wrote in *The Reenchantment of Art* (New York: Thames and Hudson, 1991, p. 173) that Serra "is not interested in the public's response to his work, having no stake in it and no loyalties," she is misrepresenting Serra, who was passionately interested in initiating among both workers and visitors an active rather than a passive response to the working conditions in and around the Jacob K. Javits Federal Building that towers over Federal Plaza, and in provoking a critical awareness of social and political responses implied by the architectural relationships within the site. For Serra's explanation of the site-specificity of this work, see "Paper Presented by Richard Serra to 'Tilted Arc' Site Review Advisory Panel, December 15, 1987," published in *The Destruction of "Tilted Arc": Documents*, ed. Clara Weyergraf-Serra and Martha Buskirk (Cambridge, MA, and London: Massachusetts Institute of Technology, 1991), pp. 180-87.

The rage against *Tilted Arc* has also blinded people to the remarkable context in which this sculpture was formed. On October 26, 1963, when Serra was a graduate student in the painting department at Yale, President John F. Kennedy gave a speech at Amherst College on the occasion of the dedication of the Robert Frost Library. In it he defined the artist as a solitary figure, "faithful to his personal vision of reality," the "last champion of the individual mind and sensibility against an intrusive society and an officious state." The Art-in-Architecture program that commissioned *Tilted Arc*, and indeed the National Endowment for the Arts founded in 1965, were shaped by the idealism and absoluteness in this talk, as well as by Kennedy's belief that artistic creation needed to be protected against "polemics and ideology." This speech deserves the closest attention, not only for its attitudes toward art and culture and its now-lost governmental ease with art, but also for the degree to which its cultural idealism served a pragmatic role in the Kennedy administration's struggle to show the world that America was superior to the Soviet Union, where the kind of abstract art Serra would make was condemned and artists were expected to uphold institutional laws. The Cold War ended in 1989, the same year *Tilted Arc* was dismantled, the same year the attack on the funding policies of the endowment effectively dismantled the New Frontier's formulation of a national artistic mission.

The Kennedy speech is published in its entirety in *The New York Times*, Oct. 27, 1963, p. 87. The speech is discussed in John Wetenhall, "Camelot's Legacy to Public Art: Aesthetic Ideology in the New Frontier," *Art Journal*, winter 1989, pp. 303-308.

3. Arlene Raven, *Art in the Public Interest* (Ann Arbor, MI: UMI, 1989). The David Nelson painting is discussed in greater detail in Part III of this essay. Malpede and Lacy are also discussed in Gablik (note 2), pp. 102-105, 109-11. On pages 69-74 Gablik discussed another of the canonical figures of community-based art, Mierle Laderman Ukeles, who has been working with the New York City Department of Sanitation on grand yet intimate collaborations since 1978.

4. Michael Ventura, who grew up in the South Bronx, has articulated this foreignness. "The Metropolitan Museum of Art — however much my mother loved it," he has written, "made me afraid. For one thing, the people there weren't like us. Our best clothes weren't as nice as their casual dress. They spoke differently. And if they spoke to us, it was with that slightly thickening of the voice that people have when they visit the sick in hospitals. But, really, it was the art that made me most afraid. What was it about? Who was it about? Here and there, I would recognize something as almost human, almost natural ('natural,' for me, meant the street), but 'almost' wasn't near enough. Every hall, every wall, had one message for me, and it was the same message I saw on television: 'You don't exist,'" see Michael Ventura, "Love Among the Ruins — An Appreciation In Three Parts," in Houston, Contemporary Arts Museum, *South Bronx Hall of Fame: Sculpture by John Ahearn and Rigoberto Torres* (Houston, 1991, p. 42).

5. *The New York Times* music critic Bernard Holland could have been speaking about museums when he wrote: "Never forget that concert halls are built not so much to keep music in but to keep the rest of the world out" (see Bernard Holland, "Critic's Notebook: Mozart and Daltrey as Two Kinds of Religion," *The New York Times*, Feb. 26, 1994, p. 13).

6. "Eminent Domain" was taken through the research and development phase in "Culture in Action" to the point where the paint chart exists in prototype form. Because of graphic design and production delays, the project was unrealized within the time frame of "Culture in Action"

(ending September 1993). Strong efforts were still being made in spring 1994 to raise funds to produce the 60,000 charts and have them distributed through True Value Hardware Stores, as was originally planned.

7. "What I care about is the children. They're the future," Arrie Martin said in front of a garden tended by and designed for seven-to-thirteen-year-old children. "I want them to look around and see there are adults who care" (conversation with Arrie Martin, Aug. 30, 1993).

8. If the paint chart is available in paint stores, it will be possible to order by their name on the chart, colors such as "Slum Clearance," or "Robert Taylor Monolith," which matches the brick of one of Chicago's largest and now one of its more dangerous housing developments.

9. According to Ericson, the residents group would literally say, "we've been studied, we've been analyzed, and we're really sick of it. We don't want to be analyzed anymore." The group let the artists know that it would not work with them if they were not willing to make a real commitment of time. Each of the roughly half-dozen workshops that produced the paint chart lasted a few days. During the workshops, Ericson and Ziegler spent several hours a day with the women, discussing the details of the project, but also talking about their daily lives. Ericson says, "There was something about spending five or six days together and having meals together and just working that convinced the group to participate in the collaboration" (conversation with Kate Ericson and Mel Ziegler, Sept. 17, 1993).

10. "What I tell everybody who comes into the project," Manglano-Ovalle said, "is you're going to be tested by these kids, and the best thing you can do for them and for yourself is chill out and listen, look them straight in the eye and don't talk too fast to them, and make sure they ask questions. When they stop asking questions, you know you've lost them. If it looks like they're understanding everything you say, you've lost them because these are kids who are very independent, questioning, stubborn, and it's good" (conversation with Iñigo Manglano-Ovalle, May 25, 1993).

11. Ibid.

12. Conversation with Nilda Ruiz Pauley, Aug. 31, 1993.

13. Moshe Barasch, *Icon: Studies in the History of an Idea* (New York: New York University, 1992), p. 37. Texts I have come across on art and healing in non-Western countries include text by Wyatt MacGaffey, *Art and Healing of the Bakongo, Commented by Themselves: Minkisi from the Laman Collection*, Stockholm, Folkens museum-etnografiska, 1991, and " New York, Center for African Art, *Wild Spirits, Strong Medicine: African Art and the Wilderness* (New York, 1989), pp. 58-62. In his book *The Myth of the Eternal Return, or, Cosmos and History* (Princeton, NJ: Princeton University Press, 1954, p. 83), Mircea Eliade discussed the role of Navajo sand paintings in curative rituals. For the fall of 1995, New York's Museum for African Art (formerly the Center for African Art) is planning an exhibition called "Art That Heals: The Image as Medicine in Ethiopia," accompanied by an interdisciplinary symposium on "The Power of Images on the Body."

14. The last ten years has seen a tendency among critics and historians to demonize modernism, finding in it not only expressions of racism, sexism, and imperialism, but even the causes of everything evil. In her *Reenchantment of Art* (note 2), Suzi Gablik wrote beautifully about the need for a new kind of art in the service of healing, compassion, and dialogue — for the kind of art encouraged by "Culture in Action" — but she undermined her message by caricaturing modernism as little more than the alienating impulses to individuality, originality, and self-expression. Her book is a fervent attack against dualistic thinking of all kinds, yet she set up a textbook dualism, with noble, empathetic, community-based art on one side and ignoble, self-centered, misguided modernism on the other. Her distortion of modernism is an example of the kind of dehumanization of what one is not familiar with and not normally drawn to that her book argues so forcefully against.

15. Cited in Pierre Schneider, *Matisse* (New York: Rizzoli, 1984), p. 10. Near the end of his book, discussing the paper cutouts, Schneider wrote: "More than ever, the basic criterion of Matisse's final works is utility rather than beauty. He considered a work of art successful when it was able to 'cure,' to 'alleviate' suffering — in short, when it affected life. Only when it functioned poorly did the merely aesthetic come to the forefront" (p. 706).

16. In his writings and on television, Cornel West has returned again and again to this torn fabric and our need as a country to mend it. His view of the social and spiritual consequences of Reagan's America is succinctly presented in his article "The 80's: Market Culture Run Amok," *Newsweek*, Jan. 5, 1994, pp. 48-49. See also Jervis Anderson, "The Public Intellectual," *The New Yorker*, Jan. 17, 1994, pp. 39-48. Anderson cited West's remark in his book *Race Matters* (Boston: Beacon Press, 1993) about the "unprecedented collapse of meaning" in America. West spoke with Anderson about the importance of establishing a "framework in which we can come together for dialogue, an open-ended conversation within which other constructive voices might emerge" (p. 43).

17. This is not the place to debate whether this tradition is partially or wholly part of modernism, or whether it is something that is in the end entirely different. The point I want to make here is there is no either/or polarity between "Culture in Action" and modernism. The quality of attention to the world outside the artist; the distrust of institutional power; the heightened awareness of the psychological, cultural, and political collisions and conflicts in an ever more global and technological world; the respect for the powerless and for the outsider; the struggle to offer artistic experiences that can set a moral and human example; the awareness of the fragility and sacredness of life — all of which help define "Culture in Action" — are characteristics of modernism after Courbet and Manet.

18. Cited in Christine Lodder, *Russian Constructivism* (New Haven: Yale University Press, 1983), p. 48.

19. See "Art Which Can't Be Art," in The Blurring of Art and Life: Allan Kaprow, ed. Jeff Kelley (Berkeley/Los Angeles/London: University of California Press, 1993), pp. 219-22.

20. Gablik presented Beuys as an alternative to the evils of modernism at the end of her book Has Modernism Failed? (New York: Thames and Hudson, 1984), pp. 124-26.

21. See Ann Temkin, "Life Drawing," in Ann Temkin and Bernice Rose, Thinking Is Form: The Drawings of Joseph Beuys (Philadelphia Museum of Art/The Museum of Modern Art, 1993), p. 43.

22. See Ann Temkin, "Joseph Beuys: An Introduction to His Life and Work," in Temkin and Rose (note 21), p. 12.

23. Cited in Bernice Rose, "Joseph Beuys and the Language of Drawing," in Temkin and Rose (note 21), p. 76.

24. Cited in Temkin, "Joseph Beuys: An Introduction to His Life and Work," in Temkin and Rose (note 21), p. 13.

25. Cited in Rose (note 23), p. 114.

26. Ibid., p. 107.

27. Ibid., p. 110.

28. Cited in Heiner Stachelhaus, Joseph Beuys (New York: Abbeville, 1991) p. 80.

29. Cited in Temkin, "Joseph Beuys: An Introduction to His Life and Work," in Temkin and Rose (note 21), p. 13.

30. One of the students, Naomi Beckwith, remarked that "Nature forms humanity and I think people have to contribute to art and nature. Through our activities we will try to improve the ecology of Chicago" (cited in the "Culture in Action" program guide, p. 2).

31. Conversation with Bob Peters, May 24, 1993.

32. Conversation with Bob Peters, Sept. 2, 1993.

33. The discomfort now generated by abusive language, and the institutional reluctance to engage the issues it raises, is reflected in the response to the script of the telephone journey by the corporation that provided the toll-free number. In June 1993, Ameritech Audiotex Services was contracted by Sculpture Chicago to establish the number. Then, without contacting Peters or Sculpture Chicago, Ameritech delayed the inauguration of this voice-mail service from July 4 to July 13, and it built into the recording a disclaimer that could not help but undermine faith in the project. "You have reached 800-808-THEM," callers heard. "The program 'Naming Others: Manufacturing Yourself' is a project by Bob Peters. This program is part of 'Culture in Action,' a public arts project by Sculpture Chicago, and is sponsored by Randolph Street Gallery. This service contains material that is explicit and vulgar. At times listening to this program may be uncomfortable. Callers under the age of eighteen should obtain their parents' permission prior to calling. To hear this program in its entirety, please hang up and dial 1-708-986-1399. If at any point you find the material offensive, please hang up. Thank you." In many letters and phone conversations, Peters tried to encourage Ameritech to discuss its reasons for distancing itself from his script. As of April 1994, Ameritech's response to Peters's requests for clarification and dialogue has essentially been silence.

34. For an article on and an article by Lacy, see Moira Roth, "Suzanne Lacy: Social Reformer and Witch," and Suzanne Lacy, "Fractured Space," in Raven (note 3), pp. 155-74 and 287-302.

35. See Eliade (note 13), esp. pp. 20-21.

36. For a thoughtful chronicle of and meditation upon the events surrounding the Nelson painting, see Carol Becker, "Private Fantasies Shape Public Events: And Public Events Invade and Shape Our Dreams," in Raven (note 3), pp. 231-53.

37. Unless otherwise noted, all quotations are taken from a conversation with House, Palmer, and Ploof, May 24, 1993.

38. Conversation with Caroline O'Boyle, Oct. 1, 1993.

39. Conversation with John Ploof, Aug. 31, 1993.

40. Conversation with Caroline O'Boyle (note 38).

41. Ibid.

42. See Michael Brenson, "Sculpture for Troubled Places," The New York Times, Arts & Leisure section, Oct. 15, 1989, pp. 1, 42.

43. The water hyacinths, like all the plants in the storefront, were part of Flood's medicinal experimentation. Water hyacinths, House said, are used in Belize to clean sewage.

44. Conversation with Ericson and Ziegler (note 9).

45. When asked why the residents got involved with Ericson and Ziegler, Eric L. Bailey, the resident initiative coordinator for Real Estate Management and Housing Consultation — which manages the Ogden Courts apartments for the city — and a constant presence around Ogden Courts, made it very clear that the group wanted to break its isolation and open lines of communication to the movers and shakers of Chicago (conversation with Eric L. Bailey, Aug. 30, 1993).

46. Conversation with Jethro Head, Sept. 1, 1993.

47. "It's very, very clear now that we're at the end of the project in terms of getting things done," Grennan said, "that management had no intention of doing anything with this at all from the beginning, so that dialogue has also been a dialogue of a particular kind of doublespeak" (conversation with Simon Grennan and Christopher Sperandio, May 24, 1993).

48. Conversation with Grennan and Sperandio (note 47).

49. Conversation with Suzanne Lacy, May 22, 1993.

50. Nilda Ruiz Pauley suggested the value of following these projects into the future. "It's like teachers being mentors and not knowing how much effect they have on them until years later," she said. "It will be very interesting to know what does come out of this" and how it affects "people who will become men and women very soon" (conversation with Nilda Ruiz Pauley [note 12]).

OUTSIDE THE LOOP

Mary Jane Jacob

ART IN CONTEXT. The nature of contemporary art during the past three decades has led art out of the museum into the world. Art has demanded spaces beyond the galleries of the institution because of its scale, its tie to the land or a given location, or because its message depended on a social context. For those artists with a pronounced social and political agenda, their work reached a desired, wider audience by being placed in a particular, everyday setting that actualized their critique of culture. Some even brought the audience into their work, extending the boundaries of the work of art into that of social sculpture. For others working in a post-Dada, post-Fluxus vein, the aim of having their work approximate, even be mistaken for, life was fulfilled by the site; being in the reality of the world increased the work's readability as a part of the cultural or physical landscape rather than artifice. Those who sought to depart from purely personal artistic expression also found noninstitutional venues a more sympathetic forum for achieving cultural expression. Moving away from the context of the modern museum as the repository of works of art of individual genius, artists were able to create contemporary idioms that incorporated past cultural traditions - Western and non-Western - and often included performative, interactive, or other collective elements. Museums have usually excluded such forms from their domain by virtue of the authority they have placed on the object. It was often necessary, too, to leave the institutional framework to satisfy an artist's needs when the organizational structure and object-based operations of the museum inhibited experimentation or were at odds with the artist's experiential, temporary, idea-based approach.

Thus, the use of exhibition locations outside the museum has been motivated not only by a practical need for space, but also by the meaning that such places convey and contribute to the work of art, the freedom they allow for innovation, the potential they offer for public accessibility, and the psychic space they afford artists and audience.

The organization of temporary exhibitions for museums and the administration of art for public spaces have become more closely aligned in recent years as both have adopted the practice of commissioning artists to create new works, installations, or projects for specific sites. Unlike conventional curatorial connoisseurship, whereby existing works are selected for an exhibition, this newly created art uses the actual exhibition opportunity in formally, conceptually, and critically interpretive ways. Thus, by extending the museum's walls to indoor or outdoor spaces brought into service on the occasion of an exhibition – abandoned buildings, the subway, or the street – or using the museum itself as a site-specific venue, the art museum has entered a territory previously identified with public art. Public art, on the other hand, has taken on exhibition attributes by staging installations of temporary works.

What are the responsibilities of the maker, presenter, and viewer of art?

Contextualizing the work captures a premuseum state of art as much as it may take an oppositional stance to institutions. In order to become part of the "natural" surroundings and daily experience, contextual art integrates object with site, promoting the concept of art as environmental and experiential; it looks to traditional art forms, such as parades, or employs vehicles of modern-day media, for example, billboards. It reinvestigates the place of art in society; it presents the artist as a catalyst or activist for change while it reintroduces the artist as shaman or healer in the community; it seeks to broaden the public for art that has taken on privatizing aspects in a world of museum parties, memberships, and admissions, and in cities where social boundaries corresponding to geographic divides inhibit audiences from reaching the doors of the museum. And art outside the institutional framework raises questions that, in turn, lead to parallel reflections about art inside museums: Who is the public for art? How does art address various publics? What is the role of artists today? Can art contribute to society? What is the place of our art institutions in the broader realm of culture?

These questions, now in the forefront of the museum field, emerged in the 1980s concurrent with the multicultural movement, postmodern critical thought, and site-dependent developments in contemporary artmaking. Museums today are experiencing a new age of accountability and responsibility to audience. They are facing demands from local communities and funding agencies to be audience-responsive, increase accessibility, provide didactic materials and educational programming, and expand their role beyond that of keeper and exhibitor of culture. Within museums, audience is often conceived in self-reflexive terms: the audience for art is that which comes to the museums; the definition revolves primarily around the question of museum attendance. The dilemma of bringing in new constituencies is often left to be solved by membership offices, museum stores and cafés, and museum education departments. The educator, for instance, is given the task of filling in the gaps with outreach programs that aim more to colonize individuals and communities and turn them into museumgoers, than to establish continuing vehicles of exchange and mutual respect. But in their Western art-collecting focus, demographic composition of boards and staff, and even Beaux-Arts style, museums as they developed in America since the end of the nineteenth century often find that at their core, they are essentially at odds with a new, multicultural agenda.

The art museum, in fact, may not be the most appropriate starting point for certain audiences to become involved with contemporary art; it may never be the venue that some frequent. Yet, just because an individual does not visit museums, it does not mean that he or she has neither the interest nor the capacity to relate to what contemporary art has to offer. Art existed long before museums, yet we have come to define art today according to that which the museum sanctions. The implicit hierarchical division between what is inside and outside the museum walls creates a high and low art distinction. One culture's works are elevated over another's; a particular medium is more esteemed; purely aesthetic works are favored over those with a practical function; works by famous artists are valued over those identified only by their culture or produced by collectives, especially if composed of nonarts professionals. This value scale is also reflected in and reinforced by a market system that prizes works of "museum quality," equating monetary value with aesthetic value. Thus, the art museum, which may already pose a physical and mental barrier for some audiences, further removes itself from some constituencies by defining art in ways that deny or demean the value of artistic forms of cultural expressions outside its own space.

Artists, often working independently, are exploring community relationships that can serve as valuable models for cultural institutions. By stepping outside the domain of the museum to work in the public arena, the artist can escape the Western hierarchy implicit in traditional art institutions. Art can become more experimental in nature, expanding upon the usual museum genres and finding a conceptual link to its audience by rooting itself in a specific site. The artist's engagement of cultures existing outside the dominant cultural venue of the museum establishment also points to a reconsideration of the operations of these art organizations at the center of cultural power and their relationship to the so-called margins. Thus, site-dependent artists' projects – both inside and outside the museum – and recent site-related public art may serve as an apt testing ground for the issues surrounding the relationships between institution, audience, and the artist:

Should museum programs reflect the identity and present-day concerns of the surrounding community? If so, how should these issues be presented and what place does the public have in determining its own representation? How does the museum address different publics? What are the responsibilities of the maker, presenter, and viewer of art?[1]

By designating the physical and conceptual locus of a work of art outside the institution, art is taken to its audience, even if viewers are brought into the experience unknowingly. **Thus, recent developments in curatorial practice outside museums and in public art have made the audience a new frontier for contemporary art.** If, in the 1970s, we were extending the definition of who the artist is along lines of nationality or ethnicity, gender and sexual orientation; and in the 1980s the place of exhibitions expanded to include any imaginable venue, such as churches, prisons, schools, and so on; then in the 1990s we are grappling with broadening the definition of who is the audience for contemporary art. Arthur Danto wrote in 1992 that: "What we see today is an art which seeks a more immediate contact with people than the museum makes possible – art in public places, specific to given sites – and the museum in turn is striving to accommodate the immense pressures that are imposed upon it from within art and from outside art. So we are witnessing, as I see it, a triple transformation – in the making of art, in the institutions of art, in the audience for art."[2]

Resituating audience outside the art center, whether in the city-at-large or within a community, site-specific public projects challenge definitions of audience as much as notions of art.

PUBLIC ART. Public art accepts and claims an unbounded, infinite audience simply by being in public view. Educational or evaluative tools are not regularly employed, so the only gauge of a work's success or failure in reaching its audience is when debate erupts into protest. Committees of a handful of representatives stand for "public" approval. For all intents and purposes, contemporary activity in public art dates from the establishment in 1967 of the Art in Public Places program at the National Endowment for the Arts and the subsequent formation of state and city per-cent-for-art programs. Government funding seemed to promise democratic parti-cipation and the expression of public, rather than private, interests. Selection panels of arts and civic leaders were appointed "as the representatives of all the people" by mayors, who were initially enlisted to authorize NEA applications. The late 1960s and early 1970s was the era of the civic art collection more related to art history than to city or cultural history, and which fulfilled the NEA goal "to give the public access to the best art of our time outside museum walls." Commissioned based on approval of a maquette, these large-scale sculptures were closely related in style to their smaller counterparts in collections and signified the expansion outdoors of the private museum viewing experience; communal festivals, rallies, or other plaza gatherings supplemented, but were not integral to, the work of art. Because these works were public art monuments representative of the personal working method of the artist, rather than cultural monuments symbolic of contemporary society, the controversy they engendered necessarily centered around artistic style (that is, abstract versus figurative art), rather than around public values.

It was precisely at the time when the NEA launched its public art program by commissioning Alexander Calder's *Grande Vitesse* in nearby Grand Rapids, Michigan, that private foundations in Chicago made possible the fabrication of Picasso's *Head of a Woman*, catapulting Chicago to the position of leader in the field. Up until that time, public art in the city had been figurative, as was characteristic of the late 1800s and early 1900s, and dedicated to real personages and mythical personifications (the Republic, the Great Lakes, Music, Brotherhood, Time, Peace). These works of art were primarily civic monuments commemorating heroes and ideals. With the unveiling of the Picasso on August 15, 1967 in the new Civic Center

Plaza, commented critic Franz Schulze, the situation in Chicago "shifted radically and lay-man and expert alike began to think differently about public art....it cleared the way for the appearance of many more objects like itself: large, often mammoth works executed in the 'modern manner' (seldom definable as somebody or something), erected in public spaces at considerable public expense, and accompanied by public fanfare....more than any other object or event [the Picasso] ushered in a new period in the history of public art."[3] Ironically, it also signaled the supplanting of public art commissioned by private benefactors and special interest groups as a show of civic pride in favor of publicly funded commissions of works of solely personal artistic expression. Art that had previously been known by the subject – the Grant Memorial, Shakespeare, Alexander Hamilton, Lincoln – now became known by the artist's name. So, too, the place of art narrowed from the ring of neighborhood parks planned by Daniel Burnham that spread to the city's interior, to a concentration in the one-mile square area called the Loop. Even more specifically, a downtown strip of Dearborn Street became the favored location for what Schulze called "a veritable public museum of modern art on a gargantuan outdoor urban scale."[4]

How can we enable artists to contribute creatively to the needs of society beyond the realm of aesthetics?

This new focus on downtown as the prime space for public sculpture emerged just as the Loop, like many American urban centers, was in decline and businesses were vacating this area for the suburbs. Over the next decade Chicago's commercial core of diversified office and warehouse buildings was transformed into a high-end financial, governmental, and cul-tural district employing a far smaller percentage of the city's work force than ever before.

Here, as throughout the country in the late 1960s, modern art was called to come to the service of urban renewal and revitalization in an attempt to reestablish the value of place and provide it with an identity.[5]

Art on the plaza, however, often seemed physically and socially divorced from – even dis-cordant with – its surroundings. Recognizing the aesthetic and functional benefits of integrated urban design, in 1974 the NEA began to stress that public art should be "appropriate to the immediate site."[6] It encouraged proposals that integrated art into the site and moved beyond the monumental, steel object-off-the-pedestal. By the end of the 1970s, it embraced "the wide range of possibilities for art in public situations" of "any permanent media, including earthworks, environ-mental art, and non-traditional media, such as artificial light." In order to extend the field, the commissioning of younger and mid-career artists, who might offer innovative solutions, was also promoted. As site became a key element, the mechanisms by which public works were commissioned also required revision. The NEA sought to institute the artist's direct participation in the choice and planning of the site; by 1982 the Visual Arts and Design programs joined forces to encourage "the

interaction of visual artists and design professionals through the exploration and development of new collaborative models." Some of these site-specific works had a practical function.[7] To the general viewer/user, such works appeared less self-indulgent, remote, and precious, and more engaging and accessible. They were seen as more than "just a sculpture"; use helped to mediate the expenditure of the people's tax dollars or, at least, make it seem like a wise investment. Scott Burton, one of the most accomplished artists of public art in the 1980s, fully understood the potential of this way of working. He believed that "what architecture or design or public art have in common is their social function or content.... Probably the culminating form of public art will be some kind of social planning, just as earthworks are leading us to a new notion of art as landscape architecture."[8]

Chicago did not acquire its first outdoor site work on an environmental scale until 1991, when Sculpture Chicago commissioned Ronald Jones to revamp a city block slated for demolition. It was proposed for Sculpture Chicago to hold its customary biennial event of jury-selected sculptures on this site. It was subsequently agreed, however, that this should be a single, integrated site work, and that a curatorially selected artist be given charge of the project. The result is the now-permanent Pritzker Park, a park-cum-artwork. The only public green space in the Loop, its gently graded, undulating floor slopes to below street level, providing the visitor a moment of retreat and it is a park with a story to tell through its sculptural elements and overall plan.[9]

Like Jones's park, the nearby works of Houston Conwill, Estella Majozo Conwill, and Joseph De Pace; Kate Ericson and Mel Ziegler; Joseph Kosuth; and Tim Rollins & K.O.S., commissioned just prior for the Harold Washington Library Center – a pinnacle of the city's percent-for-art program under the leadership of Jim Futris – sought to update the nineteenth-century tradition of public works on Chicago subjects, interpreting them through the means of Conceptual Art. These artists raised a number of questions: **What can a contemporary artwork commemorate? What is the new urban monument and what can it signify to its audience – the public of Chicago?** Emerging out of a decade of postmodernist critique, this public art took site not only as an element in need of physical enhancement, but also as the inspiration and departure point for the content of the work. This approach paralleled works being created for a host of site-specific exhibitions in Western Europe and the United States which also explored the subjective possibilities offered by site. In these projects for exhibitions and public art commissions, artists in the 1980s moved from predominantly formal considerations to themes of social history and cultural identity.

While interdisciplinary collaboration, or at least cooperation, among design professionals was encouraged by the NEA and the integration of site and object deemed essential to the successful public art commission, the relationship of art and audience, and the responsibilities of the artist and administrator to the public, remained on the sidelines until the 1990s. Up until that time public information about public art took the form of modified museum education: lectures, display of the maquette, and publications.[10] In 1982 Mary Miss, whose work beginning in the 1970s had focused on large-scale outdoor constructions and public projects and who became a spokesperson for the field, wrote: "Artists need to engage with a community at the beginning of a project rather than retroactively at

the end."[11] This interaction took forms as wide-ranging as planning visits to the site, to open forums in the community, to Christo's negotiations and enlistment of others in the production of his massive projects. Yet Mary Miss was not merely offering a word of warning to artists to help dispel disputes, but was pointing to the formative role that artists can take in affecting communities and shaping our world: "Art and artists are likely to remain on the periphery of our culture unless they are permitted to become actively engaged. Many are attempting a more integrated role, but their efforts must be recognized and supported. The visual sensibility of our best public artists can provide insight into our complex environment and possibly help to create a pathway through it."[12] Mary Miss pointed to how the artist's visual acuity and sensitivity to the formal elements could be brought into solving problems in the aesthetic design of our built environment. **Community-based artists a decade later have adopted this notion of a cooperative artist-audience relationship to demonstrate how the artist's unique perceptions and creative mechanism can be employed to solve problems of social design in our urban environment – to show that the artist can contribute socially as well as visually to our world.**

Site as a forum for dialogue and action takes public art from the passive disposition of objects, functional design, or conceptually appropriate thematic works, to social intervention.

What is the role of the artist in the public arena and in society?

In the late 1980s an activist strain of contemporary art, though present since the late 1960s, became more pronounced and recognized. This aggressive stance may have grown out of postmodernist criticism's support of a social and political dimension for art. Public art, not confined to the museum or gallery space and audience, offered a direct route for artists to get their message out in order to influence or transform society. Modes of collaboration among design professionals fostered earlier by the NEA took on new meaning by extending to any discipline and including the public itself as collaborator. This work changed the definition of art as we have known it in this century by bringing the community into the creative process as coauthor, rejecting the modernist notion of the artist as sole heroic artistic genius, and returning art to its communal origins, especially as evidenced in non-Western traditions. As public art shifted from large-scale art objects, to physically or conceptually site-specific projects, to audience-specific concerns (work made in response to those who occupy a given site), it moved from an aesthetic function, to a design function, to a social function. Rather than serving to promote the economic development of American cities, as did public art beginning in the late 1960s, it is now being viewed as a means of stabilizing community development throughout urban centers. **In the 1990s the role of public art has shifted from that of renewing the physical environment to that of improving society, from promoting aesthetic quality to contributing to the quality of life, from enriching lives to saving lives.**[13]

Community-based art emerges today as the new public art at a time when NEA Chair Jane Alexander is building her platform on the concept that the arts build communities.[14] In a utopian spirit, many are looking to art to empower communities and to act as an agent of social change. **But as socially minded artists work to make their projects more inclusionary and**

bring those usually outside art institutions into their work - through subject matter, noninstitutional locations, or actual involvement by nonarts participants - many from the art world audience flee; a substitution rather than expansion of audience occurs. Is the art world audience separating itself from community-based projects because individuals feel uncomfortable that they are not part of the targeted community? Do they believe that their art - mainstream Western contemporary art - can have a universal audience? The concentration of the community-based projects around subjects pertinent to those marginalized by society (women, youth, the poor and lower class) can seem exclusionary - an act of reverse discrimination - exploitative, or romanticizing of a community's problems. Is it because this work is understood and "appeals" to those uneducated in contemporary art, and so must represent the lowest common denominator and lack quality, that the art world finds this work to be less than art? Is it because the appeal of art for many in the art world may be its very refinement and remove from the everyday and everyone?

Some art critics have claimed that community interaction is at odds with quality artistic practice and challenged whether social issues are a proper domain for art. The community-based artist's emphasis on process – events, education, dialogue – rather than object-driven concerns, and the political and social orientation of these public works are seen to override aesthetics. Yet the Russian Constructivists early in this century certainly provide a model in which aesthetic quality could comfortably coexist with the social activism of the artist. Is it the functional nature of this work in addressing social needs that lessens its status as art, and subjects community-based work to the same high-low dichotomy that has traditionally existed between painting and crafts? Surely the many recent, distinguished site shows in Western Europe and the United States have demonstrated how the most important artists of our time can poetically and visually create great art outside the museum or gallery.

CULTURE IN ACTION. "Culture in Action" merged curatorial and public art administrative practices of recent decades. The projects that comprised this program were temporary, commissioned works whose nonarts institutional context and public siting of activities or objects were fundamental to their meaning. As with public art or museum ventures in open-access locations, there was an opportunity for audiences who might not attend an art event to partake in these projects. But unlike museums and public art as we have known it, the process of establishing these works was an integral part of the art, as important as any objects created; members of the audience were engaged from the point of conception. In focusing on the community-based practice of artists working outside the museum, "Culture in Action" responded both to changes in contemporary artmaking and to a diversified audience for contemporary art.

"Culture in Action" began by questioning assumptions: Who is the audience for public art? How can public art represent the public when there are many publics?

Is community-based public art better suited to today's urban environment than monumental art objects? What ramifications might this work have for cultural institutions, for public art, contemporary art, art education? What is the role of the artist in the public arena and in society? How can artists collaborate with communities? Can artists work in communities that are not their own? How can public art contribute to community? Can art empower a community and can art affect society?

What are the aesthetic forms by which art can reach different audiences?

In addition to rethinking the form and audience for public art, the format and scope of site exhibitions and public art were reconsidered. How to make a public art exhibition program for a major urban environment? A walking tour would necessarily be confined to a neighborhood or, as in past Sculpture Chicago programs, to a downtown district and usually on private land, often areas under commercial redevelopment. "Culture in Action" looked to bring public art back into communities from which it had sprung more than a century earlier, recapturing its role as a cultural symbol and galvanizing force in contemporary terms. Initially conceived of as "New Urban Monuments," this program positioned itself in relation to public art as it had existed in Chicago since the 1860s.

"Culture in Action" aimed to bring into being public art that was as much about the public as about art. It revolved around notions of public or social space: contested public space (the street, the market); public housing; candy counters and hardware stores; public education and the environment; public health; and the public telephone. It was less about geography than it was a topography of social and cultural forces within the city. And while it was specifically linked to Chicago, this city became a paradigm for the urban condition in the late twentieth century. Most important, while "Culture in Action" adopted the mode of scattered-site exhibitions – depending upon where the artists found their subject and collaborations – it also defied a single, contained time frame. Each project was dictated by its own timetable and, because process and programming were an intrinsic part of each project, the work existed over time and on multiple levels. Education and communication did not take the form of museum programs (lectures, docent tours, publications) modified for public art and presented upon completion of the sculpture, but were conceived and developed with the artists as part of the artmaking. This was not outreach designed to educate an audience about art, but an attempt to establish a dialogue.

This program also sought to build upon the nearly ten-year history of Sculpture Chicago, which had offered to emerging and Illinois artists a public space and funds to make and show work that could not be realized in a studio setting. It had the additional goal of demystifying art for the uninitiated audience by publicly revealing the process of making during a six-week open studio-on-the-street. "Culture in Action" continued to commission younger artists from Chicago and elsewhere, but extended its salient features by commissioning projects that intentionally broke with studio tradition, whose shape could not be predetermined in a maquette, and, by moving into the public space of the city, demanded interaction with its audience. "Culture in Action" brought the public from various Chicago communities into the process of the work of art as active participants and cocreators, rather than as casual, albeit new, spectators.

"Culture in Action" was developed over long periods of discussion beginning in 1990 – among arts professionals, community organizers, neighborhood groups, citizens, artists, board, and staff. From the outset it sought to give new meaning to public art through a pilot program of experimental projects that could help to build a new model for public art. Invited artists began to come to Chicago in January 1992 to help shape the program and propose a project that would confront the gap between artist and audience. While the idea of creating works of art jointly with the public was considered, it was not designated as a consistent theme of the program until after a year's dialogues. Likewise, the subjects, locations, and participating constituents were determined by the artists over time through discussions and repeated visits. By December 1992, in an open forum and series of roundtables, the notions explored by artists and local constituencies were brought to professionals and representatives for debate.

As it developed, "Culture in Action" did not become characterized by a single style so much as by its audience-generated and audience-responsive orientation, related strategies, and their exploration of routes of exchange with multiple and different audiences. In each case the process began with a small group of people, and a ripple effect ensued.

Recognizing that there are many publics, "Culture in Action" addressed itself first and foremost to its constituent collaborators for whom the social issues addressed by the artists in their work were aligned with this audience's life concerns.

Thus, from the start, issues that were meaningful to a specified population were the focus of the project. These audience-participants and the artists shared responsibility for the statements made. And the most in-depth and privileged experience of the art was not reserved for individuals distinguished by wealth, reputation, or art knowledge, but was available to any who cared about the issues and wished to become involved. Audience was not so much an issue of numbers, of reaching the undefinable, elusive masses, but of who and how.[15]

Meaning was found in the subject and siting of the projects. The objects that resulted from the interactive process of "Culture in Action" were the locus for shared sentiments and means of communication with other audiences. Their form, even if unconventional and more tied to Conceptual genre than tradition, did not pose a barrier: artists and audiences intersected at the point of meaning and joined in determining the form of expression their dialogues would take. This mode of collaboration is not without its complexities of familiarity, trust, and aesthetics; authorship continually had to be renegotiated between individual and group interests. But through this process of exchange and dialogue, public art was reinvested with cultural meaning.

While each project in "Culture in Action" can be identified by a central theme, the artists and their groups recognized that the issue they were dealing with could not be viewed in isolation; it was not purely a question of education, housing, jobs, health, gender, or ethnicity, but of intertwined issues. The spirit of Jane Addams, a touchstone of Suzanne Lacy's project, offered a guiding principle. Addams perceived the emerging social ecology of the modern world and understood that to rectify one social ill, multiple concerns of various peoples had to be addressed. The same issues that the artists

collectively addressed in "Culture in Action," Addams addressed in the sweeping social agenda of Hull-House. The projects in "Culture in Action" did not claim to provide solutions, even answers, to these complex concerns, but they did take a constructive approach. By translating local manifestations of these issues into meaningful aesthetic metaphors, the artists and their collaborators sought to illuminate personal ways in which the individual could deal with these overwhelming global problems. They sought within the specific milieu that generated each project a means to tap into the human experience of other audiences in Chicago and beyond. The temporary nature of the projects was crucial to setting the tone for fluid and open experimentation, and to avoid the compromises and delays that plague public artmaking. In rejecting the goal of the universal artistic statement, concerning itself with the immediate crisis of contemporary life both locally and globally, it favored temporary, interactive forms over formalist sculpture.

How can the arts become a meaningful part of everyday experience?

In order to function as a catalyst for community dialogue and change, "Culture in Action" directly engaged audiences – physically, mentally, emotionally, and socially. A metaphor first identified by Iñigo Manglano-Ovalle is applicable: each project and the program overall became an ongoing *tertulia*, a constantly evolving conversation among circles of "neighbors." Conversations extended throughout the summer-long general public phase with five-hour bus tours that became seminars across multiple, site-specific venues. Even though Sculpture Chicago's involvement has ceased, discussions between artists and their constituencies continue still. This publication will also serve a discursive function within its readership. The eight projects had an immediate impact. Yet they live on, too, sometimes stronger than physical monuments, in collective memory and myth, in the lives of individuals, and in programs that continue and will follow.

Questions remain: How can we broaden the audience for art outside the art world? How can our cultural institutions find ways to relate to multiple audiences and varied communities and develop sustained relationships with these audiences? What are the aesthetic forms by which art can reach different audiences? How can the arts become a meaningful part of everyday experience? How can we support the artist as cultural worker as well as object maker? How can public art be supported as a temporary activity, as well as permanent object? How can we explore and enable artists to contribute creatively to other fields, to the needs of society beyond the realm of aesthetics? How can this practice enter the mainstream?

Art's role in our society will not be effectively established until it permeates our social systems and is not thought of as just something that happens inside the doors of a museum. Working outside the institution – in other sites, with everyday means, with daily issues – is a start in shifting the ideological position of art in our culture. By acknowledging the social function of art, by viewing art as an activity and creative problem-solving mechanism with applicability to all walks of life, it can go even further. This does not require so much an alteration of the definition of the work of art so much as an expanded definition of the work of the artist. The broader realm of art in life still remains to be explored and the conduits through which art can engage audiences outside the art world are largely untapped. Working with communities is an important step in demarginalizing contemporary art and artists, building new bonds with the public, and establishing a valued place for art in our society.

1. This line of inquiry has been successfully interpreted in a profusion of museum exhibitions. In addition to artists' projects (such as Fred Wilson's "Mining the Museum," organized by The Contemporary, Baltimore at the Maryland Historical Society, Baltimore in 1992-93) are curatorial initiatives (such as "The Label Show," at The Museum of Fine Arts, Boston, 1994 and "The Museum Looks at Itself: Mapping Past and Present at The Parrish Art Museum, 1897-1992," The Parrish Museum, Southampton, New York, 1992) that present critiques of museological practice, contrasting the museum's nineteenth-century origins with its changing and competing functions at the end of the twentieth century. This trend is not limited to art museums. In Chicago, for example, the Field Museum of Natural History's "Africa" exhibition, which opened in 1994, was planned with a task force of area African-Americans who helped to shape this view of a distant, foreign land and connect it to the local community. The Chicago Historical Society's "Neighborhoods: Keepers of Culture: (1994-97) is a joint venture with communities to self-determine the presentation of their histories.

2. Arthur C. Danto, *Beyond the Brillo Box: The Visual Arts in Post-Historical Perspective* (New York: Farrar, Straus, Giroux, 1992), p. 12.

3. Ira J. Bach and Mary Lackritz Gray, *A Guide to Chicago's Public Sculpture* (Chicago: The University of Chicago Press, 1983), pp. xi-xiii.

4. Ibid, p. xiii.

5. This trend continues worldwide to mixed results. In recent years it can be dramatically seen in the agenda of the city of Barcelona, for example, which began an aggressive urban renewal campaign in 1980, culminating just prior to the 1992 Olympics with the completion of dozens of outdoor works on newly designated squares and neighborhood sites.

6. All related statements and quotations are taken from the official Art in Public Places grant application guidelines of the Visual Arts Program of the National Endowment for the Arts.

7. A long list of functional public artworks now exists, from many seating arrangements of Scott Burton, such as his early masterwork *Viewpoint* (commissioned 1981, completed 1983) at the National Oceanic and Atmospheric Administration Western Regional Center, Seattle, to the collaborative design of Michael Singer and Linnea Glatt (commissioned 1989, completed 1993) for the city of Phoenix Department of Public Works's Solid Waste Management Center, a transfer/recycling center where the artists worked with a team of consultants to "develop a functioning design that integrated all aspects of the facility, eliminating hidden areas and satisfying aesthetic criteria while encouraging public involvement" ("Michael Singer and Linnea Glatt," in *Reuse Refuse*, Honolulu Academy of Arts, 1994, p. 26).

8. *Insights/On Sites: Perspectives on Art in Public Places*, ed. Stacy Paleologos Harris, Partners for Liveable Places (Washington, D.C., 1984) p. 12.

9. The granite wall and grove of trees beyond are modeled after René Magritte's *The Banquet* (on loan to The Art Institute of Chicago for twentieth century reinstallation from Mrs. Edwin A. Bergman), a hallmark of Chicago's modern collections. The three council rings, as seating and a metaphor for community, and choice of plantings are adapted from the Prairie-style work of Jens Jensen, a renowned Chicago landscape architect and protégé of Frank Lloyd Wright. Inscribed in a council ring-turned-sandbox, the title of a poem by the little-known nineteenth-century American Henry Abbey ("What do we plant?") serves as a reminder of the late Mayor Richard J. Daley's retort ("What trees do they plant?") about the Yippies in defense of his actions during the 1968 Democratic National Convention in Chicago.

10. The National Endowment for the Arts Art in Public Places application guidelines of 1979 asked for a demonstration of "methods to insure an informed community response to the project," and in 1983 called for planning activities "to educate and prepare the community" and "plans for community involvement, preparation, and dialogue." A decade later they specified "educational activities which invite community involvement."

11. *Insights/On Sites* (note 8), p. 71.

12. Ibid.

13. For theater director Peter Sellars: "Artists should be at the center of society keeping 'alive a utopian vision,' because society will not improve if the people envisioning a better society are politicians" (Peter Sellars, "Artists, the Cities and Hard Times," *The New York Times*, July 4, 1992).

14. Reaffirming the value of art and its place in society, Alexander called for an examination of "what role the arts will play in enriching the lives of our citizens, the spirit of our communities, and our character as a nation" in the press release of March 21, 1994 for "Art-21," a national conference convened in Chicago (April 14-16, 1994) that presented publicly for the first time the then-new chairman's sweeping social agenda for the arts in the United States.

15. As Christopher Sperandio wrote: "Simon [Grennan] and I move outward to bridge our community (cultural workers) with other specifically targeted groups in a nonoppositional manner. That is, we view our work as the opportunity for different people to approach each other simply on the basis of a now and shared cultural experience....One never thinks of the museum exhibition with the same kind of urgency: 'If [it] affects just one person it was worth it.'" (Christopher Sperandio, letter to art critic Eleanor Heartney, March 1, 1993, that followed up on a debate at Sculpture Chicago's December 1992 roundtable discussions).

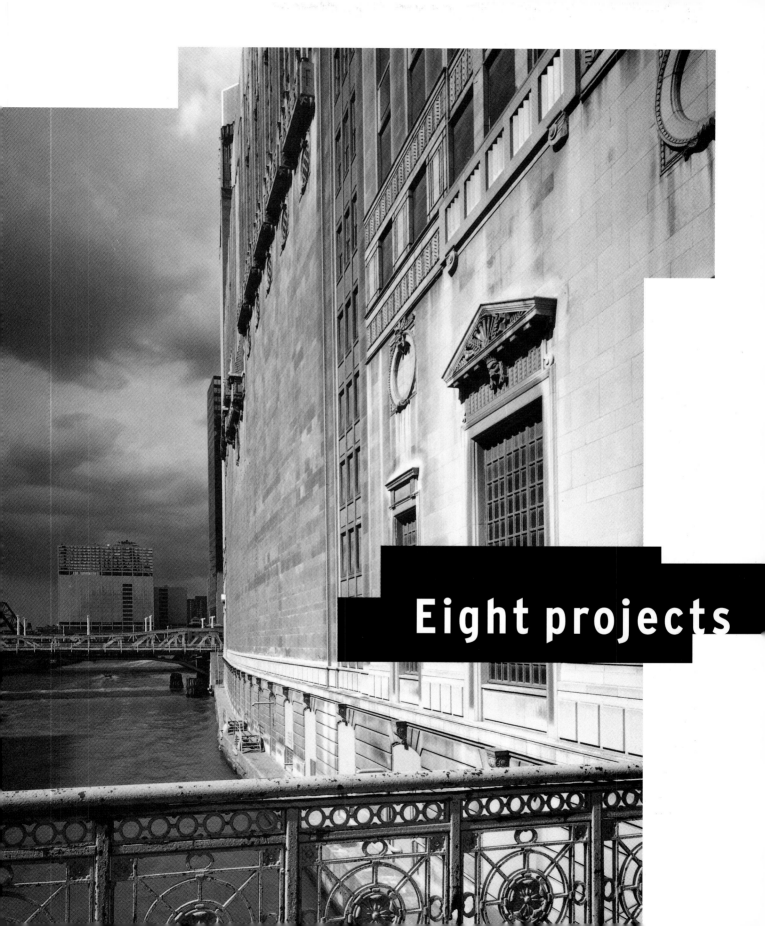

Eight projects

FULL CIRCLE

Suzanne Lacy and A Coalition of Chicago Women

Often artists pose questions that shape the outcome of their art. Suzanne Lacy approached "Culture in Action" with both a political and aesthetic query into the nature of "cultural forgetting." She was particularly interested in the repression of the history of women's contributions to the American public agenda, how their role is not recognized, and how the cultural construction of femininity which operates so forcibly on individual identity has alternated between, as the writer Susan Faludi has suggested, moments of empowerment and backlash. The question for Lacy was not so much why cultural forgetting occurred, but whether or not a cultural action, such as an artwork, could in some way inform this situation, provoking viewers to recognize the phenomenon and reframe their perception of gender. For her, social themes are a vehicle to question how we construct our perception of reality.

Suzanne Lacy has been a pioneer in developing and theorizing an art of social dimension. Emerging out of an era of feminist consciousness – awareness of the politicized reality of being a woman – her work has addressed social inequities for over twenty years. But to simply identify this work by the issue addressed (be it women, race, age, economics, or violence) is to assume a one-dimensional reading that does not encompass the totality of her art. Questions about the shape, strategies, meanings, and philosophical issues of art in life drive Lacy's work. In this case, an interest in the construction of audience prompted her to explore whether a piece could embody a complex set of ideas about women's culture in a concise representation that could reach a broad constituency, especially through systems designed for reductivist information modes such as mass media or the public streets.

One of the goals I set up was to make a work that was extremely accessible. The dilemma is that the more complicated, layered, and esoteric a work, the less readable it is to a mass audience. Public artists, often trained within an avant-garde sensibility, must deal with their desire to communicate widely and their desire to experiment with form, context, and information. I've manipulated content - the information in a work; voice - who is telling the story; narrative - how it is told; and form - structures or strategies, in order to layer the work. If a work can speak in different ways to different people, then it has a chance to say one thing to the art world (perhaps about form and meaning) and another thing to the mass audience (perhaps about politics and, ultimately, meaning). SUZANNE LACY

JANE ADDAMS, CATHERINE DUSABLE, LUPE PEREZ MARSHALL GALLARDO, ELLEN HENROTIN, HARRIET MONROE, AGNES NESTOR, LUCY PARSONS, HANNAH GREENEBAUM SOLOMON, IDA B. WELLS, FRANCIS WILLARD, BLANCA E. ALMONTE, ETTA MOTEN BARNET, REV. DR. WILLIE T. BARROW, MARJORIE CRAIG BENTON, DR. ARNITA YOUNG BOSWELL, MARCA BRISTO, GWENDOLYN BROOKS, ABENA JOAN BROWN, DR. MARGARET GOSS BURROUGHS, JEAN BUTZEN, JUDY LANGFORD CARTER, ANN CHRISTOPHERSEN, KAY CLEMENT, REV. DR. JOHNNIE COLEMON, ELLEN C. CRAIG, DR. DOLORES E. CROSS, MAGGIE DALEY, GERALDINE DE HAAS, AMINA J. DICKERSON, ROSE FARINA, SUNNY FISCHER, ANN IDA GANNON BVM, SUSAN GETZENDANNER, HELYN GOLDENBERG, INES BOCANEGRA GORDON, SANDRA P. GUTHMAN, JOAN W. HARRIS, RONNE HARTFIELD, CHRISTIE HEFNER, RHONA HOFFMAN, NICOLE HOLLANDER, KATE HORSFIELD, RUTH HORWICH, MAHA JARAD, HAZEL M. JOHNSON, MARVA LEE PITCHFORD JOLLY, TAE SUE KANG, KANTA KHIPPLE, CAROL KLEIMAN, ARDIS KRAINIK, NANCY LANOUE, NGOAN LE, LUCIA WOODS LINDLEY, BEATRICE CUMMINGS

MAYER, LUCYNA MIGALA, PEGGY A. MONTES, JEANNIE MORRIS, MARY F. MORTEN, SENATOR CAROL MOSELEY-BRAUN, GLADYS R. ARANA NELSON, MARY NELSON, DAWN CLARK NETSCH, LISA NIGRO, CAMILLE ODEH, SISTER THERESE O'SULLIVAN, SARA PARETSKY, AUDREY R. PEEPLES, BETTY JEANNIE PEJKO, CINDY PRITZKER, BARBARA PROCTOR, AURELIA PUCINSKI, SUE PURRINGTON, ARLENE RAKONCAY, GUADALUPE A. REYES, RUTH M. ROTHSTEIN, ILANA DIAMOND ROVNER, BETTYLU K. SALTZMAN, FLORENCE SCALA, ADELE SMITH SIMMONS, RITA SIMO, ANDREA SMITH, FAITH SMITH, MARGARET STROBEL, TINA TCHEN, INDRE PALIOKAS TIJUNELIS, ERMA TRANTER, SISTER MARGARET TRAXLER, NGAN-HOA CHUNG TRINH, HELEN VALDEZ, JACQUELINE B. VAUGHN, MARY-FRANCES VEECK, CARMEN VELASQUEZ, VAL WARD, ANNA WASYLOWSKY, LOIS WEISBERG, THELMA K. WHEATON, JESSIE ANDERSON WOODS, REV. ADDIE WYATT, KIYO YOSHIMURA, LINDA YU.

Jane Addams (1860-1935) was a reformer, suffragist, writer, and pacifist. In 1889 she founded Hull-House, Chicago's first and most important settlement house, with Ellen Gates Starr. Others joined her in her work as advocate and organizer on behalf of immigrants' rights, juvenile justice, industrial safety, protective legislation for women and children, labor unions, women's rights, public health issues, social welfare legislation, political reform, housing and sanitation reform, public recreation, progressive education, multicultural understanding, and community arts programs. The founder of the Women's International League for Peace and Freedom, she was honored by being the first American woman to receive the Nobel Peace Prize in 1931.

In considering the invisible nature of women's culture, past and present, Lacy drew upon a connection between Chicago of 100 years ago and today. Jane Addams became the guiding image. One hundred years ago, Hull-House was a dynamic gathering place for energetic individuals dedicated to creating solutions to the urban problems of their day. It rapidly became a focal point for intellectual debate, social reform, and educational experimentation. Sweeping transformations in society due to immigration and industrialization made change critical. Women from all classes and backgrounds came together at Hull-House to help remedy the situation. Yet today the full scope of their work remains largely unrecognized. **Is there a parallel today as we approach the turn of another century and women's issues and achievements have once again come into view?**

Jane Addams was a most visible symbol of the notion of public service. This project will be a modern-day "portrait" of Jane Addams – not the person herself, but the vision, the ideals, and the activities that typified women's contributions during her time.

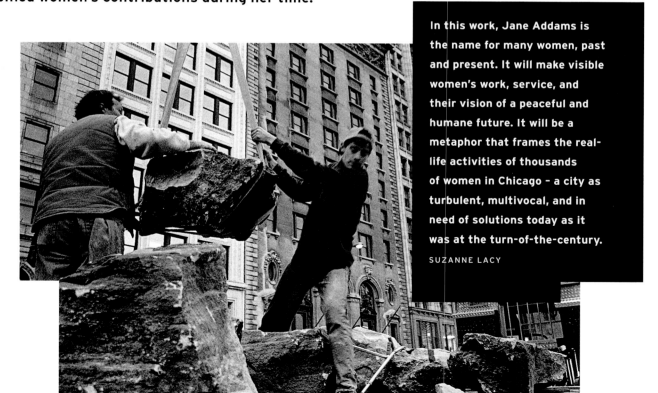

In this work, Jane Addams is the name for many women, past and present. It will make visible women's work, service, and their vision of a peaceful and humane future. It will be a metaphor that frames the real-life activities of thousands of women in Chicago – a city as turbulent, multivocal, and in need of solutions today as it was at the turn-of-the-century.

SUZANNE LACY

I have long been struck by the ways nineteenth-century feminism has been lost or reinterpreted by time. It seems as if a history has been erased, and that the perceptual frame we need to adequately "know" this time and its implications does not exist. This erasure of history is reflected today in Chicago through its public face – the lack of a female presence in public monuments and sculptures. SUZANNE LACY

Lacy developed a project that would acknowledge the contributions to community by Chicago women today, positioning them as heirs to the legacy of Jane Addams. As an image of commemoration and signification, she hit upon the idea of monuments in the form of boulders. In part inspired by her recent work in Ireland, where the countryside is dotted with rock outcroppings, these rocks would spring up seemingly spontaneously onto the urban landscape of downtown Chicago; each would represent a single woman. In her subsequent travels between California and Chicago, Lacy began networking with large numbers of women, some of whom became part of the Steering Committee that was the sounding board for metaphors and the means by which others were brought into the work. It was clear from the beginning that for the project to be successful, it would need to appeal to many ages, races, and religions. Since Chicago's identity is based on communities, many of which are ethnically described, and because inclusiveness has always been an important part of Lacy's work, she wanted to make certain that the women honored on the rocks were broadly representative. An open public solicitation devised by the Steering Committee included advertising and field investigation, and resulted in 350 nominations. A committee of fifteen women made the final selection of ninety contemporary women, while a historical commission named ten from earlier eras.

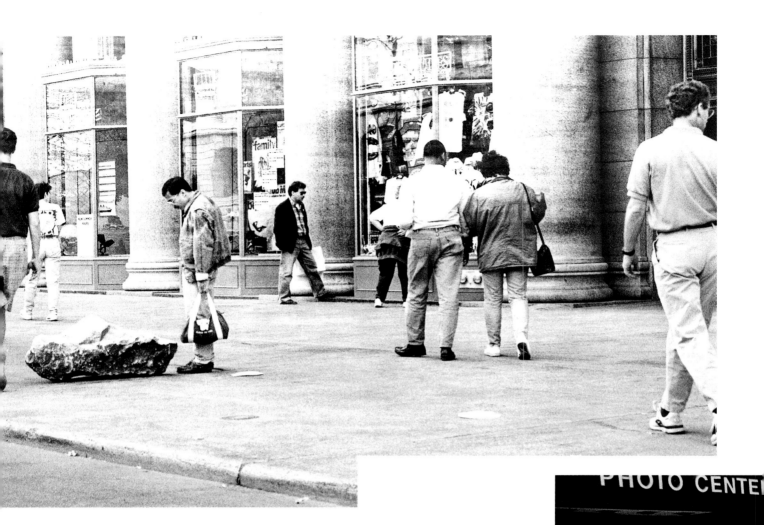

The rocks were obtained from one of two women-owned quarries in the United States identified by Antonio Pedroso of World Trade Granite and Marble Co. He contacted Joanne and Ceci Gillespie, two sisters who had recently inherited the Wapanucka Limestone Quarry in Oklahoma started by their grandfather and who were attempting to resurrect this turn-of-the-century business. They donated the boulders. Onto each, a bronze plaque designed by Leslie Becker was affixed bearing the name and a quotation by the honoree.

It was the siting of the rocks that proved to be the most difficult task. Ted Stanuga and Lacy wandered the Loop photographing and selecting locations, followed by Jessica Rath who undertook the monumental effort of negotiating the necessary public and private permissions. Finally, on the evening of May 19, a crew of about twenty loaded up three forty-foot semitrailers and, accompanied by cherry pickers, each crew set to their task of placing rocks along the streets of the Loop; the last crew finished at 3:30 a.m.

Although the rocks functioned as a Surrealist gesture and an ironic comment upon public art (several were sited in close proximity to the major public art icons of downtown Chicago), they also operated in the style of guerrilla theater. Dwarfed by the surrounding skyscrapers, they were cranky, individual, and rough-hewn - a bit of nature encroaching upon the built environment.

Each rock was sited visually, and, at times with an association between the woman named and a nearby building. The number of rocks made reference to the millennium and to the anniversary of the first Woman's Building at the Chicago 1893 World's Fair, while it gave a larger dimension to the installation. Their street presence created an immediate, shared public experience. Cab drivers, pedestrians, the press all talked about them. An architect, taken with the rocks as visual expressions, projected a permanent siting within the landscaping plans for a new city facility west of the Loop.

As the idea of Jane Addams and the rocks grew, the issue that seemed to connect them was service - and a sensibility, whether through culture or nature, that seemed particular to women. "Service," an inadequate word, often challenged throughout the project, still seems the best way to describe a quality of supporting, nurturing, correcting injustice, promoting equality.... Often service has a religious connotation, as in Mother Theresa's work. I guess I wanted that implication. Often service smacks of essentialism, as in, "it's women's nature to serve." That is dangerous territory, for theoretical reasons as well as because it suggests that women can and, therefore must, serve. Nevertheless, it still seems the best word to describe a sense of freely embraced responsibility for nurturing life ... and the activism that goes with that responsibility. SUZANNE LACY

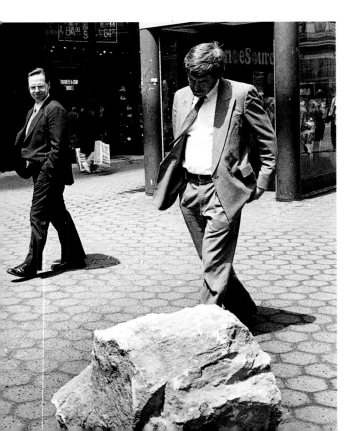

The installation also functioned on an intimate level for those named, their families, friends, and associates when a week later the women came together to celebrate the occasion. Before an audience of hundreds and each other, they received a certificate specially prepared by Chicago artist Esther Parada; then they dispersed with family and friends to the sites of their individual rocks. During the four months the rocks were in place, several events around them were staged by women's groups. One year later, the "rock women" (as they began to call themselves) held a reunion.

The invented nature of the nomination process grounded the project in the community and with the women selected. Communicating with them over time, we built up a relationship with each of the ninety living honorees. SUZANNE LACY

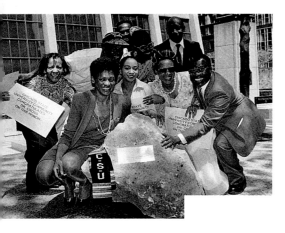

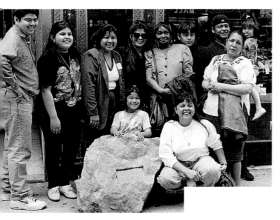

Somewhere in this work, Lacy wanted a personal image of service, a private performance in life, perhaps one achieved by volunteering her work to a local cause. But the reconciliation of this proposed private act with any meaningful "good" that she could contribute in a limited time, led to problematic questions of ethics and aesthetics. **One of the criticisms lodged against socially engaged work is its intimacy. Lacy, however, felt the vastly public rock monuments of "Full Circle" needed that balance – actually and symbolically – through a means that could make personal the global aspects of service.**

Instead Lacy created a complementary image in the form of a private dinner at Jane Addams Hull-House among fourteen women leaders from around the world whose stature lent the event a profound resonance. In a sense, the rocks and the dinner portion of "Full Circle" functioned in the same way: framing women's efforts to improve social conditions and experiencing a sense of shared community.

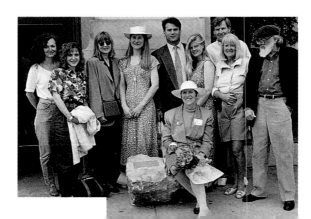

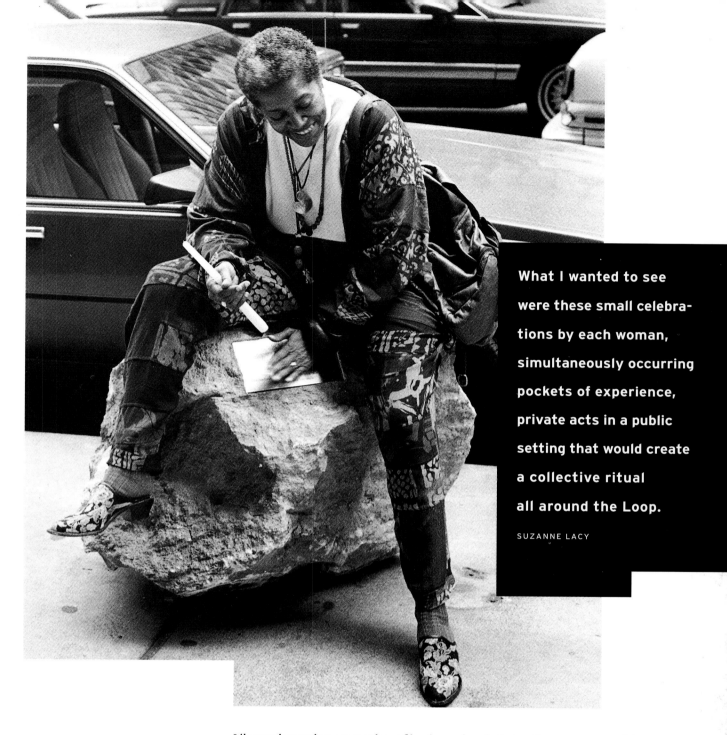

What I wanted to see were these small celebrations by each woman, simultaneously occurring pockets of experience, private acts in a public setting that would create a collective ritual all around the Loop.

SUZANNE LACY

Like art that makes a metaphor of boxing or baseball, is a dinner party a social form appropriate for the investigation of aesthetic issues while probing aspects of women's culture? The dinner at Hull-House was the most searching and speculative image in "Full Circle." Sited in an historical setting, it was composed in the manner of a site installation; framing daily reality, it was a performance. Connecting two eras, it echoed turn-of-the-century Hull-House when agendas for change and visions of a better future were a part of each evening's meal.

Letters to our daughters

As a child prone to prolonged bouts of daydreaming, I expended an inordinate amount of my growing-up years imagining myself one of two women - Jo March or Jane Addams. These two women, one fictional, one real, became my objects of hero-worship, linked and even interchangeable in my mind, for a reason that only struck me years later: they had both broken with society's strictures but had not, as a consequence, had to break with a social community....it is a version of Hull-House I keep returning to in contemplating how women can confront a world that excludes us, without fearing the punishment of social exile. What Jane Addams offered to the marginalized of America was a place of "settlement" that had as its mission the unsettling of the status quo - a house that sought to shelter humanity and shake society's rafters simultaneously. If we are to prepare a ground on which the next generation of women can navigate toward genuine progress, we must find ways to forge communities that are both rebellious and regenerative, circles of replenishment from which we can launch a sustained feminist challenge.... SUSAN FALUDI

Only seven years remain before we enter the twenty-first century. I hope that this century will be different. That in it we find more justice, more freedom, more humanity than we have seen in the twentieth century, less suffering than the suffering caused by a patriarchal class system that continues to create wars, to massacre hundreds of thousands of people, to cause widespread starvation, to destroy human beings and nature in vast areas of the globe and especially in the poorer countries of Africa, Asia, and Latin America. When I was a young child I witnessed the effects of the Second World War on my family and my country, Egypt.... Then came the war over Palestine in 1948.... In 1956 Israel, England, and France launched the tripartite aggression against Egypt. Then came the war of 1967 followed eleven years later by the war in 1973. In 1991 thirty-one countries launched the "Desert Storm" on Iraq.... Is it feasible for young women like yourselves to do something in order to change a world order that brings with it so much destruction?... I think so. I believe so.... NAWAL EL SAADAWI

Traditionally, when Native communities have faced tough decisions, it is the women who have advocated taking a long view. Among the Iroquoian people, a matriarchal society, it is believed that leaders must consider the impact of their decisions on seven generations. What a different world we would live in if all leaders would follow this advice.... According to one Native prophecy, this is the "time of the women," a time when women's leadership skills are needed....

CHIEF WILMA P. MANKILLER

Our dear daughters, ... Sadly, in fact, there has been a conservative backlash. A conservatism has been born out of the uncertainty of where to go from that initial fervor.... All this conservatism has demeaned fundamental human freedoms. It pushed back the frontiers of hard-earned women's rights.... My country of South Africa is, ironically, a source of great inspiration and optimism. Change is positive.... We have strong women who are good role models.... Our daughters, walk tall, walk proud. Create new spaces of freedom in our homes, in our streets, in our world.... Let us say to all who call themselves democrats, that women's rights are human rights. As we say in South Africa – "Sekunjalo" (now is the time, come along)! CHERYL CAROLUS

I was destined to live in a part of the world in which succeeding generations lost all their possessions in uprisings and wars.... This atmosphere created a growing interest in the individual: sensitive, able to dream, able to imagine; a human being of deep intuition, endowed with a capacity to admire and to love, capable of sacrifices.... So many men were killed in my country during the last World War that women had to replace them in all kinds of jobs.... We became used to the fact that gender should not determine one's position in society. We observed that women are somehow more patient and more resistant, somehow differently sensitive and tenacious. Perhaps not having the ancient experience of ruling and waging wars, they seem to be not so prone to ruthlessness and aggressiveness. Could they be a new power less cruel and more farsighted?

MAGDALENA ABAKANOWICZ

The "Full Circle" dinner guests the evening of September 30, 1993, were **Magdalena Abakanowicz**, artist, Poland; **Cheryl Carolus**, Executive Committee member of the African National Congress, South Africa; **Hyun-Kyung Chung,** feminist theologian, Korea; **Johnnetta Cole,** President of Spelman College, U.S.A.; **Dr. Mirna Cunningham**, physician and Congresswoman, Nicaragua; **Dr. Nawal El Saadawi**, psychiatrist and writer, Egypt; **Susan Faludi**, writer, U.S.A. **Susan Grode**, lawyer, U.S.A.; **Anita Hill**, law professor, U.S.A.; **Dolores Huerta**, organizer of the United Farm Workers, U.S.A. (not shown); **Devaki Jain,** economist, India; **Wilma P. Mankiller**, Principal Chief, Cherokee Nation; **Gloria Steinem**, writer, U.S.A.; **Rev. Addie Wyatt**, labor organizer, U.S.A.

At the turn of the century, another activist woman, a labor union organizer, wrote about how men thought them frivolous with their dinners and gift-giving events, but the women knew that through such activities many a woman laborer would be drawn to their ranks.

The impact of the dinner lies as much in the fact that the meeting actually occurred and who the women were as in any single exchange that took place. This gathering was a symbolic act; it operates best in the artistic realm of the visual and mythological. It is the relationship between women, evident through this event, that fueled Jane Addams's social interventions and much of nineteenth- and twentieth-century feminist activism. It is this relationship that is so foreign to our popular culture which ignores or trivializes these female alliances. Yet it is the sustenance provided by these relationships that can provide the power for change. SUZANNE LACY

While the dinner was the most private aspect of "Full Circle," being necessarily closed to the public, it may, paradoxically, prove to be the most significant expression of women's service as it becomes known to a mass audience by means of a planned televised program.

Inasmuch as Lacy's works are based on questions (about the nature of art, or female identity, or ethics) her art is also constructed from rather indefinite impulses, artistic sensibilities akin to those of a painter. The humorous "dropping" of the rocks overnight, their sudden appearance on the streets, appealed to the artist's sense of aesthetics, as did the intimacy and power of watching Magdalena Abakanowicz and Susan Faludi talk across the dinner table. It is this investigation of the line between art and life that is the compelling factor in all of Lacy's art. With this exploration, Lacy situated herself as an artist in relation to Jane Addams, to one hundred "rock women," and to the fourteen dinner guests. And it is this relationship between art and life through which Lacy creates some of the most moving metaphors of our culture.

PARTICIPANTS: Steering Committee and Advisors: Diane Chandler; Amina J. Dickerson; Joyce Fernandes; Nancy Floy; Stephanie Fogg; Sandra Furey; Michelle Gazzolo; Camille Gerstel; Juana Guzman; Ronne Hartfield; Sharon Irish; Mary Ann Johnson; Barbara Kensey; Kanta Khipple; Grace Lai; Susan Larson; Juju Lien; Virginia Martinez; Esther Parada; Marianne Philbin; Kavita Ramdas; Eunita Rushing; Jane Saks; Ann E. Smith; JoAnne Stone-Geier; Janet Treuhaft; Thelma Tucker; Manny Tueter; Helen Valdez; Cheryl Yuen.

STAFF: Iris Kreig, Hull-House Dinner Producer; Mary McCall, "Full Circle" Coordinator; Ktalia Simon, Administrative Assistant; Ted Stanuga, Installation Manager. Student Team: Ericha Ahlschier, Karen Baraducci, Shalona Byrd, Courtney Cooney, Tracy Hudak, Mary Zerkel. Photography: Lynne Brown; Patricia Evans; John McWilliams; Melissa Ann Pinney. Video, Hull-House: Tom Weinberg, Producer Hi-8; Phylis Geller, Producer Betacam; Jane Kaplan, Producer Betacam; Dick Carter, Video Director; Skip Blumberg, Camera Operator; Andrew Jones, Camera Operator; Nancy Cain, Camera Operator.

CREDITS: Jane Addams' Hull-House Museum at the University of Illinois at Chicago; Chicago Foundation for Women; City of Chicago: Department of Transportation, Department of Cultural Affairs, Department of Planning and Economic Development; Eli Cohen, CBM, Inc.; Ceci and Jo Anne Gillespie, Wapanucka Oolitic Limestone Quarry; Bette Cerf Hill; Judith Neisser; Antonio Pedroso, President, Granite and Marble World Trade; Sidley & Austin: Jack Guthman, Rolando Acosta; Sheraton Chicago Hotel and Towers; Barbara Yergin, Chicago Development Council. Co-sponsored by The School of The Art Institute of Chicago.

VIDEOTAPE CONTRIBUTORS: Marjorie C. Benton; Chicago Foundation for Women; Sage Fuller Cowles; Susan Crown; Dolly Fiterman; Agnes Gund; Joan W. Harris; Ruth Horwich; Barbara Kipper; Lucia Woods Lindley; Patricia R. Lund, Diana Meehan; The Playboy Foundation; Ilana Diamond Rovner; Evelyn Salk; Phyllis S. Salsberg; Bettylu Saltzman; The Sister Fund for Helen Hunt; Emily Anne Staples; Bernice Steinbaum; The Tides Foundation for Effie Westerveld; Peg Yorkin.

TELE-VECINDARIO

Iñigo Manglano-Ovalle and Street-Level Video

Iñigo Manglano-Ovalle knows firsthand the challenges of immigration and the struggles of acculturation. Born in 1961 in Madrid where his father's family lived, he grew up between there, his mother's native city of Bogota, Columbia, and Chicago, becoming a naturalized United States citizen in 1989. His work has always been rooted in localized communities and reflects his personal experience of living between cultures. Among his early work was "Assigned Identities," produced in collaboration with Chicago's Emerson House Community Center and designed to complement the center's efforts in assisting undocumented immigrants to obtain "amnesty" under the Immigration and Naturalization Service status adjustment procedures. The project informed the participants as to the current methods used by the Justice Department to document "illegal aliens"; this became the platform from which they created personal cartographies exploring cultural stereotyping through alternative means of self-documentation.

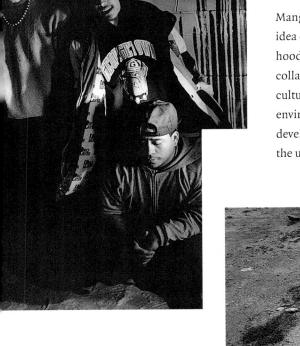

Manglano-Ovalle's "Culture in Action" project began in January 1992 with the idea of "Sereno/Tertulia" that would be centered in the artist's own neighborhood of West Town. In this milieu, Manglano-Ovalle wanted to undertake a collaborative work whose organizational processes could bridge the social and cultural isolation of residents, and create a space for dialogue. And in the fearful environment that has been created, primarily because of gangs, he wanted to develop a project aimed toward reclaiming and transforming the social space of the urban residential street.

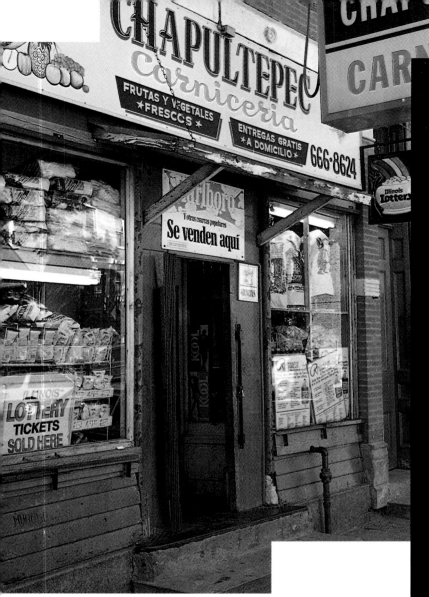

West Town, a formerly Polish, Ukrainian, and Italian district at the turn of the century, is now predominately Mexican, Puerto Rican, Central and South American. There are lower-income, working-class residents and others who depend on public assistance or have jobs in informal labor markets. Primarily renters within their own community, their homes have become increasingly vulnerable to speculation and growing gentrification. A considerable number of artists have also moved into the area to take advantage of the affordable rents. The usual urban problems (lack of jobs, school drop-outs, crime, drugs, gangs, teen pregnancy, and AIDS) afflict West Town, too. But with an over 100-year history of community involvement, several agencies and many committed individuals are today fighting back against these destabilizing forces.

Physically – and sculpturally – the project, as initially proposed, was to take the form of public seating and street lighting. In Latin cultures adults gather outside at evening for the *tertulia* – to socialize and talk. For Manglano-Ovalle's project, this ritual would be preceded by the manual lighting of the *faroles* or street lights in the vicinity. The artist's grandfather used to tell him of the *sereno*, the lamplighter who announced the time and provided the news to the community. Younger members of the community would take on this task traditionally performed by the *sereno*, thus bringing into contact two generations that are increasingly estranged.

The maintenance of lighting in poorer neighborhoods is a low city priority and its deterioration contributes to the cycle of crime and fear on the street. Manglano-Ovalle sought to take action by inserting into this situation a gesture – the simple but empowering act of manually turning on street lamps – that

would metaphorically turn these common urban fixtures into *faroles* and initiate a new dia-logue on the urban streetscape among community members who share space but do not communicate. Negotiating who turns on the lamp would be a first step in the community's assertion of its own power; it would define who represents the community from within, while proclaiming to the outside that the community has the authority to determine its own existence. Traditional, handcrafted jute chairs and *faroles* would be used to invest the site with an atmosphere of tolerance and shared experience – to transform the territorialized street into a communal promenade, the Ramblas, lost to contemporary urban spaces.

Street-Level Video's (S-L V) first completed tape, "This Is My Stuff," was shown continuously on the facade of Emerson House from May to September 1993. Here the role of community representative shifted from the *sereno* to a vast range of youth, activists, and neighbors. The aim of the video was to provide residents with a means to speak out and claim their community, interrogating and challenging viewers to reconsider the line between public and private space: "This is my neighborhood; is it your neighborhood?"

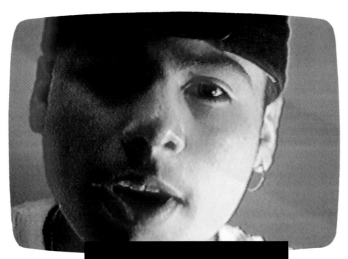

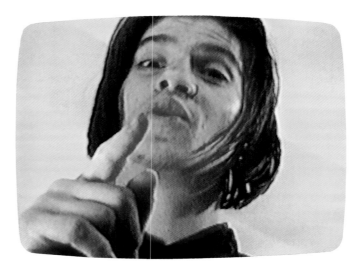

Make art to stay in the community and contribute to its survival.

NILDA RUIZ PAULEY

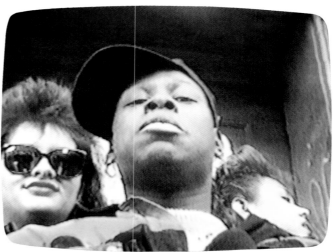

Tele-Vecindario

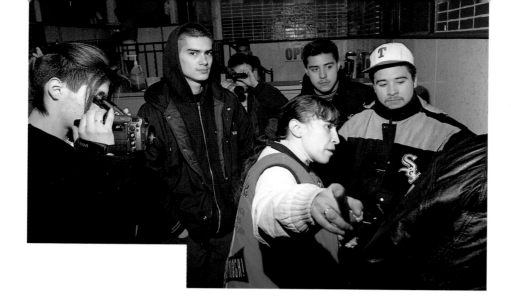

Throughout 1992 Manglano-Ovalle visited over forty social service agencies in order to refine his approach to this project. By June he realized, "This stage of the project has already developed into an ongoing *tertulia*, and it is the leadership of these individuals that has already begun to light the way for the *sereno*." However, Manglano-Ovalle's proposal, though constructive, seemed to have some potentially damaging ramifications. Bob Brehm, a housing advocate and director of Bickerdike Redevelopment Corporation, a not-for-profit group dedicated to obtaining permanent housing in the area for Latinos, observed that the lighting project might be misinterpreted as yet another attempt at street beautification, even, ironically, jeopardizing the stability of the neighborhood and displacing the very people the work aimed to benefit.

Samuel Soler of Better Days for Youth saw the project as presenting a positive image of young people to the community and creating a safer place for youth. Out of discussion with him, the artist began to think of the site of the work as a neutral zone. In September 1992 he also met Nilda Ruiz Pauley, an English teacher and youth-at-risk coordinator at Wells High School, whom he believed could be an ally in getting young people involved. Pauley's vision of "Sereno/Tertulia" as a means of providing positive leadership roles for participating youth and rechanneling gang energy into constructive areas, played a formative role, and her energy made it happen. **But as the project developed, it became clear that even more than the chairs and the lamps, the street was the key element of this work and that in the streets, the dominant concern is gangs.**

Street gangs provide an alternative social system when familial and societal structures give way. It provides a social outlet to dispel anxieties and can seem like the only space for a community that has the feeling of no space – physically, psychologically, socially, and politically.

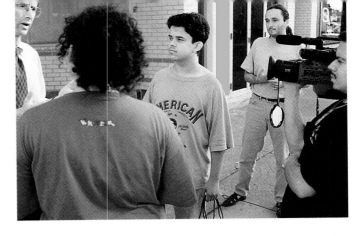

In seeking an intergenerational dialogue, Manglano-Ovalle knew he would have to address gangs. Thus, to his proposal he added the concept of a fifteen-minute "video map," a tape to be produced by area youth describing the neighborhood. It could prove to be a valuable tool for getting into the neighborhood, enlisting students, meeting other people, and learning the terrain.

Video already had a role in the community through popular culture. Its mass media images were, in part, responsible for the promotion of negative stereotypes of Latino youth. Manglano-Ovalle and his associates would eventually teach S-L V members to take the power by decoding these images and creating their own, alternative ones. By October 1992 video training workshops began as preparation for making a video map as a first phase of the *tertulia*. But out of these workshops, video emerged as the very tool of the *tertulia*, the means by which a dialogue between peers and with adults could be facilitated. And so by the end of 1992, video moved from a supporting element to the forefront as the project was transformed into multiple video dialogues among neighbors, known cumulatively as *Tele-Vecindario*.

The intention of the project is not to organize, but to channel and illuminate the vitality of the community's own organizational structures. My hope is that collaboration in the project will prove to be beneficial to participating individuals and groups. It is already certain that this project could not exist at this stage without their involvement. IÑIGO MANGLANO-OVALLE

Manglano-Ovalle knew that the active involvement of area leaders would be essential to integrate this project into the life of the community, so he sought to identify a host organization – one which would have a similar mission and whose ongoing activities would be benefited by working together. Ultimately, he formalized the associations and alliances he had been building over a year's time with the creation of a new coalition of youth organizations which called itself the Westtown Vecinos Video Channel (WVVC). Its name, making a symbolic reference to a television channel, described its function as a conduit for discourse among the parties involved. Its youth division, an open-ended group numbering about twenty young men and women, took the name Street-Level Video.

WVVC was composed of Wells High School's School-within-a-School Program, headed by Nilda Ruiz Pauley, that builds partnerships with local businesses and others to provide opportunities for youth-at-risk; Emerson House Community Center, the 1912 settlement house whose youth coordinator is Lucy Gomez; Erie Neighborhood House, also a turn-of-the-century settlement house whose youth options program is directed by Olga Lopez; and Community Television Network (CTVN) founded and directed by Denise Zaccardi to build the media literacy of economically disadvantaged minority, inner-city youth, provide a means for them to voice their opinions, and teach job skills in the field. WVVC brought together the separate youth-directed efforts of each of these groups to support the creation of S-L V. But once established, WVVC passed out of existence, while S-L V remains actively engaged in the comunity. It began by interviewing its *vecinos* (neighbors): community organizers, business owners, families, friends, peers, and rivals.

S-L V's videos for "Culture In Action" revealed the alienation experienced by youth within and without the community, cultural and class demarcation, gang affiliation and violence, housing and real estate, jobs, the domestic setting, cruising, and sexism. The videos were intended to serve as a catalyst for change – to transform a neighborhood and the public perception of it. S-L V continues to work between sectors of the neighborhood, producing videotape programs. To date, about fifty videos have been made by S-L V.

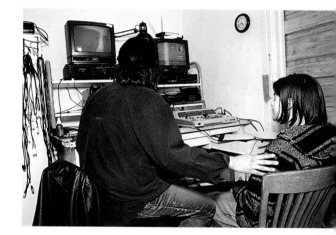

One S-L V member, Alfonso Soto, stated: "We got started as a way of getting different people from different streets talking. We work with gangbangers and others, young and old. We use video as a way to work with others in and off the streets."

In addition to an ongoing one-screen out-door installation at Emerson House, tapes were also shown during the spring and summer of 1993 at a range of local spots – from Duks hot dog stand to Wells High to a local video arcade or grocery store to CTVN's "Hard Cover," a program pro-duced by teens for Cable Access Channel 19. In addition, just prior to the public inauguration in May of "Culture in Action," an opportunity arose to show at the Museum of Contemporary Art. S-L V responded to the invitation with a pilot for their block party, an open studio work-in-progress and installation called "Cul-de-Sac." It made use of this specific museum con-text to contrast an officially labeled "public" space with the public space of the street in their community. This distinction could be observed not only in the arrangement and aesthetic resolution of this installation in an indoor versus outdoor space, but by the nature of the museum versus street audience. The usual contemporary art audience that frequents the museum did not, by and large, travel a couple of miles west to West Town to see these tapes *in situ* or attend the subsequent, more extensive block party/installation. However, many from the local community ventured to the museum for the first time. Yet it was perhaps S-L V members who benefited most by transcending geograph-ical and social boundaries, and seeing their tapes both in the shared space of the street at home as well as in an art muse-um near the city's lakefront.

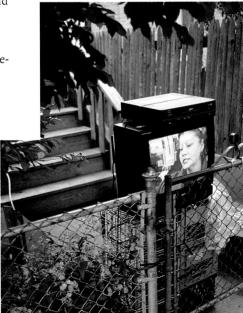

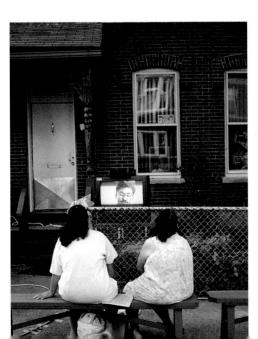

hot in gang-related incidents.

The meeting of local residents could create a sense of place, ownership, and home; not just a "site of critique," but a "site of possibility," where productive change might be initiated.

IÑIGO MANGLANO-OVALLE

"Cul-de-Sac:" A Street-Level Video Installation was comprised of eleven video programs by S-L V played out on a fourteen-monitor installation illuminated by the orange glow of sodium vapor lights. It was conceived by Manglano-Ovalle and Paul Teruel, who also worked closely as teacher, coproducer, and mentor for those in S-L V. Evoking a cul-de-sac (a blind alley or impasse), Manglano-Ovalle aimed to draw a parallel to a community under siege, a hemmed-in place that has become isolated and offers few options to its residents for change and betterment. This metaphor came soon after Mayor Richard M. Daley announced the city's own cul-de-sac program aimed to inhibit drive-by shooting. In contrast to the suburban use of this road device to define residential exclusivity, city cul-de-sacs, S-L V argues, trap residents in their neighborhoods, limiting their physical mobility and sense of freedom. In this installation, the urban cul-de-sac was dramatically evoked by the use of chain-link fencing to contain most of the monitors, caging in the images and the persons speaking, and serving as a metaphor for social, economic, and ethnic or racial boundaries that define and restrict community growth and interaction.

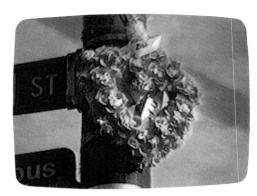

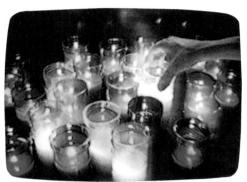

Television promotes a shared cultural identity that locks society into stereotypical images which viewers receive passively. Like the street, television can be a means of escape or entrapment. Inverting the usual viewer relationship in their installations, S-L V took the television set outdoors to the street, externalized it, and manipulated the equipment rather than having it manipulate the receiver; using their own voices rather than those of the network or advertising, they tell their version of the story - "this is my stuff."

The culmination of S-L V's year-long work was an event of impressive magnitude – encompassing one residential street, using seventy-five monitors, involving four rival gangs and S-L V members, with an audience of over a thousand. Planning involved numerous meetings, even gang arbitrations, to secure a neutral space.

As S-L V member Eddie Carrion put it, "We are young people armed with camcorders, giving voice to the community, and producing videos in, around, and about our community."

Tele-Vecindario

For six hours, tapes grouped in multiple installations occupied high front stoops, lawns behind chain-link fences, the sidewalk, and the street; they were stacked on milk crates or placed in cars. Words and images filled the scene. It was both block party and video installation; a stage with teen performers and Pauley as master of ceremonies; a "Westtown Respect" peace mural whose negotiated design involved S-L V, representatives of local gangs, some neighbors, and the Spray Brigade crew, who executed it with characters by Rafa and wild style text by Zore. Insiders and outsiders to the neighborhood blended as they strolled down the street for the evening's *tertulia*. They were found in conversation with each other or listening to each other on the videos.

In one vacant lot an eleven-monitor installation called "Rest in Peace" became a temporary cemetery in memorium to youth who had died in gang violence.

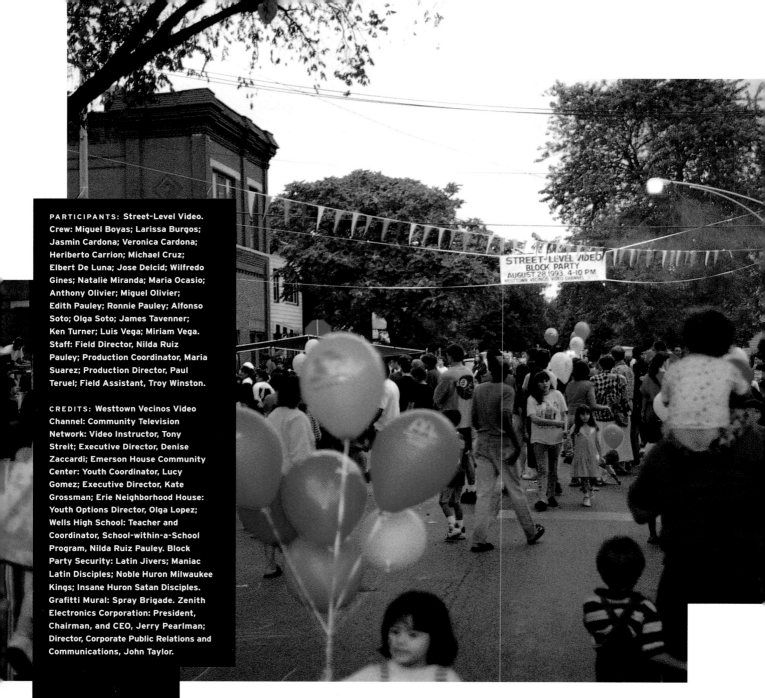

Earlier thoughts of employing residents' own televisions to show the tapes gave way to plugging into residents' electricity. The long, yellow extension cords coming out of people's houses became a potent metaphor for the sharing of power. Nearly 100 extension cords were dropped from apartment windows or threaded out front doors for *Tele-Vecindario*.

Calling from a second-floor apartment to the installation crew

below, a local resident announced: "I have power. Take my power."

Tele-Vecindario

This feature, along with the monitors, constituted the main sculptural elements of this massive video installation. It also literally and metaphorically extended and distributed the power in the community, taking it from private living space to the public street. Just as turning on their own street lamps in "Sereno/Tertulia" would have signaled the power of the community to participate in its own self-determination, so, too, here the residents recognized their power and used it – to turn on the monitors, to speak to each other, to speak for themselves. And like the earlier concept of the street lamp, as the evening progressed, the monitors lit the street and provided a hospitable atmosphere for shared activity.

Conversations and video production continue. The editing equipment, monitors, and decks, purchased in lieu of spending funds on rentals and editing services outside the community, remains. As a combined public art strategy of artist and agency, it was decided that it was more beneficial to place this equipment in the hands of S-L V as a permanent public art vehicle than to erect a permanent public art work. Today S-L V occupies a storefront across from Wells High School; members are currently working on "Neutral Ground," a video dialogue among gang members that surround the school. They continue to work with Iñigo Manglano-Ovalle as artistic director, Paul Teruel as production director, and Nilda Ruiz Pauley as field director. Taking the power into their own hands, the S-L V crew uses these video tools to create an ongoing *tertulia*.

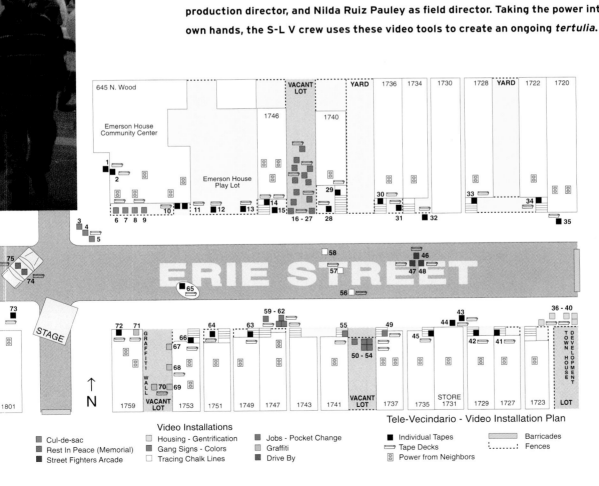

Tele-Vecindario - Video Installation Plan

Video Installations

■ Cul-de-sac	▫ Housing - Gentrification	■ Jobs - Pocket Change
■ Rest In Peace (Memorial)	▪ Gang Signs - Colors	▫ Graffiti
■ Street Fighters Arcade	▫ Tracing Chalk Lines	■ Drive By

■ Individual Tapes	▭ Barricades
▭ Tape Decks	⋯⋯ Fences
▣ Power from Neighbors	

FLOOD

Haha and Flood: A Volunteer Network for Active Participation in Healthcare

The four members of the Chicago-based collaborative Haha – Richard House, Wendy Jacob, Laurie Palmer, and John Ploof – began making art together in 1988, around the time they all graduated from The School of The Art Institute of Chicago. While House is a writer and the individual artistic output of the other three varies in style, the work they have become jointly known for through exhibitions in the United States and Europe deals with social or physical positions within particular sites or spatial situations. To do a work of art that finds its place in a real-life context was the starting point for Haha when first contacted in August 1991 about making a proposal for "Culture in Action." Their most challenging preceding work of this ilk was "Murmur," a project they initiated on their own. Over a year's time they built a working relationship with the African-American water-polo team that met at La Follette Park fieldhouse. The culmination in 1990 was a performance-installation that pointed up issues of racial polarization in Chicago. While the local community was quite welcoming and literally

at home with the piece, and the athletes were willing and proud participants, the art audience had quite a different experience. Its effective staging brought a white, art-community constituency into this black neighborhood; the visitors' discomfort caused outrage, expressed in the guise of art criticism, which marked the geographical and psychological distance the visitors had traveled from the city's East to West sides.

For Sculpture Chicago, Haha wanted to work again with the residents of a place. After canvassing the city, they found that the rich cultural and social complexity they desired was present in the wide array of immigrant groups in their own backyard. By March 1992 they had proposed a community garden that would occupy a vacant lot behind a series of family-owned businesses along the 7000 block of North Clark Street in Rogers Park. In an effort to transform part of this back alleyway into a vegetable garden, they would have to take on the massive task of cleaning up debris, reorganizing the collection of trash and parking of vehicles, and making space for the homeless who found refuge there.

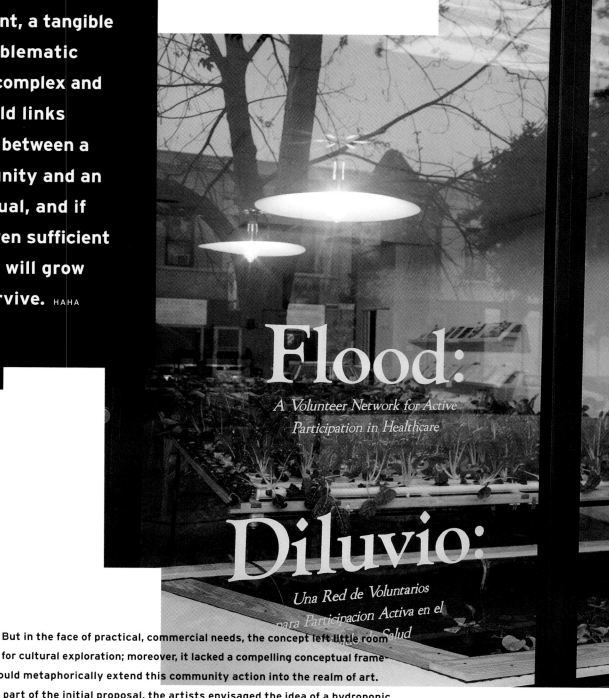

The garden is a covenant, a tangible tie, emblematic of the complex and manifold links of care between a community and an individual, and if it is given sufficient care, it will grow and survive. HAHA

Flood:
A Volunteer Network for Active Participation in Healthcare

Diluvio:
Una Red de Voluntarios para Participacion Activa en el Salud

But in the face of practical, commercial needs, the concept left little room for cultural exploration; moreover, it lacked a compelling conceptual framework that could metaphorically extend this community action into the realm of art. However, as part of the initial proposal, the artists envisaged the idea of a hydroponic garden in a storefront space on adjacent Greenleaf Street that could continue neighborhood gardening into the winter months. This auxiliary location on a street with a prophetic name became the center of their activities; in hydroponics, they hit upon an allied subject that could support their work on the levels of both community and art.

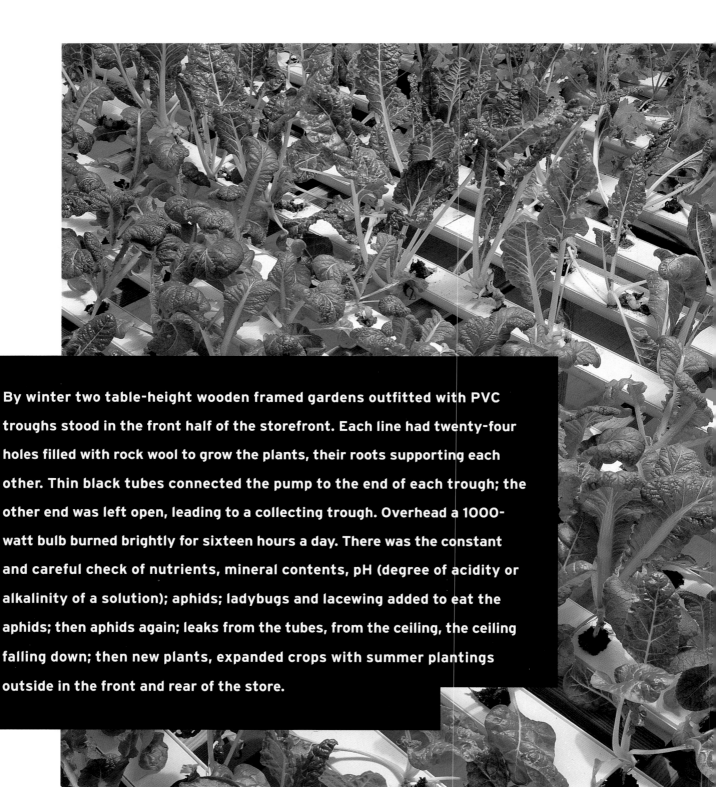

By winter two table-height wooden framed gardens outfitted with PVC troughs stood in the front half of the storefront. Each line had twenty-four holes filled with rock wool to grow the plants, their roots supporting each other. Thin black tubes connected the pump to the end of each trough; the other end was left open, leading to a collecting trough. Overhead a 1000-watt bulb burned brightly for sixteen hours a day. There was the constant and careful check of nutrients, mineral contents, pH (degree of acidity or alkalinity of a solution); aphids; ladybugs and lacewing added to eat the aphids; then aphids again; leaks from the tubes, from the ceiling, the ceiling falling down; then new plants, expanded crops with summer plantings outside in the front and rear of the store.

Hydroponics has long been used as an experimental, alternative means of food production. Since it utilizes a sterile medium (here, rock wool) to support a plant's root system, and is nourished by water and minerals under carefully monitored conditions, bacteria present in soil is not transmitted to the plant. Making the association with AIDS, Haha based their project around the enterprise of growing food for persons with HIV. In this way vegetables can be prepared without extensive washing and peeling, thus preserving the maximum natural nutrients. (On a personal level, Laurie Palmer had encountered this problem firsthand when soup she had made for a friend with HIV was declined because the carrots had not been peeled.) If they were successful, food could be produced year 'round in an expandable and replicable system, and distributed to AIDS hospices and other care facilities.

The garden, too, could serve as a metaphor for the person with AIDS: the survival of plants grown hydroponically is dependent on the maintenance of a fragile ecosystem; their growth and stability requires the horizontal interlacing of individual root systems into a cooperative network. In this way the garden could "be representative of each participant's dynamic within a community."

In addition to the growing area, the other half of the space was devoted to a meeting and education area stocked with brochures from the many related service organizations and articles about AIDS, equally half the focus of activity. Using art in the guise of hydroponics as a vehicle for education and dialogue – about AIDS, about safe sex, about being an AIDS volunteer, about social responsibility and caregiving – provided a nonthreatening way to get people to talk about these issues.

After attending a hydroponic gardening workshop in October 1992, Haha began to set up operations in the Greenleaf storefront. By early the next year, they were fully moved in and beginning work as the Flood collaborative. They met with representatives from AIDS organizations in order to explore ways that Flood members could intersect with the existing HIV/AIDS support network and build a stronger and more multilayered relationship with the larger community. This led eventually to members delivering meals, a buddy system offering direct assistance to people with AIDS (from daily needs to learning to read), cooking weekly for a women's AIDS organization, writing grants, and developing a curriculum for high-school students about the AIDS virus.

By April 1993, they wrote: "Today is a good day in the life of the

garden. We planted the remainder of the hydroponic system

with kale, Swiss chard, and mustard greens. Now, finally, there

is an eight-by-eight foot square lush with vegetation and many

seedlings on their way... it finally feels as if the green portion

of the project is underway."

The project required the involvement of others. That Haha works as a collaborative and is Chicago-based proved essential: they needed to be able to devote time to caring for the garden and making the larger program operations part of their daily lives. The involvement of others encompassed various other acts of sharing: tending the garden; becoming newly enlisted healthcare volunteers; determining the direction of the project and making decisions; and lending support through the exchange of experiences. Haha's own team efforts slipped seamlessly into those of this larger group of volunteers, who by the beginning of 1993 gravitated to the project and took on the identity of "Flood." Simultaneously designating themselves and the project "Flood," as a statement of practical and aesthetic purpose, the garden, the overall operation, and those who cared for it became synonymous.

According to the program designed by the Flood members, they would work in both the garden and the community, offering their time to assist those living with AIDS. They would attend weekly Tuesday meetings to share their experiences and insights; they would work on the garden on Sundays. They would welcome visitors and contribute to making the garden "a public site to stimulate awareness and share information regarding caregiving within the community." Plants and people would become intertwined in supporting each others' activities. This volunteer program could also serve as an experimental connection between interested persons and organizations. It also offered students the chance to become involved in an interdisciplinary and community-based project with the aim to expand the orientation to artmaking which traditional academia provides.

As first outlined, the garden would begin with the Rogers Park location as a pilot site and by spring 1993, during the general public phase of "Culture in Action," it would multiply to fill other locations around the city that would magnify the educational potential of the project while situating the installation in unusual and provocative spaces. At these sites they proposed to employ the element of surprise. Like other Haha projects – from their earliest collaboration, "Open House" (1988), in which interventions reinterpreted the uses of domestic rooms, to "Nana" (1992), a lipstick-covered roving blimp "kissing" the walls of a gallery – the unexpected would play a powerful role. Haha imagined the wonder upon discovering a lush interior garden in an office storeroom, a corporate lobby, spaces newly revealed to the workers as well as public, upper-floor rooms visible from a passing elevated train in the Loop. They also considered using space related to the AIDS epidemic (hospitals, insurance company offices). For all the formal possibilities these venues offered for their art as installation, the most important question remained: "What would the community located there get from seeing the piece?"

For those who are HIV-positive, the garden functioned as a source of safe, healthy food. But these individuals, too, could join Flood, growing their own food and herbs, becoming involved in the therapeutic activity of gardening, and participating in the social dimension of working with and meeting others. Most importantly, they could take part in their own care. As Dr. John Phair, director of the Comprehensive AIDS Center at Northwestern University Medical School, remarked in a meeting with the artists in August 1992, the idea of a hydroponic garden can contribute to the quality of life, even if it does not prolong life.

92
93

But the garden also began as an attempt to empower those of us who feel hopeless in the face of the AIDS crisis, to bring some aspect of the enormity of this circumstance into our personal lives, to make understanding and action possible.... The garden can be a useful metaphor, not for direct medical treatment, but for caretaking of the social body as a personal and shared responsibility. HAHA

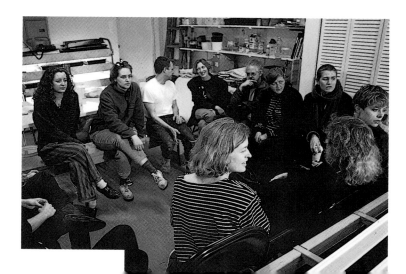

Therefore, while this work could help to generate a greater understanding of the AIDS epidemic, it also offered those under care and caregivers the opportunity for active participation.

Research led Haha to HIV service organizations – BE-HIV, Chicago House hospice, and Open Hand Chicago (a meals-on-wheels program) – which became recipients of produce grown by Flood. The artists also consulted with nutritionists and dieticians at health facilities, botanists involved in the science of hydroponic food production, horticultural therapists using gardening as a treatment, as well as urban gardening groups, practitioners of Western and Chinese medicine, and others providing support and care for the HIV-affected population. In these organizations, Haha observed a relationship between community gardening (which supplies food outside the commercial agriculture system) and AIDS agencies (which attend to immediate human needs before or in lieu of established institutions). Each has developed similar strategies of self-support and organization "to ensure a better quality of life" and a "higher level of determination in the decision-making affecting their lives." In the same spirit, they felt their garden could function as a service to provide free vegetables and herbs, information, and a site for discourse among those groups who service and those who use the garden.

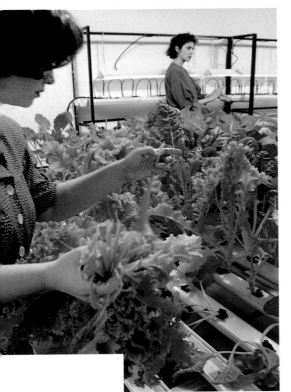

At the heart of the project is caregiving: the tending of a garden, the production and sharing of food, and the sharing of ideas, information, and time with others. HAHA

Flood

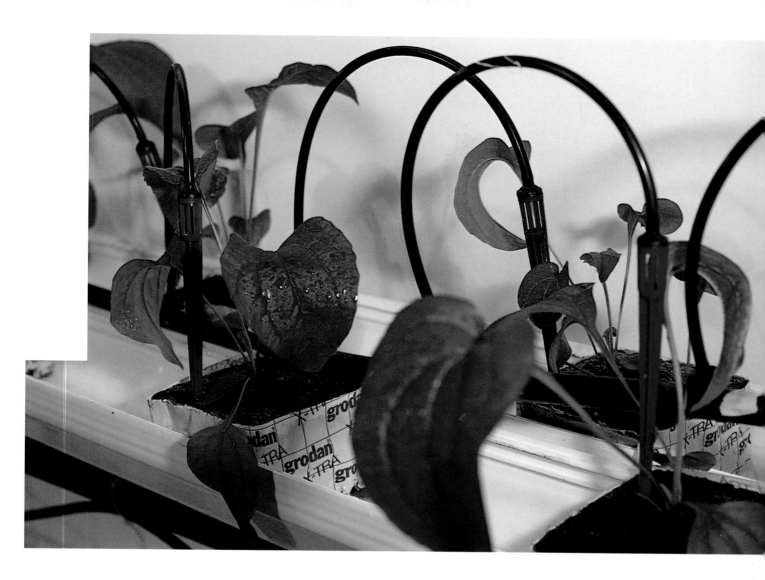

Haha's understanding of art in this project, and in our
collaborative work as a whole, encompasses an idea
of usefulness. The potential usefulness of a garden goes beyond the practical
level of production. A garden is a site for cultivation and growth - it demands
both active caretaking and a surrender to basic and essential growth processes.
(You cannot make something grow - you can only encourage it.) A garden can
also be a place for recreation, for contemplation - a place to meet. In choosing
the hydroponic garden as our focus, we want to activate its practical benefits
as well as its usefulness as metaphor. HAHA

But this activity was not to be confused with a medical remedy. As the group remarked at one of its weekly meetings: "The experience of interacting with the garden is like reading a book: one is not necessarily changed by it, but the condition for change then exists."

The Rogers Park location became a clearinghouse for communications and services among a vast, interconnected complex of agencies and persons. It became both a local and an AIDS community center – one geographically defined, the other defined by need. Paths crossed at the garden: a drug-manufacturer employee and gardener, a nutritionist, art people, a local resident interested in starting a greenhouse to provide jobs for the homeless, people picking up free condoms, the mailman, people bearing gifts (plants, books), people seeking advice, meeting others, getting to know neighbors like never before, local kids to play with the ladybugs, new visitors, return visitors, those to talk about hydroponics or AIDS, teachers, classes, church people, community workers, AIDS workers, people from other organizations who come to see and talk about potential linkages with the garden, an herbalist interested in a plant known to boost the immune system (Echinacea). The log recounts the visitors for a typical day (Saturday, May 29, 1993): a small boy interested in hydroponics, an elderly man interested in hydroponics, a neighbor to talk about HIV, three men admiring the garden, a Spanish-speaking couple and their small daughter to look at the AIDS literature, a tour, a student who had read about the project in *The Reader*, a family from Milwaukee directed here by their Chicago-resident son. The public aspect of Flood continued energetically throughout the summer of 1993 with forums, weekly meetings, open houses, and lectures by a doctor, dietician, and nutritionist. Sculpture Chicago used the hospitable garden as the focal point for its all-day tours of the "Culture in Action" projects. It afforded not only the opportunity to talk about this project, but set the scene for a symposiumlike luncheon in which to consider art as community action. To this, Flood added tours for the youth of the community to learn about AIDS and hydroponics.

The mobility of the garden is critical. Should one of the coworkers become sick, either a growing unit or hydroponic unit could be installed and maintained at home or at a hospice. The garden becomes a reminder that they are part of a vital, existing network, that they have attachments and links with a community outside their home or hospital. HAHA

Flood continues to explore new possibilities, for example, portable units for homes and other sites. They have seen the potential for the project to multiply as new groups, schools, and hospices reinvent the garden for practical reasons, therapy, and education. The concept of multiple venues, at first a source of information dissemination and artistic manipulation, has become most important as a means of accessibility to the activities and nourishment of the garden.

Discussions about the future of the garden continue. Its association with Open Hand Chicago as an outlet for its produce - a link to get these hydroponic vegetables to those in need - has been strengthened. The Rogers Park space is now in its second year of operation. It looks the same: green leafy vegetables fill the hydroponic tables, and people, working and talking, come and go. New and original Flood members remain dedicated to this project for its artfulness and its life contribution. Plans are underway to get funding for gardens at city food pantries serving persons living with AIDS. The neighborhood association has taken interest in this side-street block of stores and there is talk of buying the building in order to turn all the storefronts over to social agencies. Most importantly, AIDS organizations, persons with HIV, and caregivers from the health-care system continue their links with Flood and the garden. The nourishment this place has given can be found in the many personal stories that multiply and grow.

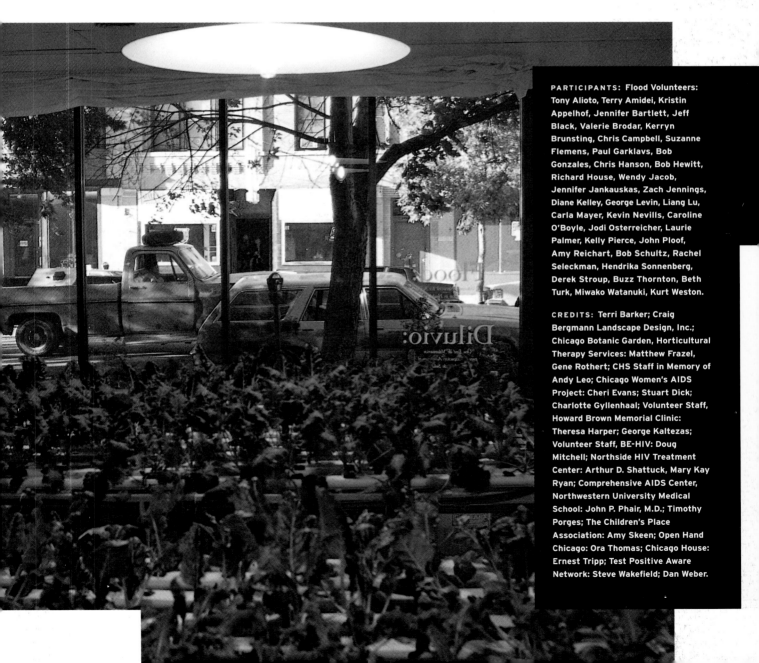

PARTICIPANTS: Flood Volunteers: Tony Alioto, Terry Amidei, Kristin Appelhof, Jennifer Bartlett, Jeff Black, Valerie Brodar, Kerryn Brunsting, Chris Campbell, Suzanne Flemens, Paul Garklavs, Bob Gonzales, Chris Hanson, Bob Hewitt, Richard House, Wendy Jacob, Jennifer Jankauskas, Zach Jennings, Diane Kelley, George Levin, Liang Lu, Carla Mayer, Kevin Nevills, Caroline O'Boyle, Jodi Osterreicher, Laurie Palmer, Kelly Pierce, John Ploof, Amy Reichart, Bob Schultz, Rachel Seleckman, Hendrika Sonnenberg, Derek Stroup, Buzz Thornton, Beth Turk, Miwako Watanuki, Kurt Weston.

CREDITS: Terri Barker; Craig Bergmann Landscape Design, Inc.; Chicago Botanic Garden, Horticultural Therapy Services: Matthew Frazel, Gene Rothert; CHS Staff in Memory of Andy Leo; Chicago Women's AIDS Project: Cheri Evans; Stuart Dick; Charlotte Gyllenhaal; Volunteer Staff, Howard Brown Memorial Clinic: Theresa Harper; George Kaltezas; Volunteer Staff, BE-HIV: Doug Mitchell; Northside HIV Treatment Center: Arthur D. Shattuck, Mary Kay Ryan; Comprehensive AIDS Center, Northwestern University Medical School: John P. Phair, M.D.; Timothy Porges; The Children's Place Association: Amy Skeen; Open Hand Chicago: Ora Thomas; Chicago House: Ernest Tripp; Test Positive Aware Network: Steve Wakefield; Dan Weber.

Naming Others: Manufacturing Yourself

NAMING OTHERS: MANUFACTURING YOURSELF

Robert Peters with Mushroom Pickers, Ghosts, Frogs, and other Others

Robert Peters is a surveyor of culture. Moving away from an emphasis on formal concerns, he began in the early 1970s to use art as a means to engage others in his musings on the construction of our "social realities." The objects and operations of everyday became the basic elements of these ruminations on how we categorize, order, and "name" our world. For "Culture in Action," propelled by the question of "how culture presents itself to itself and to others," he entered into a revelatory conversation with hundreds of Chicagoans whom he did not know and most of whom he never met. Yet in each case, the uniqueness - the differences by which each of us defines ourselves and is defined - was respected and identified.

Difference is a key concept in the breakdown of the mainstream power structure and in understanding the complexity of multicultural identity. Difference, too, rules social relationships. Even in our democratic society, racism, sexism, classicism, and agism are still common.

Two personal experiences shaped the conception of Peters's project. A number of years ago he came across a compilation of names, "Terms of Abuse for Some Chicago Social Groups" by linguist

Lee A. Pederson (*American Dialect Society*, 1964, University of Alabama Press). His reaction to the list was persistent and unsettling, one lodged in the recognition that he knew unspeakable terms for others. This shift into socially unacceptable space made Peters acutely aware of how he

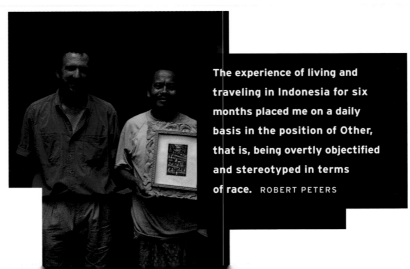

The experience of living and traveling in Indonesia for six months placed me on a daily basis in the position of Other, that is, being overtly objectified and stereotyped in terms of race. ROBERT PETERS

acknowledged and produced difference. It also brought to mind the elaborate naming acts and euphemisms through which we bury difference in politeness. Then in 1992 Peters traveled to Indonesia, a country romantically defined by others and designed to live up to that invented image. His experience as a "self-conscious tourist" also helped to shape this project.

The impetus for this project became the experience of being objectified, the perceived lack or inability to forthrightly examine the structures we use to name and identify difference, and the invention of language that buries all difference in sameness.

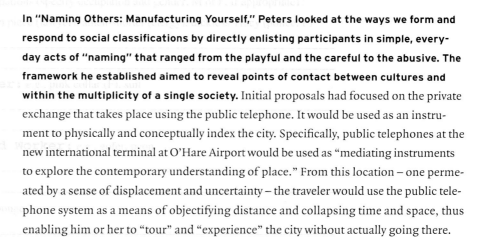

The work looks at the part of social reality that is systematically and inventively excluded from open discussion because it is controversial. ROBERT PETERS

In "Naming Others: Manufacturing Yourself," Peters looked at the ways we form and respond to social classifications by directly enlisting participants in simple, everyday acts of "naming" that ranged from the playful and the careful to the abusive. The framework he established aimed to reveal points of contact between cultures and within the multiplicity of a single society. Initial proposals had focused on the private exchange that takes place using the public telephone. It would be used as an instrument to physically and conceptually index the city. Specifically, public telephones at the new international terminal at O'Hare Airport would be used as "mediating instruments to explore the contemporary understanding of place." From this location – one permeated by a sense of displacement and uncertainty – the traveler would use the public telephone system as a means of objectifying distance and collapsing time and space, thus enabling him or her to "tour" and "experience" the city without actually going there.

In the next phase Peters developed a survey form on which participants recalled terms they possess that classify individuals or groups, then chronicled their subjective experiences of these calculated acts of "name calling" and reflected on the origin and meaning of these terms. In addition to anonymous distribution, this form was used by the artist in interviewing individuals, each of whom had intimate linkages to a particular segment of the Chicago populace, at the Urban Life Center (where nonmetropolitan students are sensitized to issues of diversity through the direct experience of living and working in the city) and at the Resource Center (a gathering place for individuals at the economic margin).

Participation was also available through an 800 number connected to a voice-mail system whose structure paralleled that of the survey form; it could be accessed by dialing 1-800-808-THEM. Callers were asked at each branch point to categorize themselves ("if you are a person of color, press PC; if you are a person of non-color, press NC"). Interspersed were musings on life and the nature of language and a recitation of terms collected in earlier face-to-face discussions. At the end of this self-directed voice-mail tour that mimicked passing through the social structure, participants were invited to "name" themselves and comment on the experience of traversing this conceptual maze.

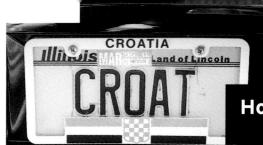

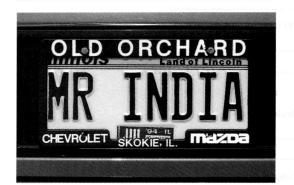

How do you call your neighbor?

"It was not a feeling I liked – I think it is because there was no way to make a distinction from what I've heard and if I've said it." Respondent (male, 45, heterosexual, advertising director, born U.S.A., Estonian heritage, agnostic, Lincoln Park)

"Somewhat embarrassed at knowing so many of these." Respondent (female, 50, heterosexual, retail sales, born U.S.A., WASP, Libertyville)

"I think now when they are used they are stronger than when we used them in our neighborhood. These terms described people you knew and were used in their presence and were not always negative, but identified us as individuals who belonged to groups with different habits and ways." Respondent (male, 52, heterosexual, mason, born Italy, Italian heritage, Catholic, Beverly)

"Do the categories of people that are at the furthest extremes get the most names? There are more terms for black than for brown, red, or yellow. More terms for the old and the young than for the middle-aged." Respondent (female, 37, heterosexual, art administrator, born U.S.A., German heritage, Mennonite, Hyde Park)

"It is refreshing to see them on paper and out of my head in one place. These words I know have always scared me. This list is no longer so scary to me; it's manageable." Respondent (female, 40, heterosexual, professor, born U.S.A., WASP, Back of the Yards)

"Name calling is a political means to control others." Respondent (male, heterosexual, real estate, born U.S.A., WASP, Episcopalian, Lake Bluff)

"I don't like where you're leading me with these questions. They bring out most base prejudices which aren't necessarily a fair view of how I see those people." Respondent (female, 32, heterosexual, administrator, born UK, agnostic, Caucasian, Lakeview)

"All these words are about defining boundaries between categories of people. It seems from the above attention to words that 'describe' me, that I'm not necessarily defining myself only by negation, ('I'm not that'), but also thinking something like, 'Oh, so that's what I am.' Of course, my reaction to some words that apply to me is anger, but a lot of the time I am also curious and interested." Respondent (female, 38, heterosexual, journalist, born France, Afro-Caribbean heritage, Episcopalian, New York)

"Almost all of my responses were derogatory. Though this does not surprise me, I find it quite disturbing that I don't know more neutral or positive terms." Respondent (female, 27, mostly heterosexual, social worker, born U.S.A., Caucasian, Hyde Park)

"Thanks for the opportunity to think about it. Even though it's not always pleasant." Respondent (female, 32, homosexual, art director, born U.S.A., WASP, Ukranian Village)

"I had a really good time doing this. The above kinds of terms give me pleasure. And part of the pleasure is sharing them, thinking/saying 'Oh, I found a really great one. Listen to this.' We agree (you by providing this form, me by filling it out) not to believe that the other is a horrible person for liking this activity.... Are we immoral? Doubt creeps in. This permission we give each other may be the same kind of permission [to participate in name calling] that any group gives to its own members when among themselves. Being funny or 'elegant' does not make the term innocuous. It makes it more effective, possibly more hurtful." Respondent (male, 40, likes girls, tavern owner, born U.S.A., Caucasian, Methodist, Lakeview)

"I feel that there is a strong correlation between 'bad words' and 'politically correct' terminology in that they are both ways of avoiding the subject they mean to represent." Respondent (male, 28, heterosexual, data base manager, born U.S.A., Italian heritage, Catholic, northwest side)

"This makes me uneasy and brings me too close to aspects of society that I do not like. It is good, though. You make me confront things I try to avoid. Thanks?" Respondent (female, 30, heterosexual, artist, born U.S.A., Irish heritage, Catholic, Bucktown)

"In the emergency room we use 'names' for our patients that would offend them if they were to hear them because they objectify them, making them less human. These names are a form of self-protection, a way to distance us from the emotional stress of dealing with people in life and death situations. Our 'naming,' like much 'abusive' naming, allows us to avoid confronting ourselves with our fragility, our ordinariness." Respondent (female, 41, heterosexual, nurse, born U.S.A., WASP, Presbyterian, Hyde Park)

"'Regular guys' (used by several working and middle-class white guys I have met) insist that they are the standard for humanity. They use 'names' more than any other group I know." Respondent (male, 45, heterosexual, high-school teacher, born U.S.A., Hillbilly, Baptist, Cicero)

Several days after this toll-free number began operation, an unanticipated message written by Ameritech officials replaced the artist's original program. It warned listeners of an impending aural assault, advising them to hang up and call a toll number outside the Ameritech system in order to hear the program, additionally admonishing teenagers against listening without parental approval. The artist had been recently told of "internal complaints" over the program's language, and that "upper management" had put the service on hold until they could decide what to do. This turn of events led Peters to a second level of public interaction in this work: the communication between a public utility (the telephone company) and a member of the public (Peters as consumer and critic).

(25) "If persons..."

"If a tree fell in the forest and..."

(26) Prompt

e the correct choice? If you wish to reconsider whether you are one of
or one of Them press *, # (return to *'if you are one of Us...')*"

error

#

(27) SOCIAL

"Are you socially conscious?
If you are Press F. If not Press N"

N
(28A)
GEOGRAPHICAL RESIDENCE

"The reason Americans deem dogs...
Did you grow up in a rural or urban setting?"

(28B)

"Press R for rural
Press U for urban
To skip to the next category press #" (OCCUPATION)

error

R (29)

Terms
"What I mean..."

#

U (30)

"What I mean..."
Terms

(31) OCCUPATION

"If you are employed press JOB
If you are unemployed press BOJ
To skip to the next category press #" (RECAPITULATION)

error

J,O,B (32)

"If you are a boss, press BS
If you are a worker, press WK"

B,O,J (33)

Terms

W,K (35)

"In 1753 when..."
Terms

#

B,S (34)

"Money and information are...."
Terms

(43) RECAPITULATION

"What about words like, optically challenged..."
"To leave your accumulated..., Press M,E"

From this point on, Peters was moved to examine the public telephone as contested public space. He posed the questions: Who controls the dissemination of information through the U.S. tele-communications systems? How does Ameritech determine what is publically acceptable language? How does Ameritech interpret Wittgenstein's dictum "the meaning is the use?" How does Ameritech make the distinction between an artwork about personal and cultural classifications and the "personals" of 800 and 900 numbers?

When Ameritech takes on the role of 800-number gatekeeper, deciding what can and cannot be heard, it has an obligation to the customer and to the public to account for its decisions. *Whom* is Ameritech protecting and from *what* is it protecting them? How would Ameritech respond to a program that contained no controversial language, but contained what some would construe as "unapproved" thought? What would Ameritech do with a program that argues the Holocaust did not occur? On what basis would it accept or reject it? Does not Ameritech provide service for phone sex, for white supremacist organizations, for right-to-life organizations, and for all kinds of potentially controversial ideas and organizations? How did my service differ?

I see the discussions with Ameritech prompted by this engagement as the corporate analogue to an individual's experiences of struggling with the demands of the project, particularly the survey form which is a critical element of individual engagement. At the heart of "Naming Others ..." is this self-conscious appraisal of one's responses (in Ameritech's case, corporate responses) to acts of classification that represent how we as individuals and society construct difference. I cannot think of a more relevant subject for corporate managers to grapple with in preparation for business in markets comprised of increasingly diverse customers. ROBERT PETERS

Peters hoped to engage Ameritech on substantive issues it had raised and then integrate those exchanges into the larger project. He asked Ameritech to indicate on the script what they found offensive, but to no avail. It seemed Ameritech's concern was a reaction to the idea of some language being offensive and, as in all art censorship cases of recent years, not grounded in actual experience or knowledge of the work of art. For over a year the corporation continued to resist stating its objections and philosophical position to the artist. Rather, Ameritech demonstrated that it owned and controlled the lines of public communications. Peters has contributed his extensive, one-sided, unanswered correspondence with Ameritech to Antonio Muntadas's *File Room*, a major archive-installation on world cultural censorship.

"Reach out and touch someone."

ILLINOIS BELL, A SUBSIDIARY OF AMERITECH CORPORATION

"Hello?" ROBERT PETERS

To Ameritech, August 8, 1993:

"It seems strange that a company whose business is communication engages in so little of it."

ROBERT PETERS

I interpret community to be any individual, group, or institution that interacts in any way with this project. Thus, the story of Ameritech's and my interaction is not a matter of public relations in which one tries to contain the discourse, but rather a matter of establishing a set of relations between parties that allow those interactions to be revealed and examined. I want to focus my attention on the processes that have been triggered by the work: they are the most important aspect of this artwork. I do not see institutional interactions as annoying impediments, but rather as integral to the process of bringing to consciousness the place which acts of categorization have in our lives. ROBERT PETERS

Art will only move closer to life when it becomes a vehicle for all of us to examine our lives. ROBERT PETERS

The dialogue about cultures – cultural definitions of ourselves and others – that had been initiated with "Naming Others . . ." was extended to another major aspect of this project undertaken in collaboration with Randolph Street Gallery and with the support of the Chicago Cultural Center. Entitled "Meeting Grounds," it was a symposium that looked at cultural objectification.

Peters based "Meeting Grounds" on the following observation:

In today's shrinking world, we are witness to an acceleration of unlikely and often unwanted cultural contacts. In this time of rapid developments in communications and transportation, every gesture, landscape, cultural practice, and artifact becomes visible and thus available for potential absorption, annihilation, exploitation, or explanation. As Robert Heilbroner stated in "The Triumph of Capitalism" (*The New Yorker*, January 28, 1989), in this world the Sony Walkman has transformed taking a stroll into a profit-providing activity and the unknown is tamed by transforming it into recognizable wholes and media fictions, as in ". . . graded levels of adventure from easy guided walks to Outward Bound style hikes that make you feel like the real Indiana Jones" advertised by an Ecuadorian Amazon hotel (*Chicago Tribune*, June 18, 1989). How do representations in this world, increasingly articulated in economic and material terms, take shape? How do these media fictions and fanciful idealizations intersect with local interests and realities? How and where are these representations contested and negotiated? What or who determines which parts of a cultural landscape to market and which parts to ignore, to hide?

To gain insight into these questions and their corollaries, Peters assembled individuals whose work (as artists, anthropologists, sociologists, historians, traders, and so on) and cultural heritage situate them at points of contact between cultures or between distinct traditions within a culture. They are both cultural mediators and observers. This cross-cultural and cross-disciplinary encounter was composed of presentations and open discussions. By offering diverse perspectives on the critical question of how cultural practices intersect, this two-day event maintained a nonlinear, nonideological exchange that allowed for direct and active dialogue, while making tangible, as participating anthropologist Sharon Stephens suggested, "the moral ambiguity and political complexity of all cultural objectifications."

Johannes Birringer chronicled the provocative day in *P-Form Magazine* ("Standing with the Natives," 32 [Summer 1994]), noting, for example: A presentation on the agents of cultural process/change was given by Sharon Stephens in her very concrete and detailed description of the Sami struggle for recognition of the various ways in which their business, their survival, their actual lives, and cultural existence had been threatened by the radiation fallout after Chernobyl . . . how such an ecological crisis led to diverse Sami strategies of ethnic/cultural self-dramatizations (of their identity as an indigenous community) vis-a-vis majority culture.

One of the unsettling paradoxes of the political struggle remains the issue of identity, since the essentializing and exclusionary dimensions of claiming a particular identity (or centricity) tend to reproduce technologies and ideologies that repress others or that misrecognize that others are part of this identity (this involves, of course, the complex historical issue of shared colonial space).

The issue of identity construction was taken up again, in a dialectical echo, by Lisa Brock later that day, when she spoke eloquently about the historical invention of race as a category, and about modern race consciousness.

Others who presented their perspectives included: artist David Avalos; artist James Luna; trader James Ostler and artist/trader Milford Nahohai of the Zuni Pueblo; Iranian sociologist Amhad Sadri; and anthropologist Terrance Turner and videographer Kinhiabieiti of the Kayapo Video Project.

Departing from the identification with a particular constituency as collaborator to the literal identification of all constituencies, Robert Peters's work serves as a curious and articulate connecting point between the "Culture in Action" projects, while it reshapes one's conception and sense of the cartography of Chicago. As in the other projects, global and age-old issues were reexamined from a personal, intimate, and localized point of view – out of memory, recollection, and experience. For Peters, this private space was rich territory for the exploration of "the public" in public art.

PARTICIPANTS: Urban Life Center; Resource Center.

CREDITS: Business Volunteers for the Arts, Connie Esler. Jerzy Kucinski. Interview Assistants: Gary Cannone, Dan Peterman, Karen Reimer, Hamza Walker, Mary Young. Tape Voices: George Kase, Robyn Kase, Sarah Peters, Randy Alexander. Randolph Street Gallery: Peter Taub, Director; Paul Brenner, Exhibitions Director. Co-sponsored by Randolph Street Gallery.

THE CHICAGO URBAN ECOLOGY ACTION GROUP

Mark Dion and The Chicago Urban Ecology Action Group

By merging his skills as an artist – a specialist in representation – with those of the scientist, Mark Dion posits that art can function as a productive partner in environmental undertakings. He believes that images can be created that affirm our connection to the environment rather than our domination over it. To do so, he brings to the general discourse of science and conservation, techniques of art that have been untapped for this purpose: irony, humor, metaphor. He seeks to contribute to the ecological movement by raising issues of representation and exposing what images of nature tell us about institutions, societies, and cultures, as well as about the animals or landscapes depicted.

A New York-based artist, Dion considers his art to be an integrated practice – whether it take the form of an object, a museum installation, a book, an ongoing activity in a gallery, a group interaction outside an art setting, or conservation field work. In addition, he looks to the dominant modes of presentation in natural history museums as part of his rethinking of didactic display. Like other contemporary artists, such as Fred Wilson, Dion is interested in manipulating and rearticulating the conventions of museum exhibitions. But because he believes art can have a productive social function outside the hermetic confines of the museum, Dion, like other ecologically directed artists today (like Mel Chin, Helen and Newton Harrison, Mierle Ukeles, among many others), joins forces with those outside the art world, both to bring his art to a larger audience and to find a place where art can be used as an agent of social change.

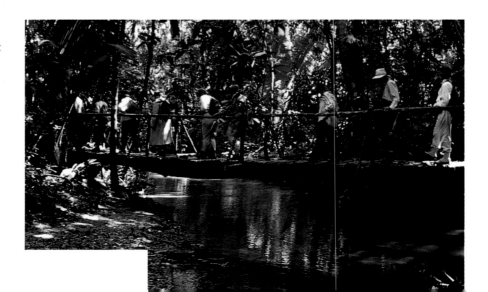

> A unique partnership could express a common commitment to environmental issues through an exchange of materials, ideas, and experience.
>
> MARK DION

Calendar (handwritten):

Monday	Tuesday	Wednesday	Thursday	Friday	SATURDAY
28 DARWIN WEEK	29	30 First EXecutive Comarte Meeting	July 1 Micheline Brown 10:30	2 12:00 Mitchel KANE	3
5 Classification week	6 phone 1030 Interview Juan Suarez	7 3:30 Skyline Ted Allah 10:J.Vinci	8 North Path Village Nature center ZOO	7 Bus Tour Scala Nature Due	10 BIRDHOUS +FLOOD
12 Ecology week	13	14	15 Jack Daven Sierra club 11:00	16 Bus tour North Park Village Natura Center	17 North Br Prairie Pr Bus tour
19	20	21 Site tour Academy of Science	22 Acad. of Science Tour 9:45	23 Bus tour Rachel Abarca Greenpeace 11:00	24 North Bran Prairie Pro
26 Animal WEEK	27	28	29 2 NEWS	30 2:00 HERB SCHROEDER USDA FOREST SERVICE	31 BUS Tour
2	3 Alexand Wilson Reading	4 Niel Peck North Branch Prairie Project 12:00	5 Mike Paha 6:00	6 Greenpeace 11:00 Daniel Goldfarb 1:00 Pm	Praire Restoratio
8 Miss. Archaedoay center 5:00	9	10	11 openlands Project 2:00 Suzane	12 11:00 Phil Berkman The Bear	13 Bird houses BUS TOUR
15	16 Hirsch FARM WISCONSIN		19 Project proposals Due	20 BUS Tour NANCY CRABAPPLES	14 BUS TOUR Lagoon clean Up 10:3
22	23	24	25	26 Paul towell	27 Open House Cook Out 5:00-7:00

Mark Dion moves assertively into the realm of public art while redefining that realm. At the first meeting about "Culture in Action," conversation centered around questions of how an artist can work with the public, involve others in an essential way, establish real exchange and cooperation, and use art as an educational and community tool. He developed a three-part project that would address these concerns: a high-school rainforest study program; an expedition with these students to Belize; and their re-formation as an urban ecology action group, redirecting their efforts to making a difference at home in Chicago.

While the task as mapped out in December 1991 would require considerable work by all those involved, the artist trusted that "the result of our effort would do a great deal to widen the discourse on art in the 'public realm' ... to strengthen the discussion around the ideas of the use of a monument." The comprehensiveness of this project – the first to be defined by an artist participating in "Culture in Action" – helped to define the characteristics of the program:

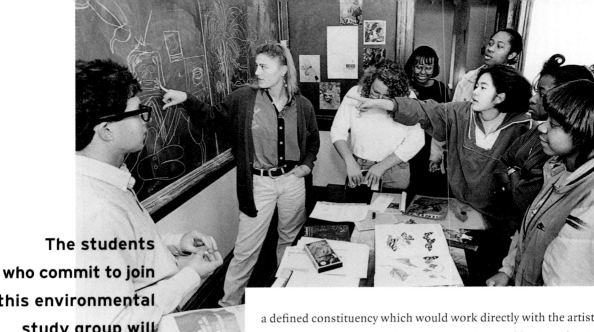

> **The students who commit to join this environmental study group will be encouraged to become personally involved in a global concern – that of wildlife conservation.**
>
> MARK DION

a defined constituency which would work directly with the artist; a collaboratively executed project; a commitment to working together over an extended time; the incorporation of the process of exchange and programming aspects as intrinsic parts of the work of art; and a consideration of the public or audience for art. Key among these emerging concepts was the fact that the primary or initial audience – the collaborators – were relatively small in number. Rather than a program that claimed matter-of-factly to be public because it was advertised in an agency's mailings, yet ultimately attended by a small, predictable constituency, these projects tried to bring in new audiences and build a fundamental relationship with them, exchanging the number of hours involved for number of people through the gate. In Dion's case, the selection of students was restricted to fifteen. He hoped that his investment in them would pay off as they assumed a leadership position during the summer, public phase or in their future life, thus extending the number of people served by the project and augmenting its publicness in a ripple effect.

As the artist described it, this art project in the form of a student program aimed to give these high-school juniors a chance to know other options at a crucial time in their lives, to give them a chance to consider a career in art or conservation, and provide an edge as well as direction for their college applications. But it was also an opportunity to explore together the often unacknowledged relationship of art and science which Dion uniquely felt was a fundamental, "natural," and useful alliance. In October 1992, The Chicago Tropical Ecology Group, as they were initially called, began meeting.

As someone who has worked with many international conservation organizations, I have witnessed this need for creative visual input, as I have also experienced the productive value science can inspire in artistic endeavors. My first trip to the Cockscomb Basin in Belize several years ago had a tremendous influence on the direction and sensibility of my artwork. With firsthand knowledge of the rainforest, the students could traverse the vast physical and mental distances that separated them from the rainforest: they might discover the ways they could personally aid in this world crisis of overwhelming proportions and learn as well about concerns close to home that likewise affect the ecological balance. MARK DION

On December 28, 1992, the students and artist departed for Belize on a ten-day trip. Dion chose this small Central American country as the site of their field work because it is a peaceful, independent, liberal democracy with low population density and large, unspoiled wilderness areas. Reverence for nature, reinforced by governmental policy, is shared by the resident Indian groups, Caribbean Blacks, Chinese, and others. While Belize possesses no museum or university, it has a world-renowned zoo and wildlife sanctuaries that are models for Latin American conservation efforts. Dion had visited the country several times, and in 1989-90 had worked on a public art and education project with the Belize Zoo and Tropical Education Center. Founded by Sharon Matola, an American biologist, the zoo is a source of national pride. As a primary site for visitors, it has become influential in the development of other ecology-minded tourist attractions. Dion proposed to create for the zoo a system of didactic signage; up until that time, visitors had been greeted personally and escorted around, but its growing popularity was making this impossible. In his graphics, Dion opposed a factual zoological text (typeset) with a conservation-minded statement (hand-printed to evoke the hands-on, personal stewardship that was the zoo's origin). He also juxtaposed Mayan and British colonial renderings of the species under discussion.

Forming a relationship with Ernesto Saqui, a Mayan leader and director of the Cockscomb Basin Wildlife Sanctuary, the first jaguar preserve in the world, Dion sought again to make a tangible contribution to Belize's conservation program. The artist became interested in the visitors' reception and educational center, which since construction had remained empty. In an effort to make the facility operational, Dion spent the summer of 1992 in Belize working on displays; returning to Chicago to begin leading The Chicago Tropical Ecology Study Group, he vowed to return at the end of the year with the students to complete and inaugurate the center. In the end, the students brought and installed there a watershed model that they had constructed in part during the fall in Chicago.

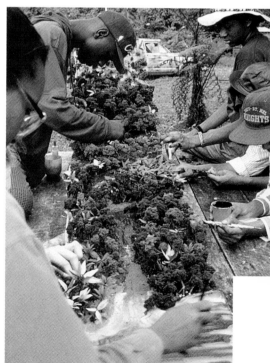

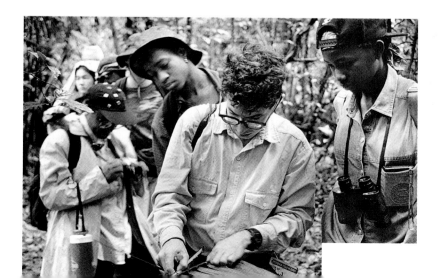

The students came from two Chicago schools – one private, one public. The former, Providence-St. Mel, was founded in 1978 by a visionary principal, Paul J. Adams II, after the Catholic archdiocese closed the facility. Since that time the school has been dedicated to breaking "a desperate generational cycle of poverty and welfare through education." The school is located west of the Loop in Garfield Park, an African-American area with sixty percent unemployment and one of the highest crime rates in the city. The all-black student body comes from within the surrounding three-mile area. Most attend on scholarship; 100 percent enter college upon graduation. Lincoln Park High School (LPHS), located in a fashionable, gentrified neighborhood, is a magnet school within the Chicago Public School system that draws its diverse student population from around the city. The fifteen participating students, preselected by teachers, met at Providence-St. Mel school each Saturday from October 1992 to June 1993 to work with Dion. While the composition of the group lacked balance (the number of girls far outweighed boys) and few had art training – a situation endemic to the American school system – Dion was deeply committed to the program, despite knowing that his efforts might not bear fruit quickly, perhaps not at all during his tenure in Chicago.

Upon their return to Chicago, the students, changed by the experience and knowledge they had acquired, renamed themselves The Chicago Urban Ecology Action Group, and rededicated themselves to the investigation of parallel issues between tropical ecosystems and their own environment. Dion aimed to present a variety of perspectives on ecological problems with conservationists and activists on the ecology and community fronts contributing their points of view.

Students were exposed to the workings of groups such as the Chicago Rainforest Action Group, Sierra Club, Greenpeace, Green Chicago, Nature Conservancy and North Branch Prairie Project, Turn-a-Lot-Around, U.S. Dept. of Forestry, Great Lakes Protection Fund, and others. Dion saw to it, too, that they became familiar with other artists whose work is concerned with ecology through contact with Phil Berkman, Phil Kalinowski, Mitchell Kane, Mike Paha, Dan Peterman, Christian Philip Müller, Alexis Rockman, and Vincent Shine.

The culmination of their activities was an experimental field station that would be a site for their continued studies with frequent guest speakers, and for their experiments and other activities. The field station would also be a base of operations as the students went out weekly to offer practical assistance in community restoration and clean-up projects. For the public, this space would serve as an art installation, a workshop, and an ecology information center in operation all summer long.

Ecology is important because it not only involves the study of plants, animals, and biology, but it also involves human beings and their interaction with nature. So, because ecology involves people, people should be involved with ecology. Artists may not necessarily be interested in preserving the earth, but I know that some of the great artists' inspiration comes from nature. You can look at the works of Georgia O'Keeffe, or Matisse, or Renoir and you can see the influence of nature…for an artist, Earth Day should be everyday. As an ecologist, you may not necessarily be interested in art, but, whether or not you believe in God or a divine creator, when you look at nature, you can see some form of art. Nature is beautiful and I noticed when I was in Belize that I felt the same aesthetic experience that I feel looking at art. I feel deeply influenced by this whole experience…and I feel that we should go on and work to preserve art and ecology because they are the most important aspects of human civilization. NAOMI BECKWITH, JUNIOR, LPHS

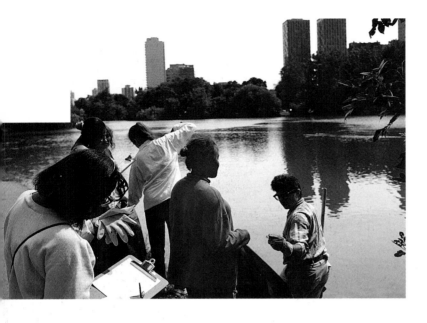

The search for a suitable facility proved to be difficult and long. Zoos and museums seemed resistant to collaboration and hemmed in by schedules and other priorities, even though contacts began with the initiation of the project in January 1992; other locations seemed isolated and remote. Finally, in April 1993, just one month before the public opening, a site was found in heavily trafficked Lincoln Park, just a short distance from the Chicago Academy of Sciences and Lincoln Park Zoo; both institutions had been of great interest to the artist and could be resources – for the students and for interested members of the public. With the intervention of Al Neiman, the executive assistant to the general superintendent of the Chicago Park District, this site was secured for an "eco drop-in center and clubhouse," as the artist called it. During its earlier use as a casting club, entrance to this publicly funded facility was restricted to a select group of men; the hope was that the ecology group, while also small, would nonetheless advance the public nature of this space through their activities on site and around the city. As for the building itself, although abandoned more than a decade ago, it retained vestiges of its former operations that could be of continued use: worktables, lockers, and tools. A lagoon just outside offered additional opportunities for the study of the natural habitat and present-day pollution. Recycling the building – if only temporarily – became a demonstration of urban conservation.

This project merged the modes of art and education into one genre - using art as education, education as art - to frame nature in an art context and to frame art in relation to the natural world. It initiated in the students a way of thinking about nature.

With this project students were asked to consider what art can do to make a difference in the world. Interested in the potential relevance of art to science and ecology, they approached this question without skepticism. As for many of the collaborators working with the artists in "Culture in Action," the public manifestation that they helped to develop did not become a cause for dispute around the definition of whether it was art (as it did for many from the art world), but was a form that gave new meaning to art and nature.

Like the students working with Iñigo Manglano-Ovalle, they were brought to a new way of thinking by decoding the images around them – in their case, those of nature; in the case of Street-Level Video, the media's representation of youth. And as for the students in Manglano-Ovalle's project, making the global local was a productive and empowering route. Through their Lincoln Park field station and through their weekly projects undertaken in other neighborhoods, their inquiry and ideas reached a wider public. Beyond the scope of this project, the students will continue to reach others over time.

PARTICIPANTS: The Chicago Urban Ecology Action Group: Students: Naomi Beckwith, Sharmaine Hendrix, Nynier Hodge, Tresnita Ivy, Catherine Mach, Dionne Emiko Mason, Charmaine Morgan, Muneerah Muhammad, Claudia Travis, Karlyn Westover, Jerry Winners, Kazumi Yoshinaga; Art Teacher: Lisa Langken, Providence-St. Mel High School; Principal: Paul Adams, Providence-St. Mel High School; Director: Cheryl McWorter, Lincoln Park High School Dance Program.

CREDITS: American Airlines; Phil Berkman; Chicago Park District; City of Chicago Department of the Environment; Frannie and Tom Dittmer; Phil Kalinowski; Kim Sherman, Refco, Inc.; Uncle Dan's Ltd.

WE GOT IT!
The workforce makes the candy of their dreams

Simon Grennan and Christopher Sperandio and The Bakery, Confectionery and
Tobacco Workers' International Union of America Local No. 552

Since 1988, when Simon Grennan and Christopher Sperandio were both graduate
students at the University of Illinois at Chicago, they have organized over a dozen
public artworks that engage nonart audiences in communal art-making. Grennan
and Sperandio incorporate into their work humor and accessibility as keys to
establishing public involvement and ownership in public art. Their works are the
occasion for meaningful exchange - not limited to the cultural - among individuals
who would not otherwise have come together. Among their many public interactive
works since 1990, "Confectioneries at Civic Sites" (1991), done in collaboration
with a pastry chef, used food as a medium to create additions to turn-of-the-centu-
ry sculptures in Chicago parks in order to question the nature and function of
such public monuments in daily life. Later that year the artists undertook a similar
event in Manchester, England called "Sugar Additions at Civic Sites." These two
series also celebrated the art of the tradesman - here the confectioner - and began
to extend their working method to include others whose job skills they employed
and brought to the attention of the world of fine art.

When first contacted by Sculpture Chicago in April
1991, the artists wanted again to take up the theme
of the worker and his trade. They were motivated by the desire to consider the person behind
manufacturing, an anonymous mode of production dominated by the image of the task-oriented
machine and the corporate logo. They talked about how products in stores never tell of the people
who actually make them. They wanted to foreground the lineworker and enable him or her to
reverse positions with management, if only momentarily in the sacred space of art. To accom-
plish this, the artists proposed setting up a situation in which a group of workers with equal
voting power would research and determine the character and design of a new, limited line of
chocolate bar, and its promotion within the existing corporate structure. Grennan and Sperandio
would serve as art directors to carry out the plans of the creative team. This inversion of roles, in
humorous guise, was offered as a means of bringing about cross-communication in the corpo-
rate hierarchy. The worker might experience a greater sense of ownership and understanding of
the overall operation; the corporation might improve relations with staff and the community.

The first proposal called for a cooperative agreement with the Fannie
May company. As students in Chicago, Grennan and Sperandio
had frequented this pervasive local candy store chain whose thirty-five homey, friend-
ly neighborhood shops traverse the social boundaries of the city. The artists hoped
to have the workers' candy sold throughout the company's venues, along with
an in-store display and reconceived factory tours open to the public. But departing
from the marketing norm and without guaranteed sales, the proposal died at
corporate headquarters.

**Chicago is called the "candy capital of the world," and with Brach, Leaf, M & M
Mars, F & F Laboratories, and others, numerous coproducers were pursued.
The artists even considered changing strategy, joining forces with a social
agency and working within the convention of a charity promotion rather than
having their candy bar take the guise of an alternative commercial product,
albeit not for profit, aimed to reach a wider public with the message.**

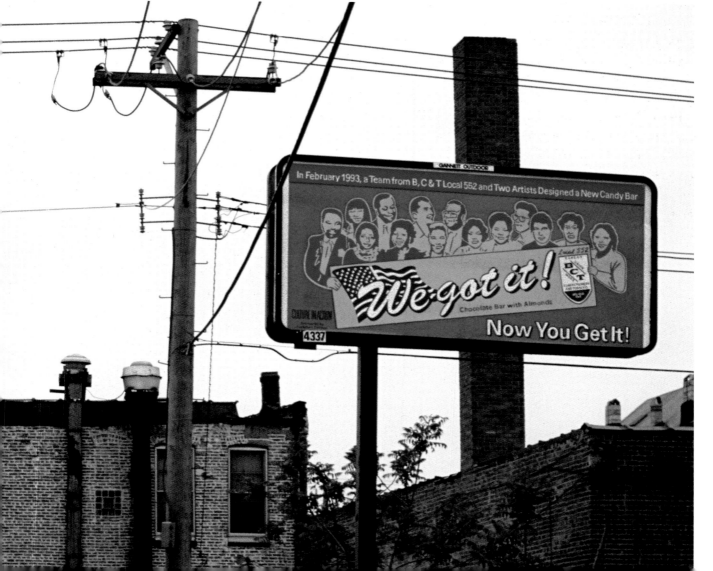

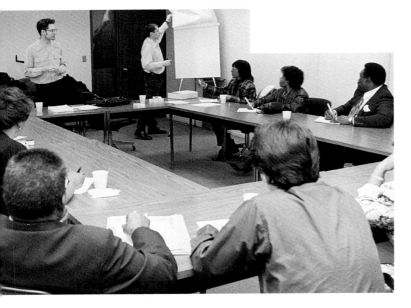

Herein lay an insurmountable gap between commerce and art: manufacturers and distributors whose motive was profit and whose values were not served by the resulting prolabor statement could not subscribe to a product that went against their usual aims of production. They also could not conceive of their factories or outlets becoming an alternative to the museum as a site of cultural meaning and a setting for public art.

While attempts to engage corporations during 1992 came to naught, what did emerge was an understanding that the operative element in this social action artwork was labor and not management. With the emphasis on the worker strengthened, the project's concept was reinforced as a vehicle for creative self-examination and a declaration by a small constituency of Chicago's workforce made to a larger body – to other workers and to other audiences – with the intention of provoking a reconsideration of issues affecting the working class in America today. The chocolate bar could become a means of communication for workers by shifting the product's meaning, if not its substance, from what they make everyday. At the same time, unlike traditional bronze statues, its form and material were accessible and articulate as a new urban monument to labor in Chicago. This product was not intended to criticize the workplace, but to celebrate the worker.

It aims to provide for the elevation of the voice of a particular constituency within the actual fabric of the city in a realm usually reserved only for commercial products. GRENNAN AND SPERANDIO

At this point the artists, both of whom came from labor backgrounds, began to contact unions to see if an alliance could be forged. By chance, in July 1992, inquiries led them to Jethro Head, the President of the Bakery, Confectionery and Tobacco Worker's Union Local 552. Its nearly 1,000 members were employed at the Franklin Park manufacturing plant of the Nestlé Corporation where Butterfinger and Baby Ruth bars are made. Head immediately recognized the ironic, but valuable, connection between the artists' project and Nestlé's new "Total Quality Management Program" which had been presented as a means of increasing worker participation in decision-making, but which Head felt was an effort to inhibit the union's presence at the plant.

Having received your proposal on involving our local in an artwork that would celebrate working people in manufacturing, let me assure you that we are extremely interested. Your proposal is unique, timely, and, most importantly, practical. JETHRO HEAD

Head's view of this art project as a way to test the true intentions of management through a parallel, metaphorical, benign forum matched Grennan and Sperandio's expectations for their work to serve as "a metaphor for larger concerns." Working hand-in-hand with the artists throughout the process, Head became a key collaborator in shaping this process of exchange.

In September 1992 the artists, Sculpture Chicago, and Jethro Head met with the plant manager, Charles E. Brashears, at the 600,000-square-foot facility which grosses $100 million in sales annually. Retooling the machinery for a different product and small run seemed impossible; repackaging existing candy would misrepresent those products and the corporate identity; jobbing the run out to an affiliated plant for special promotional items could not be arranged; funds or raw materials for production of the art-bar at another plant were not forthcoming; and support for the project could not be secured from the corporate headquarters. Each request to the company and each reply was a test in Jethro Head's estimation of just how far Nestlé would or would not go in a project honoring its workers. Finally, the company did not see any benefit for Nestlé.

It is the "social structure" that will remain after the completion of the candy and is the crucial aspect of the project. GRENNAN AND SPERANDIO

With Jethro Head, the artists developed a strategy of enlisting twelve workers, selected by Head, to design the product and promotions during a week-long, forty-hour workshop. The artists would act as facilitators. They would coordinate the workshops and develop a broad range of topics for discussion about the relation of one's work life to home life, the individual to the corporation, and the consumer to marketing strategies.

In fall 1992 the plant manager agreed to release the workers on what he called "art leave," even though the project lacked corporate sanction, in order for them to attend design meetings at the plant. But by January 1993 the manager became concerned about discussions of "empowerment" and, sensing potential problems within the Nestlé hierarchy, he asked that no credit be given to Nestlé. On the other hand, seeking not to deny the worker-participants a positive experience, he requested an additional concession from the union and the artists – that the meetings take place away from the plant. For a week during the following month, twelve Nestlé workers and Grennan and Sperandio adopted new roles. They were elevated to corporate offices with a lake view in the Loop, made available by Sculpture Chicago board members and far from the suburban location of their everyday jobs. They began by acquiring an array of junk food products, then engaged in a detailed, deconstructivist analysis of the meaning of advertising. Discussions ranged from work experiences at the plant, general attitudes toward candy, thoughts about enjoyment, ideas of luxury and purchasing, to how could work be different and how do products communicate to the people who buy them.

At no point throughout the development of the bar with the union was there a specific discussion of the "We got it!" bars' relationship to other artworks. We did not discuss art as a thing apart from the rest of the world or ask the redundant question, "Is it art?" The questions the members of the design team asked each other ran along the lines of, "How do we want this artwork to represent us?" and "How is this artwork different from other products on the store shelves?" One answer was that the public celebration of the union was of vital importance and so celebration of the union directly on the product that they produce seemed logical and fun. From all perspectives, the "We got it!" bar seamlessly joined the cultural landscape.

GRENNAN AND SPERANDIO

Decisions on the design of the two-ounce chocolate with two-color printed paper wrapper and four-color display carton, and billboard and newspaper advertisements were made by the committee of employees within the restrictions of budget, keeping in mind that there would be no plant participation.

> **We will put our abilities and knowledge as the disposal of people who want and need our ideas and resources.... It is our goal to help the lineworker to have a better voice within the company.**
>
> GRENNAN AND SPERANDIO

To make evident their union affiliation, they added their logo; to express their patriotism, they placed the American flag proudly in the left corner of the label; to be present as themselves and as spokespeople for others, they put their names on the wrapper and their faces, along with those of the artists, on the box and billboard. Much attention was given to colors in relation to personal taste, visibility, and attracting attention; acid yellow, lime green, red, and purple all figured in. And because they felt the significance of this public art work and shared a sense of pride and power, "We got it!" seemed a fitting name. "Now You Get It!" was a call to all purchasers of the bar and the potential audience for this product and for "Culture in Action."

The quest for a suitable and feasible manufacturer continued. Union headquarters was unable to help; numerous conversations with the international organization produced nothing. Finally the artists and Head proposed that two union locals collaborate, with the design taking place in Chicago, and the manufacturing in another city. Boyer Brothers Chocolate Company of Altoona, Pennsylvania, whose employees are members of BC & T Local 12, agreed to participate.

A major lingering issue was distribution, since without Nestlé's participation, independent manufacturers with no direct outlet had to be employed. Cityfront Marketplace, an upscale, Near North venue, agreed not only to sell the bar, but to create for a time a prominent display – a towering, cascading column of the festive yellow boxes. Thirty Eastern Lobby Shops around the Loop were also brought on as distribution sites. But the unapproachability of major chains (whose administrative structure is remote from its local, neighborhood venues) and the inaccessibility of independent vendors, restricted sales to these central, lakefront sites. An important aspect of the distribution, however, that addressed the core constituency and main subject of the project, was an on-site event staged by Head at the plant. At first denied access and then using union-style coercion, Head handed to each member of Local 552 – each shift in a twenty-four-hour period – a union bag with a candy bar and information sheet about the aims of the project, the role of the union, and the desire for greater employee empowerment. Thus, in reflecting the goals of BC & T 552, "We got it!" functioned in the real-life sense, on the in-house level of the ongoing power struggle between union and management.

The new product articulates their pride, and in fact tells the viewer to catch up. They are in charge of their lives and they have graciously allowed us to share in this.

GRENNAN AND SPERANDIO

Although the quantity and number of distribution sites for the product had been drastically reduced, emphasis was placed on the packaging and the message rather than the product. Forty billboards were secured from Gannett Outdoor Group, predominantly on the South and West sides of Chicago, neighborhoods selected by the artists for their largely working-class constituencies. The billboards, originally secured as public service advertising on a space-available basis, were, by the time of posting in April 1993, rejected because their wording seemed to imply a commercial venture. The copy was changed from "In February 1993, a Team from B,C & T Local 552 and Two Artists Designed a New Candy Bar" to add a second line that read: "We got it! is part of Culture in Action, a program of Sculpture Chicago." Yet it proved impossible to convince Gannett of the commemorative nature of the project and that it was a charitable, not-for-profit enterprise with nominal revenues which, like most art projects, would not approach the real costs. Instead Sculpture Chicago ultimately paid to rent the billboards which, with diminished product distribution, remained a major vehicle for reaching a larger public with the union's message.

We Got It!

PARTICIPANTS: B, C & T Local 552: Dorothy Barksdale, Richard Bowens, Leroy Brown, Barbara Fleming, Artemio Gil, Martina Herrara, Louis Mason, Minnie Mitchell, Willie Rias, Mary Ross, Thelma Smith, Regina Williamson. President, B, C & T Local 552, Jethro Head.

CREDITS: Ross Jr., Gwen, Donna, Beverly and Ross III; Roshawna Mckay; Nicky, Carolyn, Flora, Leroy Jr.; Patricia and Katricia; Everett and Lawton; Pablo, Pablo Jr. and Ricky; Maria, Artemio, Silvia and Esmerelda; Willie M. Duckworth, Latrell and Darian, Joseph Robinson II, Joseph Robinson III, Joseph Robinson IV, Frannie Green and Family, Flossie Falls and Family; Lee Edward, Tracey, Danita, Rodney; The Mason Family; Roxie Gilden, Trina Perry, Tonja and Terry L.; James Stiff, James Stiff Jr., Percy Stiff, Edward Stitts and Family, Willie Stitts and Family, Michael Stitts and Family, Millvenia Stiff and Family and the Barksdale Family; Tina Miletich; Opal Sperandio; Mark Sperandio; Debbie Elliot; Katherine Miletich; Robert Miletich; Mildred Miletich; Herb Potzus; Gary Philo; George Barbero; Paul Krainak; Carmon Colangelo; Sergio Soave; Dennis Kowalski; Andrea Rosen; Colin De Land; Tom Sokolowski; Nancy Princenthal; Pat Grennan; Penny Grennan; Dennis Grennan; Elaine Walker; Jon Woods; Nicholas Kirkham; David Simpson; Andrew Cross; Penny Johnson; The Market Place Foodstore at Cityfront Place, Peter Stellas, Manager.

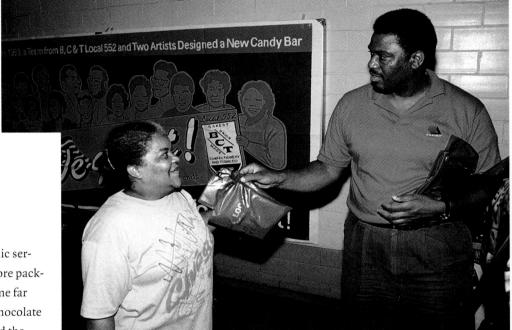

As a kind of chocolate public service announcement, the store packaging and billboards became far more important than the chocolate they advertised; they carried the message and directly achieved the goal, as the artists stated it, of placing "information about labor directly on a manufactured product, thereby making the product 'about' labor..." instead of the corporation.

As artists we ask for the scrutiny of the food that people eat, not in its nutritional value, but what the product says – who processed the flour in the bread you ate this morning? *This is the point of our work*....Our artwork is the *cultural action* of elevating the voice of an *underheard* group of people. GRENNAN AND SPERANDIO

The following historic and contemporary government-assisted housing developmen

Alabama Metropolitan Gardens, Birmingham; *Alaska* Mountain View Senior Cen

Apartment Building, Tucson; *Arkansas* Silver City Courts, North Little Rock; *Califo*

fami'v Boulder; *Connecticut* Elm Haven, New Haven; *Delaware* Liberty Court,

Geor FF Techwood Homes, Atlanta; *Hawaii* Kawailehua, Koloa, Kauai;

Tayl Homes, Chicago; *Indiana* John F. Kennedy Tow

Ka Northland

sc Louisvill

Neva Riv

Manor

City; *N*

Hugh Gallen Apa

Fairview formerly Yorksh

Mexi Life Long Learning

First Houses, New York City

A Asheville; *North Dakot*

Village of King Kennedy Estate, Cl scattered-site

Riverview Towe Portland; *Pennsy* Franklin Apartmen

Providence; *South Caro* model for /Infill Housing Progr

Siou s; *Tennessee* Lake Courts, Chatta ; *Texa* edar Springs Place, Dalla

ermont group home ed by Washington Cou Mental Health, Montpelier;

Salishan, Tacoma; *West Virginia* Fairfield Tower, Hu ton; *Wisconsin* Highland Park,

programs presented in this map are:
...neau; *Arizona* Martin Luther King
...elderly hous...
...*Florida* G...
...o Capitol P...
...ansville; *Io...*

EMINENT DOMAIN

Kate Ericson, Mel Ziegler, and A Resident Group of Ogden Courts Apartments

...ing Community, Topeka; *Ken...*
...isiana* Ouachita Grand Plaza, M...
...rtland; *Maryland* Gree...es,
...belt; *Massachusetts* ...ath,
...*Michigan* Jeffrie...oit;
...ily unit, ...*ippi*
...ace, Bil... ...Creek
...Lou... Anderson
Towers,
Helena;
Nebraska
Fresh Start
...aundromat,
...othenburg;
...Southgate
...rtments, Carson
...mpshire* Governor
...anchester; *New Jersey*
...illage, Camden; *New*
...Bernalillo; *New York*
...rth Carolina* Hillcrest
...rizons Man...o; *Ohio* Renaissance
...al help unit, S...ek; *Oregon* Schrunk
...rbondale; *Rho...d* scattered-site,
...harleston; *South ...a* scattered-site,
...*ah* Romney Park P...s, Salt Lake City;
...*ia* Diggs Town, Norfolk; *Washington*
...aukee; *Wyoming* scattered-site, Casper.

To replace housing that is presently
highrise housing, in other neighbor-
hoods and throughout the metropolitan
area, requires a level of tolerance
that is far greater than most metropoli-
tan communities tolerate today....
It requires something more than we
can communicate with the relatively
sterile words of the policy pronounce-
ments of public budgets. It requires real
communications...the arts can help
fight the violence, and crime, and
gang problems...through new forms
of expression, we can communicate
the things that bring us together – our
common sense of humanity. We can't
afford to lose another generation of our
young people....Our nation's future
depends on our ability to use our
hearts, our minds, our energies and
our artistic talents.

HUD SECRETARY HENRY G. CISNEROS, NEA
"ART-21" CONFERENCE, CHICAGO, APRIL 1994

The history of housing in Chicago includes Frank Lloyd Wright's Prairie-style houses; Mies van der Rohe's International-style lakeshore apartments; the neighborhood bungalow; Sears's prefabricated, mail-order houses; and the late 1880s communal experiments of Hull-House (see "Hull-House Radiance") and Pullman. Chicago dominated the housing market earlier in the century with its great concentration of manufacturers and suppliers. The large number of blue-collar jobs generated by this industry and others that developed around Chicago, as the country's distribution hub, in turn led to the need for more housing and the emergence of the Chicago Housing Authority (CHA).

Since Kate Ericson and Mel Ziegler began collaborating in 1978, their central subject has been the home, and they have often engaged the permission of private owners in order to use their homes as sites for the visual analysis of social concerns. The New York-based artists felt Chicago would be an ideal location to continue their exploration.

Designed by the leading Chicago architectural firm of Skidmore, Owings & Merrill, Ogden Courts was modeled on Mies's Chicago apartment towers of the late 1940s. It was praised at the time of its completion for its economical and aesthetic plan.

For this occasion they returned to a device they had employed in the past: the commercial paint chart. Paint charts perpetuate the American Dream. The expectation of someday owning one's own home and attaining a sense of identity as a homeowner is reinforced by advertising, inexorably intertwining lifestyle and consumerism. House paint and its packaging, particularly groupings of paint colors in thematic charts, were to the artists, a "subtle form of propaganda." Commercially available in hardware and paint stores, these charts allow consumers to transform their homes into elegant mansions, grand colonial homesteads, or other romantic images evoked by the colors and their names. Pragmatic but also artistic, paint charts convey taste and express individuality. Ericson and Ziegler wanted to create a chart whose color, text, and design would reflect the larger issues of government-subsidized housing. To do so, they sought to work collaboratively with public housing tenants.

The history of public housing in Chicago is one of racial segregation and conflict. In the 1940s the great immigration of Southern blacks to Chicago for jobs put increased pressure on the housing market and on the Chicago Housing Authority, which had begun in 1937 following the United States Housing Act (see "Housing Act Sunlight"). During CHA's first decade, aldermen were held at bay by the coalition of Director Elizabeth Wood (the only social work-trained head in the agency's history), board president and prominent black businessman Robert Taylor (see "Robert Taylor Brick"), and Mayor Edward Kelly. They fought for racial integration, while providing decent homes for low-income families. With Kelly's departure from office, the aldermen gained control in the 1940s, forcing CHA to build only on slum clearance land (see "Slum Clearance") - ostensibly to revitalize the city - but, in effect, to achieve full racial segregation, thereby creating new ghettos where substandard housing had once stood.

The artists proposed to develop the paint chart by first meeting people at CHA, examining the city's demographics, speaking with architectural historians, and then establishing a dialogue with a tenants' council. Meeting with the Executive Director of the Business and Professional People for the Public Interest Alexander Polikoff, who served as general counsel for Dorothy Gautreaux in 1976 **(see "Gautreaux Supreme")**, Ericson and Ziegler learned of the continued attempts to fight the racial discrimination in Chicago public housing. During that same visit, in March 1992, discussions with Dr. Carol Adams, Director of the Division of Resident Programs, and tours of housing sites with Acting Director of the Department of Education, Culture, and Senior Programs Lynell Hemphill were enlightening about attempts to better the quality of residents' lives and community efforts of residents, mothers in particular. After contemplating dealing with CHA overall, by May Ericson and Ziegler suggested working with only one housing complex in order to develop a closer relationship with a tenants' group.

In October 1992 they returned to meet with property managers and resident leaders from several housing units to assess their willingness to participate in creating a functional paint chart particularized to their lives. Guided by L.D. Barron from CHA, they made site visits to four complexes that varied in age, location, condition, and architectural style. Of those visited, they chose Ogden Courts, a moderate-size highrise which demonstrated the social problems aggravated by such urban public dwellings, and most importantly, possessed a small group of organized residents who were struggling to bring about change. This group had been among those sent by CHA Director Vince Lane to Israel to study communal living on a kibbutz.

Ogden Courts, built in 1950 to house those displaced by the construction of the Congress Expressway, was one of CHA's first highrises that resulted from the aldermanic restrictions on land use at the same time the city was facing increased need for housing. Elizabeth Wood stated, "we had very little space to work with, so we had to go to high-rises, though we tried to come up with imaginative designs that could accommodate family living" (quoted in William Mullen, "Cabrini-Green: The Road to Hell," *Chicago Tribune Magazine*, Mar. 31, 1985, p. 16).

"Because of its initial success, Ogden Courts became something of a prototype...," leading to the construction of other highrise developments (Wim de Wit, "The Rise of Public Housing in Chicago, 1930-1960," in *Chicago Architecture and Design, 1923-1993* [Chicago: Art Institute of Chicago, 1993]. One key feature was its innovative addition of access balconies or porches, semi-sheltered upstairs sidewalks that could serve as recreation space, "setting a standard of exposure and ventilation" (*Architectural Forum*, 92 [January 1950], p. 84).

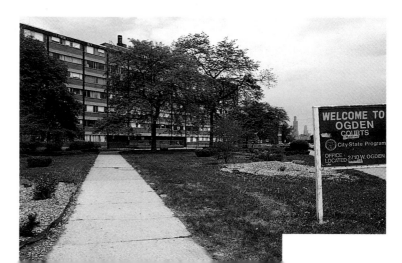

Tenement Condition Attracted by jobs in growing industries, foreign immigration and American migration from rural to urban centers was at its peak in the late 1800s and early 1900s, creating a strain on American housing. Tenements were extremely overcrowded and unsanitary, partially because of a lack of proper ventilation and bathroom facilities. Poor labor conditions, inadequate pay, illiteracy, and insensitive landlords perpetuated these conditions. New York City's government was the first to address the housing problem by developing a set of tenement regulations governing size, facilities, ventilation, and the number of tenants allowed in each unit. C428

Octavia Hill Long before government got involved, philanthropic organizations such as Octavia Hill Association, started in the 1880s, made important contributions to meeting the need for sanitary, affordable housing. By 1933, about when the United States government first concerned itself with housing, the association owned and managed 421 low-rent properties in New York City. E314

Hull-House Radiance Recognizing the need to do more than just house people, Jane Addams and Ellen Gates Starr in 1889 founded Chicago's Hull-House, an innovative philanthropic social, educational, resource, and study center for immigrant workers and their families. The resident members were activists and reformers who dealt with issues revolving around poor tenement conditions, especially sanitation and housing reform. Jane Addams and other members of Hull-House later became advocates for public housing. The color matches the brick of the historic building. B318

1892 After long debates on whether or not the United States government could and should constitutionally be involved with private housing, Congress passed a resolution in 1892 for the investigation of slums in major urban centers. Though this resolution brought no changes in conditions, it marked the first time the United States government

acknowledged a need to consider the poor and inadequate housing that existed. It is generally considered that these reports "whitewashed" the worst of the conditions. A201

Home Economics At the turn of the last century the new science of home economics proclaimed the need for clean and sanitary living conditions as essential to good health. It also acknowledged women's labor in the home as a legitimate work force. Housing reformers perpetuated this new science through education and by advocating government legislation to deal with the unsanitary conditions of much urban as well as rural housing. B208

Blue Ribbon Panel In 1908 the "Blue Ribbon Panel" of President Theodore Roosevelt's Housing Commission was organized to study slums in the United States and make recommendations as to what to do about them. Their findings outlined a need for housing reform, but no government action was taken. E123

Yorkship Village Slate It took a war for the United States government to enact the first legislation that dealt with housing people. In 1918 the Emergency Fleet and U.S. Housing Corporation were formed to help provide the first publicly subsidized housing built in conjunction with the United States government. The housing was for shipbuilding and defense industry workers. In 1918 Yorkship Village was built in Camden, New Jersey, to help house shipbuilders. It was subsi-

dized by the Emergency Fleet Corporation. Today the development is called Fairview and the homes are privately owned. They were sold soon after the war ended, with preference given to veterans. The color matches the slate roofs of the buildings at Yorkship Village Square. C132

Edith Elmer Wood Reform Edith Elmer Wood became one of the most important advocates of housing reform in the 1920s and 1930s. Her countless studies and articles exposed many of the hidden deplorable conditions of tenement life and addressed the possibility for changing these conditions through the help of government legislation. B216

Elois Smith's apartment, Ogden Courts, Chicago.

Home Loan The economic depression of the early 1930s brought severe problems to the private housing market. Foreclosures on bank loans were occurring at an unprecedented rate and the need for government intervention was paramount. In 1932 the government created the Federal Home Loan Bank Board to buy up mortgages from lending institutions so that these same institutions would give out new loans in hopes of stimulating the weak economy. Another program, the short-lived Home Owners Loan Corporation, was created to buy up failing mortgages and refinance them, thus avoiding foreclosures. E433

Knickerbocker Village In 1932 Congress passed the Emergency Relief and Construction Act, which in turn created the Reconstruction Finance Corporation

(RFC). RFC loaned money at low interest to local governments for the purpose of creating jobs through investment. Though most of the money was borrowed by banks and railroads Knickerbocker Village, a housing development in New York City, was built with RFC money. This color matches the brick at Knickerbocker Village. C307

FHA Gingerbread The National Housing Act of 1934 was the first major housing legislation of the United States government. The act created the Federal Housing Administration (FHA), which insures private home mortgages, thus encouraging lending institutions to make more loans. C109

Forget-Me-Not Mortgage The FHA created the low-interest, long-term, amortized mortgage, thus making home ownership much easier for many people. E313

Rambling Rose Resettlement The 1934 drought in the Midwest left the need to resettle many farm families from the dust bowl areas to farms newly created on federally owned lands. This was done under a program called the Resettlement Administration. The Farm Security Administration also provided housing for migrant farm workers. A207

Greenbelt Arborvitae Among the 1930s Resettlement Administration projects was the creation of experimental suburban housing called greenbelt towns. The three towns created were Greenbelt, Maryland; Green Hills, Ohio; and Greendale, Wisconsin. The beneficiaries of this program were, for the most part, families of white-collar workers. Faced with strong opposition from private enterprise the program ended and the houses and lots were sold to the private sector, with preference given to veterans. E113

Catherine Bauer Modern In the 1930s, while the government was adopting legislation for the private housing market, many housing reform advocates were working for the creation of our public housing program to help the growing numbers of unemployed and homeless. Catherine

"The exterior surface, rendered dense by use of air-entraining cement, will require neither veneer nor paint ... The visual contrast of this gray skeleton with the red brick filler panels ... will be trim and gay, in keeping with the new bright living standard." (*Architectural Forum*, 92 [January 1950], p. 84). Its reduced footprint was seen as offering open land for recreation and uncongested living. However, such public housing units, by being dramatically set back from the street or cut off by expressways, left residents with a sense of loss of the past, detachment from their own community, and isolation from the life of the city.

We will act solely as the catalyst for the project to occur; the point of view will be that of the group, and all design, color, and names their choice. This close examination of the housing development and its community will create a deeper sense of "place" for the tenants involved.... What is important to us is that our project become a voice for the people involved. That it be educational and informed and not merely a charity project. ERICSON AND ZIEGLER

When Ericson and Ziegler returned to make a formal presentation to Ogden Courts' tenants' council, they found a group that challenged their motives and questioned the project's relevance to their lives. But the residents hoped, too, that this project could help them achieve their goal of bettering the lives of those in their community. They were interested in this work of art as a means of bringing their concerns and those of other public housing tenants to the attention of individuals who could effect change. Their proactive stance and deep concern for their community could give real meaning to the term collaboration – if a partnership could be secured. Negotiations continued, aided by Resident Manager Anthony Law and Eric Bailey, Resident Initiative Coordinator **(see "Resident Initiative Plum"),** but finally it was the determination of the resident women and the artists that made the alliance possible by the end of the year. **The artists and tenants both saw that if they worked together, they could work toward their respective visions: the women's image of a decent life for their children and Ericson and Ziegler's artistic image of a social statement.**

"Eminent Domain" marked for the artists an increased level of participation and collaboration with those outside the art field. In preparation for the project, they remarked: "Symbiosis, niche, and mutualism could perhaps be applied to the way in which we as artists form various relationships with various groups for a particular purpose." Initially, the artists thought that they would elect one of the council members as a project coordinator to work directly with all the tenants, but it soon became clear that such a designation would privilege a single individual over the community. They proposed instead that the council be paid a design fee by Sculpture Chicago for their work.

The council women made dinners which they sold among the residents to earn money for community programs. Ericson and Ziegler, who occasionally participated in these cooking efforts during their stay, viewed the residents' design work on the project as yet another route to increase their financial capabilities. The artists had planned to conduct bimonthly meetings, perhaps in the format of a reading-discussion group, for the next six months in order to arrive at a design solution, but Council President Arrie Martin made it clear that such a schedule would dissipate efforts. If they were serious, the artists had better come and stay. **The next month Ericson and Ziegler came for an extended period and worked intensively with the group on issues of economics, law, race, the history and philosophies behind public housing and housing in the United States; their physical environment, decorating, color theory, and paint chart design; touching on the ongoing problems of crime, drugs, and death in their community.**

While based on local discussions in Chicago, "Eminent Domain" positioned itself within the national dilemma. On one level the paint chart is a means of self-representation and an intimate portrait of the women who were the artists' key collaborators **(see "Arrie's Dazzle Blue" and "Elois's Pink Lace")** and the issues present in their community of Ogden Courts Apartments. On the other, it is also a graphic depiction of the national public housing scene as symbolized by a map and fifty colors; their names and the accompanying explanatory text tell the hundred-year history of public housing practice and legislation in the United States. Depicted on the chart's cover is an interior view of the Blue Room of the White House – a home that is a political icon and our most rarefied example of public housing.

"Eminent Domain" (see "Eminent Domain") **was developed by the artists and tenants to dispel misconceptions about public housing – why it exists and whom it benefits – by presenting the idea of house and home from a different historical, economic, and social perspective. By becoming an actual, functional paint chart in stores, it could serve as an alternative educational tool for taking a message to a populace that might not seek out studies of the subject of public housing, but would find the information engaging if encountered in this benign and visually seductive form. Most of all, by being in a commercial outlet easily accessible to the public – where people go to satisfy their own needs rather than in an art space dedicated to an art experience – the artists and tenants hoped to bring attention to public issues and foster public dialogue.**

Eminent Domain

The project sought to raise questions and consciousness. What do we know about those in America who live in public housing? Are their homes any less their own? Or is public housing at its very core a reflection of American ambivalence, whereby charity and capitalist enterprise clash? Is this why it meets with such suspicion and resistance? why its residents face such prejudice? why Chicago has become divided – geographically, socially, and racially?

The artists' research led them to the extensive library holdings at HUD **(see "HUD Cream")**, piquing the interest of the HUD staff; to the other forty-nine state housing offices; and to historians and officials, such as Robert C. Weaver **(see "Robert Weaver Blue")**, the first HUD secretary and first African-American in the Cabinet, who at age eighty-five remains committed to the value of public housing that he began advocating in the 1920s.

As the personal stories of the Chicago tenants expanded into national public housing issues, it became evident that the audience for this chart needed to be expanded outside the art world and outside Chicago. Distribution across the country became important to the concept of the work. So, simultaneous with their meetings with the group, Ericson and Ziegler and Sculpture Chicago began to contact paint companies to support this project through funding and distribution. Discussions proved difficult: the chart was neither clearly a commercial product from which sales could be projected nor a public service donation; it did not fit into the current advertising technique of cause-related marketing. Unlike promotions in which a portion of a company's sales benefit an unrelated social cause, here the product and message were intertwined and there was no immediate gratification of buying a solution to a social problem through a purchase. Many observers incorrectly concluded that the outcome of the paint chart would be the repainting of Ogden Courts. Antithetical to the aim of both tenants and artists, such a manifestation would whitewash over the complex issues they were confronting, as if the problems of public housing and urban strife could be fixed with a fresh coat of paint. Rather, "Eminent Domain" was intended to change the image of public housing and open up the conversation between estranged social strata.

In April 1993 Tru-Test Manufacturing Company, a Chicago-area-based firm supplying paints for True Value Hardware Stores nationwide, was contacted as a means of distribution. Six thousand True Value Hardware Stores offered a potential platform for a national dialogue. The chart's colors would be coordinated with stock Tru-Test colors so that sales could be made. Moreover, Tru-Test produces its paint charts at Color Communications, Inc., a multinational firm that is the world's largest color sampling company, and whose headquarters are in Chicago's Lawndale neighborhood where Ogden Courts is also located. Due to lack of expected funds and the termination of Sculpture Chicago's involvement with the community projects of the "Culture in Action" program, the artists were unable to find an institutional base from which to realize this project once the prototype was completed in fall 1993. However, it remains the joint aim of the artists and residents to produce the chart for national distribution through this hardware chain.

A subject that the artists and residents returned to over and over during the course of their two-year collaboration was the younger generation living in public housing. Particularly devastating has been the impact on the children. At the time of the artists' initial site visits in fall 1992, seven-year-old Dantrell Davis was shot while crossing the street with his mother from their Cabrini-Green (see "Cabrini-Green") **home to school; he was the third Jenner Public School pupil killed in eight months. One year before, Alex Kotlowitz's book** *There Are No Children Here: The Story of Two Boys Growing up in the Other America* **captured national attention as he recounted life in Chicago's Henry Horner Homes. The artists were aware of this situation, but now they saw the problems firsthand. They came to appreciate that the children were the central concern of their resident-collaborators and the reason they were working for the community, and, indeed, participating in this art project. For the residents, the main theme of the paint chart was "choice." Paint charts are not part of their lives; they have few opportunities for choice in their lives. In their housing, they always encounter CHA paint color #9** (see "Authority White"); **in their education and jobs, they find few options. Thus, the paint chart, as a device for choice, came to evoke the lack of options available to many who live in public housing.**

The reality of the living conditions and their understanding of the residents' needs eventually led Ericson and Ziegler to consider other levels of association and cooperation as the artists, in turn, followed the women's lead. Foreseeing a role outside of art-making, the artists said as early as October 1992 that they would be willing: "to continue with some of the topics discussed but directly relate them to the common goals and needs of the tenants and perhaps brainstorm ideas about how the tenants can accomplish these goals." Thus, this collaboration marked a real sharing and exchange of goals: the residents joined the

HOPE

Slum Clearance

Shelter Plus Care

Bromley-Heath

Fannie Mae Lilac

1892

Elois's Pink Lace

Catherine Bauer Modern

Gautreaux Supreme

Home Loan

Decent Home Periwinkle

Housing Starts

Tenement Condition

Housing Census Shadow

Equivalent Elimination

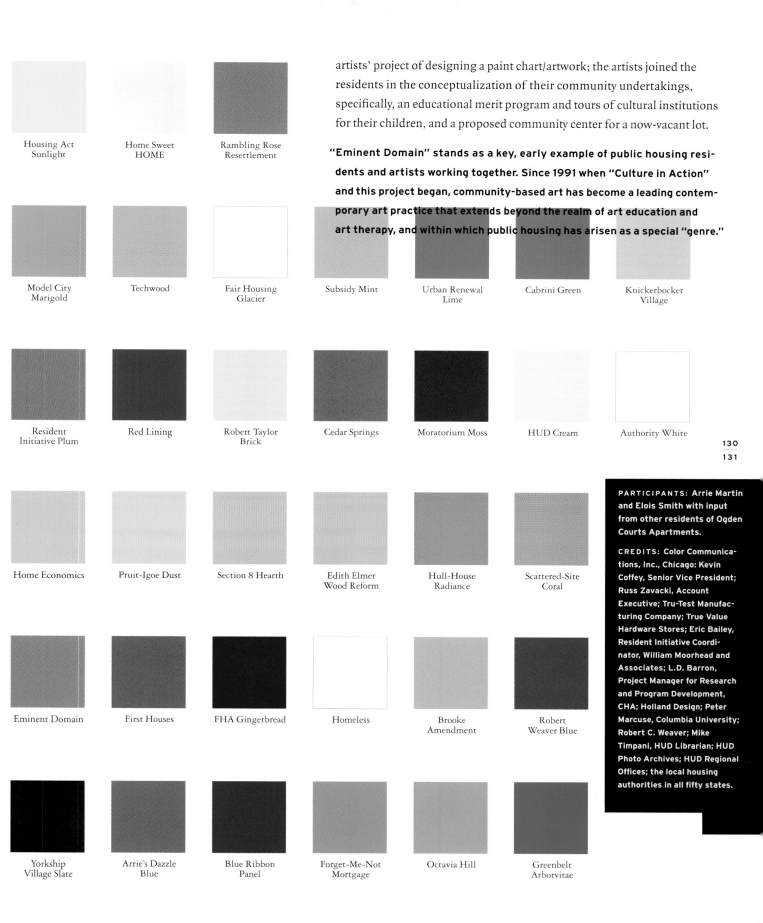

artists' project of designing a paint chart/artwork; the artists joined the residents in the conceptualization of their community undertakings, specifically, an educational merit program and tours of cultural institutions for their children, and a proposed community center for a now-vacant lot.

"Eminent Domain" stands as a key, early example of public housing residents and artists working together. Since 1991 when "Culture in Action" and this project began, community-based art has become a leading contemporary art practice that extends beyond the realm of art education and art therapy, and within which public housing has arisen as a special "genre."

Housing Act Sunlight

Home Sweet HOME

Rambling Rose Resettlement

Model City Marigold

Techwood

Fair Housing Glacier

Subsidy Mint

Urban Renewal Lime

Cabrini Green

Knickerbocker Village

Resident Initiative Plum

Red Lining

Robert Taylor Brick

Cedar Springs

Moratorium Moss

HUD Cream

Authority White

Home Economics

Pruit-Igoe Dust

Section 8 Hearth

Edith Elmer Wood Reform

Hull-House Radiance

Scattered-Site Coral

Eminent Domain

First Houses

FHA Gingerbread

Homeless

Brooke Amendment

Robert Weaver Blue

Yorkship Village Slate

Arrie's Dazzle Blue

Blue Ribbon Panel

Forget-Me-Not Mortgage

Octavia Hill

Greenbelt Arborvitae

PARTICIPANTS: Arrie Martin and Elois Smith with input from other residents of Ogden Courts Apartments.

CREDITS: Color Communications, Inc., Chicago: Kevin Coffey, Senior Vice President; Russ Zavacki, Account Executive; Tru-Test Manufacturing Company; True Value Hardware Stores; Eric Bailey, Resident Initiative Coordinator, William Moorhead and Associates; L.D. Barron, Project Manager for Research and Program Development, CHA; Holland Design; Peter Marcuse, Columbia University; Robert C. Weaver; Mike Timpani, HUD Librarian; HUD Photo Archives; HUD Regional Offices; the local housing authorities in all fifty states.

CONSEQUENCES OF A GESTURE and 100 VICTORIES | 10,000 TEARS

Daniel J. Martinez and The West Side Three-Point Marchers

For Daniel J. Martinez, political action and making art are intrinsically linked. During his first trip to Chicago in March 1992, he proclaimed to an impromptu audience of forty artists gathered in the back of a Mexican restaurant in Pilsen to hear him present his work: "We must insist on the idea of 'Culture in Action.'" In his native Los Angeles and across the country, Martinez has been a catalyst, focusing attention on social inequities through his art: from admission buttons at the Whitney Museum of American Art ("I can't imagine ever wanting to be white," 1993) to banners signifying the haves and have nots in the downtown commercial district of Seattle ("Quality of Life," 1991).

In developing his artistic ideology, Martinez has been strongly influenced by ideas of the Situationist International, particularly from the 1960s when, under the leadership of Guy Debord, earlier artistic goals were supplanted by an overtly political and revolutionary agenda. Debord's *Society of the Spectacle* (1967), a theoretical text positioning the Situationist stand on culture and society, argued for the liberation of alienated workers in a capitalist world; this text influenced student uprisings a year later in France. The Situationist spirit of cultural revolution in alliance with art, and the place of art in transforming everyday life reinforced Martinez's own personal artistic intention. For Martinez, art of solely aesthetic purpose is a luxury indicative of a privileged position, a route that the rest of society cannot afford to take. Rather, the question for him is not whether it is art or life, but whether it is art or war.

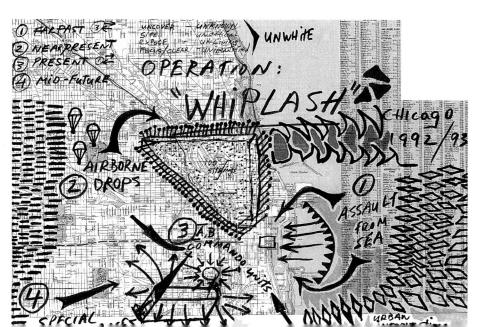

Growing up in East L.A. during an age of assimilation, Martinez was alienated from his own Mexican heritage and language. He joined what he calls "the generation of a phantom culture" – not really part of the Chicano nor the dominant culture. After a stint with the mural group ASCO, Martinez became determined to show his community's issues in a form that was progressive and forward-thinking, instead of in a tradition-bound manner that might connote Mexicans as backward and regressive. Art also became a way to express anger about the reality of his community and to offer options to that community. These goals drew him to a site-dependent and content-specific mode, working from within the midst of the subject he addresses.

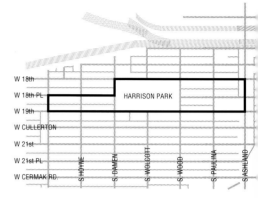

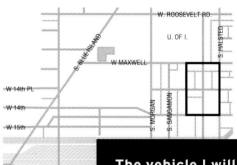

Martinez's initial proposal was conceived as an opera in four acts, or tactical mission beginning with an "assault from the sea" (Lake Michigan), sweeping over locations and images associated with the past, present, and future of the city. Scene one contrasted the myth and the reality of Native Americans today by reclaiming the *Indians,* two sculptures at Congress and Michigan Avenue (1928); scene two used thirty flat cut-out figures identical to the policeman depicted in the *Haymarket Riot Memorial* of 1889 to mark significant moments in labor history; scene three consisted of weekly performances in the Maxwell Street Market area; scene four involved building a churchlike structure on a vacant lot in the Mexican neighborhood of Pilsen.

What remained as the most salient concept from this phase of the project was Martinez's desire to track the history of the American immigrant labor movement by identifying important events in Chicago for which no monument or marker exists. It was also essential that the work recognize existing cultures in neighborhoods and encourage interaction among people in geographically and culturally isolated parts of the city. Specifically, he felt connected to the Mexican-American and African-American communities because of his own background and that of the composer-musician VinZula Kara, whom he brought in to work on part of the project. Martinez believes the dissolution of the boundary between art and life extends the frontier of reality and can even change it; he sought to affect the reality of these communities. He also saw value in being an outsider with related experience, perhaps able to see another's situation more clearly than those inside or even than his own at home.

> **The vehicle I will create for communication and action will be an absurdist parade, carnival, and spectacle. The performers will use cartography and choreography to orchestrate the event. The rest is left up to chance.**
>
> DANIEL J. MARTINEZ

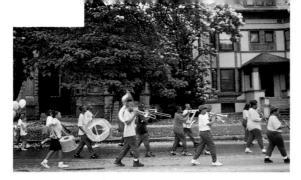

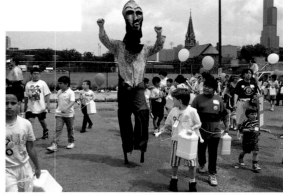

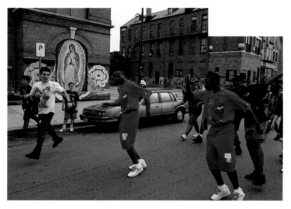

Martinez looked to the history of public gatherings – from labor demonstrations to Civil Rights marches to Day of the Dead and Mardi Gras festivals. One of the oldest forms of cultural expression worldwide, parades are a social ritual. Martinez's event would draw upon emotional links to these primal origins that exist even in the absence of personal participation. It would be a symbolic gesture, defining cultural rather than social identity.

This work takes apart and reenacts the urban drama. We recall the past not only by recording it but reliving it, by making present again its fears and pleasures. We anticipate the future not only by preparing for it, but by conjuring up and creating it. Our links to yesterday and tomorrow depend on such aesthetic, emotional, intellectual, absurd, and symbolic aspects of human life. Without this, we would not be historical beings at all. DANIEL J. MARTINEZ

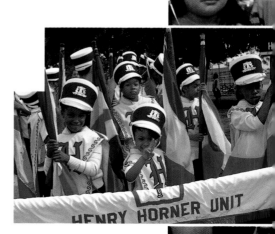

The parade was unorthodox in several respects. It brought together two ethnic groups (Mexican-American and African-American) who do not generally join forces. Martinez believed that these constituencies have more in common than they recognize. He aimed to show that their differences are not weaknesses but strengths, and that through solidarity they can achieve common goals more effectively than they can separately.

The parade took place three times, in three separate locations, sequentially one Saturday morning in June. Coincidences reinforced the concept: at Harrison Park ("Zapata Park" to locals), the parade was followed by a United Farm Workers rally in commemoration of Cesar

Chavez who had died only weeks before, shortly after appearing at an event at the same location. The date chosen, June 19, was also "Juneteenth," a day celebrating the arrival of the delayed news of the Emancipation Proclamation. Thus, the cultural duality of the parade found significant references that were rooted historically within each community.

The parade took place right in the communities. Ethnic parades in Chicago, like official public sculpture, are sited along Michigan Avenue or Dearborn Street in the heart of the Loop, far from the communities of the participants. Martinez's parade took place on the community's own streets; it aimed to be a positive event in areas often considered marginal, depressed, blighted.

The designated parade sites on the West Side were Pilsen and Garfield Park. The former was a Bohemian-Czechoslovakian settlement, now largely Mexican, and home to the Mexican Fine Arts Center Museum, which lent support to the event. Garfield Park was an affluent Jewish community, but today is African-American; some of the stately townhouses encircling this major urban park are cared for, others boarded up. After the community was dissected by the construction of the Eisenhower Expressway in the 1950s, it was abandoned by developers and city planners. Providence-St. Mel High School, a pivotal community resource and home base for Mark Dion's project, lay along the parade route.

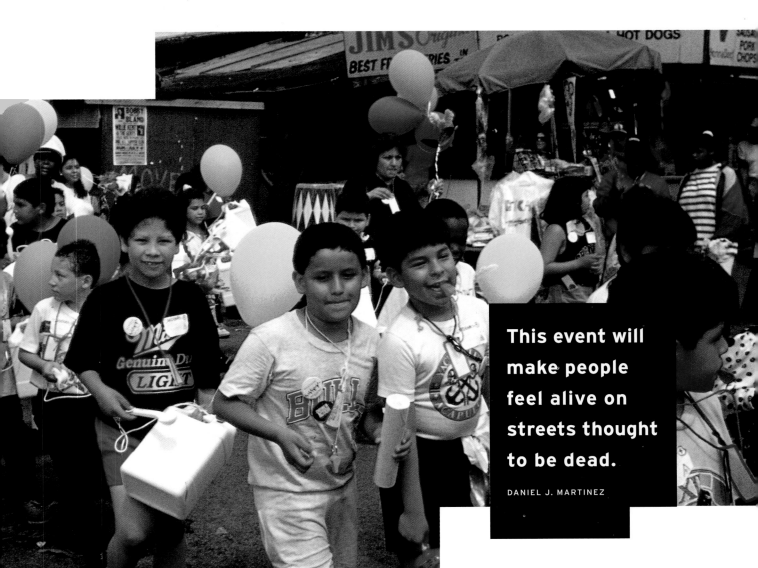

This event will make people feel alive on streets thought to be dead.

DANIEL J. MARTINEZ

The third "neighborhood" that the parade traversed was the Maxwell Street Market area, a hotly contested location and a meeting ground every Sunday for African-Americans and Latinos, among others. Located on the Near West Side, west of the Loop, this area was one of the first in the city to be settled with Irish and German immigrants in the 1850s, followed by a succession of ethnic and racial groups. Edith Abbott, a friend of Jane Addams and a resident of Hull-House, located there, described the area as she remembered it in the 1890s (*The Tenements of Chicago: 1908-1935* [Chicago, 1936]):

Immigrant tides then swept along and across Halsted Street, one overtaking the other in rapid succession. The West Side "river wards" were the poorest and most crowded sections, where the newest immigrants so often came to live, grew prosperous, and moved to pleasanter streets further west. For the old West Side was all movement. Everyone had just come - from somewhere, usually from across the ocean - and all the world was going - from somewhere else.

According to William J. Adelman, Professor Emeritus of Labor History at the University of Illinois at Chicago and consultant to the project, it was in this area that some of the first factories in the Midwest were built, and the transportation system of Chicago and the railroad network for the Middle West first began to take shape. Although the West Side began as a residential area and was a desirable address after the creation of Union Park in 1853, it was

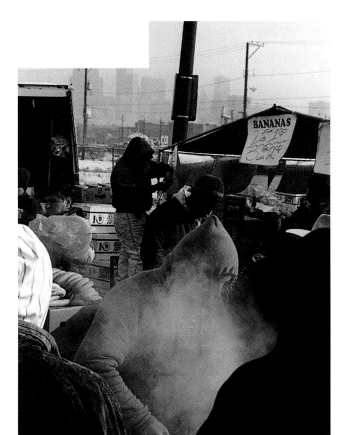

also the center of manufacturing and commerce of all kinds. Today, the former mansions and new buildings along Ashland Avenue have become union halls and are known as "union row." Of the many markets in the area to which farmers brought their goods – Market Square, the Haymarket, the South Water Street Market, the Fulton Street Fish Market – the Maxwell Street Market is the oldest, operating continuously since the 1870s.

While Jewish residents moved north and west, Maxwell Street has remained a neighborhood for lower-income families. This area was greatly reduced when in 1957 the eastern portion was removed for the Dan Ryan Expressway. By 1966 the Roosevelt-Halsted area of the market was designated a slum and blighted area by the Department of Urban Removal. The market is now targeted for the south expansion of the University of Illinois at Chicago.

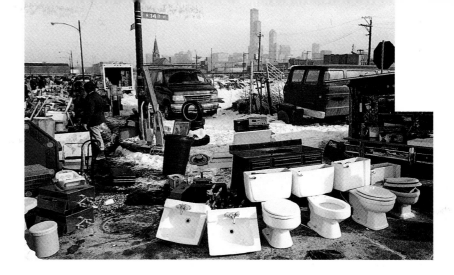

On the east side, a significant amount of vacant land south of Roosevelt presents a special opportunity for accommodating future campus expansion.... Acquisition of this area will be required if UIC's 40-year Program Projections are to be met.

THE UNIVERSITY OF ILLINOIS AT CHICAGO MASTER PLAN, AUGUST 1990

The University of Illinois at Chicago is pursuing an ambitious expansion plan that will wipe out the historic Maxwell Street Market.... Thousands of livelihoods and opportunities, mostly among the poor and black and Hispanic minorities, along with the face and character of the Near West Side and even the role of the university itself, are at stake. This is all being envisioned, and quietly but aggressively carried out, in the name of progress and what UIC sees as its future.... Why, once again, is it poor people ... who should pay the price, be pushed out, displaced in the name of progress? ... The most obvious reason is that the people now in the southward path of the plan are the most politically vulnerable....

RAYMOND R. COFFEY, "UIC EXPANSION PLAN: DOES IT MAKE SENSE?" *CHICAGO SUN-TIMES*, JULY 16, 1993

Boosters of the University of Illinois at Chicago's expansion plan refer to the Maxwell Street Market area as an "eyesore," a share of responsibility for what the market area looks like these days. The city has all but withdrawn basic services, such as garbage pickup and police presence.... The claim fences that UIC has been putting up around the properties it acquires leave less and less operating space for the 850 vendors in the market.... What the city and the university basically are doing, say opponents of the expansion plan, is creating an eyesore and then telling the public: "Look at this eyesore...."

RAYMOND R. COFFEY, "UIC, CITY CREATED MAXWELL ST. 'MESS,'" *CHICAGO SUN-TIMES*, JULY 20, 1993

Sunday, August 28, 1994 was the last day of operation of the Maxwell Street Market as it has been known for about 120 years.

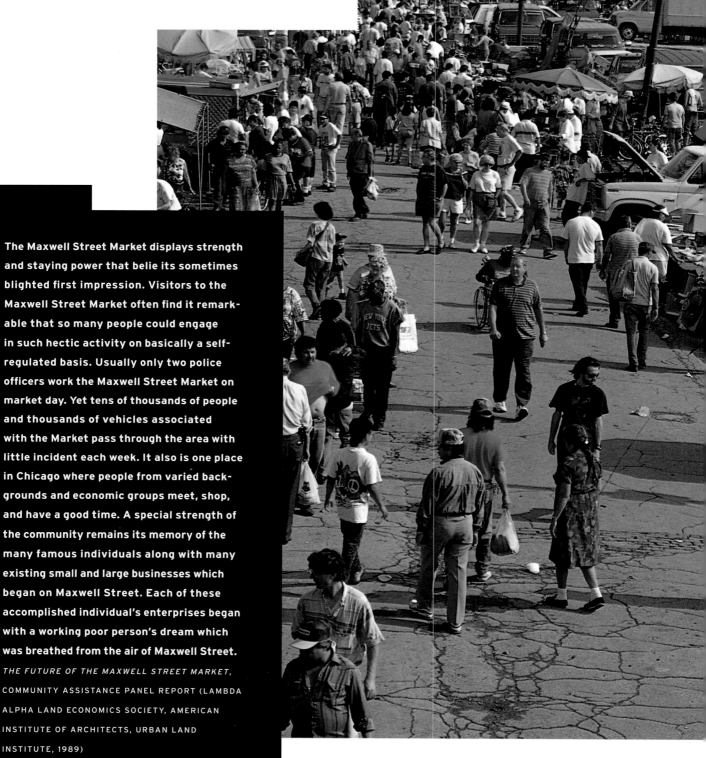

The Maxwell Street Market displays strength and staying power that belie its sometimes blighted first impression. Visitors to the Maxwell Street Market often find it remarkable that so many people could engage in such hectic activity on basically a self-regulated basis. Usually only two police officers work the Maxwell Street Market on market day. Yet tens of thousands of people and thousands of vehicles associated with the Market pass through the area with little incident each week. It also is one place in Chicago where people from varied backgrounds and economic groups meet, shop, and have a good time. A special strength of the community remains its memory of the many famous individuals along with many existing small and large businesses which began on Maxwell Street. Each of these accomplished individual's enterprises began with a working poor person's dream which was breathed from the air of Maxwell Street.

THE FUTURE OF THE MAXWELL STREET MARKET,
COMMUNITY ASSISTANCE PANEL REPORT (LAMBDA
ALPHA LAND ECONOMICS SOCIETY, AMERICAN
INSTITUTE OF ARCHITECTS, URBAN LAND
INSTITUTE, 1989)

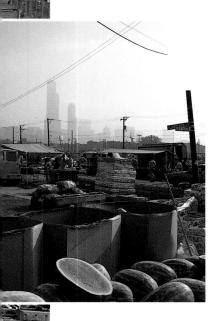

It is in the vicinity of Maxwell Street Market, around the Near West Side, that workers came into conflict with management and changed the course of labor history worldwide. This became the companion subject for Martinez from which he created a second, complementary work, a sculpture which he called "100 Victories/10,000 Tears" and dedicated to the working people. For Martinez, it was essential that the project have two parts: a parade and a monument, and that they form a dialogue and "communicate" with each other.

Public sculpture has taken up the subject of labor history in Chicago before. In 1915 a monument by Gutzon Borglum (of Mt. Rushmore fame) was erected in nearby Union Park to John Peter Altgeld, the Illinois governor who sacrificed his political career in the name of justice, pardoning the three men convicted at the Haymarket Riot trial. It depicts Altgeld protectively shielding a man, woman, and child who symbolize labor; the pedestal is designed low to the ground to bring this heroic figure close to the people. Both Altgeld and Borglum were first-generation Americans and they believed that public officials must serve the cause of the common people. It is this same spirit of art and people, working environment and culture, that Martinez placed at the heart of his project.

Soon after the Haymarket Riot, Chicago businessmen formed the "Committee of Twenty-one" to erect a statue to the police and "law and order" in Haymarket Square in 1889. The sculptor, a recent Danish immigrant, John Gelert, wanted to use the image of a female figure holding an open book over her head to portray law, but the committee – as often happens in public art – insisted on the literal portrayal of a policemen with upraised arm. This symbol of authority over the people was moved between here and several locations in Union Park to escape periodic attacks. After the last, a bomb in 1969, the sculpture was moved to Central Police Headquarters and is now available for viewing by appointment only in the garden of the Police Training Center. This work became a counter-reference for the artist.

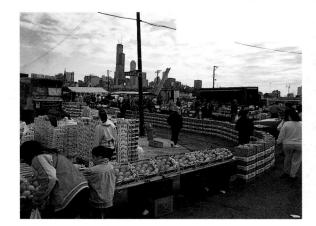

The American labor movement also dedicated a statue on the graves of the Haymarket martyrs in Waldheim Cemetery in Forest Park, Illinois, and Samuel Gompers asked a world conference in Paris, France in 1889 to adopt May 1 as the "Day of the Martyrs of Chicago" in their memory, beginning worldwide May Day events to labor. In the U.S., where tension remained high, celebrations were deferred to September, hence Labor Day, to avoid association with Haymarket. Both Chicago events – Haymarket and the world's first May Day parade – were commemorated by Martinez in his Maxwell Street installation.

LAEGER-BEER RIOT
CLARK ST. BRIDGE APRIL 21, 1855
250 VIGILANTES ATTACK & KILL GERMAN WORKERS.

**LOOK
+
LAUGH.**

HART, SCHAFFNER & MARX STRIKE
19TH + HALSTED OCT 1910 - FEB 1911
1000s OF CLOTHING WORKERS STRIKE.

I-VOTED-FOR-YOU!
THANK-YOU-VERY-MUCH-YOU'VE
GOTTA-LOTTA-NICE-BARGAINS-HERE!

BATTLE OF VIADUCT
16TH + HALSTED JULY 26, 1877
31 KILLED 100 WOUNDED BY FEDERAL POLICE.

**VICTORY WILL BE FOR THOSE
WHO WILL HAVE BEEN ABLE**
TO CREATE DISORDER (without loving it).

DC

**FREEDOM IS THE
CRIME WHICH CONTAINS
ALL CRIMES.**

**EIGHT-HOUR DAY MARCH
MICHIGAN AVE. MAY 1, 1886**
80,000 WORKERS MARCH IN FIRST MAY DAY PARADE.

HAYMARKET SQUARE
DESPLAINES + RANDOLPH MAY 4, 1886
176 POLICEMEN ATTACK 200 WORKERS 4 DIE.

**I AM NOTHING
AND
YOU ARE EVERYTHING.**

POOR PEOPLE MARCH
HALSTED FRONT OF HULL HOUSE JAN 17, 1915
LUCY PARSONS, RALPH CHAPLIN SING SOLIDARITY FOREVER.

MAXWELL ST. MARKET
1871 TO ? NO FUTURE NO FUTURE
NO FUTURE FOR YOU, NO FUTURE FOR ME.

I TAKE MY DESIRES FOR
REALITY BECAUSE I BELIEVE IN
THE REALITY OF MY DESIRES.

VAN BUREN BRIDGE INCIDENT
VAN BUREN + MARKET MAY 5, 1886
400 JEWISH WORKERS CLUBBED + BEATEN BY POLICE.

BENEATH THE
ABSTRACT
LIVES THE EPHEMERAL.

TURNER HALL
ROOSEVELT + HALSTED JULY 26, 1877
POLICE ATTACK WORKERS 1 KILLED.

HYSTERIA, AVALANCHE, MORPHINE,
BLOODY, FLAME, VIOLENT, RAVAGED,
DISTORTION, CORPSES, INFINITIES.

BENEATH
THE PAVING STONES,
THE BEACH.

BREAD RIOT
TUNNEL IN MIDDLE OF LA SALLE WINTER 1873
UNEMPLOYEDS' RELIEF TAKEN BY BUSINESSMEN.

ABSURD
IN REALITY IS
ABSURD

McCORMICK REAPER STRIKE
WESTERN + BLUE ISLAND MAY 3, 1886
4 WORKERS KILLED DOZENS INJURED BY POLICE.

TO RENDER TO CAESER
THAT WHICH IS CAESAR'S:
23 BLOWS OF THE DAGGER.

JOE HILL FUNERAL
RACINE + TAYLOR NOV 25, 1915
1000s MARCH AND SING JOE HILL SONGS.

Maxwell Street seemed the fitting place for a monument to labor since this site had figured so prominently in its history and might soon be gone. The earlier notion of historical markers was dramatically and fortuitously changed when Antonio Pedroso, of World Trade Granite and Marble Co., informed the artist that granite from the University of Illinois at Chicago would soon be available. These massive granite slabs – eight-by-twenty-five-by-one-foot-thick – had been used by architect Walter Netsch to construct raised sidewalks and elevated plazas in the original campus design. Now, less than thirty years later, these connecting arteries were being dismantled. To Martinez, this not only offered the potential to use stones too costly to acquire new, but also the opportunity to build a deeper conceptual base for his monument.

The sidewalks, thirty feet in the air, connoted to the artist detachment from the people and from the immigrant communities that had continuously occupied that very land for over 100 years. Built in the late 1960s, the walkways also symbolized physical containment at a time of student protest. But, most of all, they were the foundation of the University of Illinois at Chicago. By placing them in the Maxwell Street Market area, Martinez brought them down to earth and gave them to the people as a selling floor and memorial to those persons displaced by the initial construction of the university a few decades before and to those who would soon be pushed out as its expansion plans consumed the market. Images from public plazas to the masses dancing on the marble floors of the wealthy during the Cuban revolution came to mind. Using slabs that had formed the plaza above the lecture halls, Martinez also evoked the student uprisings of the 1960s in which the takeover of the lecture hall equaled the usurpation of power.

In Chicago, the history of immigrants and the history of labor are intertwined; thus, the parade flowed into the subject of a monument. Yet while the parade is rooted in cultural traditions worldwide, the memorial specifically addressed Western sculptural traditions as evidenced in Chicago where labor is anonymous, generalized, supporting, or just absent from the city's public sculptures.

When permission could not be secured to erect this platform on one of the open, vacant city lots, the artist, with the timely assistance of Ted Stanuga, put into practice one of the oldest and most important ways of making public art – guerrilla style – by "squatting" on university land with forty 85,000-pound stones. Around the university's ubiquitous fencing, he placed signs in a format that mimicked the university's "no trespassing/UIC property" signs. But in content they reinstated the labor history of the area, twelve decisive moments identified in collaboration with Professor Adelman, which Martinez interspersed with text from philosophic and poetic sources to support a revolutionary cause (such as the Surrealist slogan later adopted by the Situationist International: "Take your desires for reality").

Appreciated by the vendors with whom Martinez had built a relationship for over a year and who, in turn, informed his point of view on the scene; cheered on by the market supporters who saw this work as a galvanizing force in their intensified and urgent efforts; embraced by Netsch as a resurrection of his chosen material that was otherwise quickly becoming scrap; condoned by the university once it appeared without consent on its land and within its fence; this work was recognized by contingents that stood at opposite ends of the debate on the future of the market and the university. Though removed mysteriously after five months, Martinez's sculpture was a forum for dialogue and a parting memory of the Maxwell Street Market.

142
143

PARTICIPANTS: African-American Arts Alliance; Aguijon II Theater; Alpha Phi Alpha; Austin High School; Cardenas School; Cash Money; Cooper School; de la Cruz School; Erie Neighborhood House; Farragut School; Henry Booth House; Henry Horner Boys' and Girls' Club; Jungman School; Make-up Boys; Marshall High School Band; New Sounds; Phi Beta Sigma, IOTA Chapter; Pros Arts Studio; Red Moon Theater; Salazar Elementary School; Shango Temple; Spray Brigade; Suder School; Taller Mexicano de Grabado (Mexican Printmakers Workshop); Temporary Juvenile Detention Center Representatives; WGCI Dance Troupe; Whitney M. Young School. Project Coordinators: Angela Coleman, Elvia Rodriguez.

CREDITS: Alderman Ted Mazola; City of Chicago, Department of Planning and Economic Development: Commissioner Valerie B. Jarrett, Marcel Acosta, Charles Thurow; Sidley & Austin: Jack Guthman, Bridget O'Keefe; Bill Fawell; Antonio Pedroso, President, World Trade Granite and Marble Co.; Juana Guzman, City of Chicago Department of Cultural Affairs; The Mexican Fine Arts Center Museum; Lori Grove, Elliot Zashin, Project Coordinators, Maxwell Street Market Colloquium Project; William Adelman; Carlos Cortez; Dwight Conquergood; Irwin Kale, Chicago Federation of Labor.

Photography and Illustrations

All photographs are by John McWilliams ©1993, Atlanta, except for the following: Jane Addams' Memorial Collection at the University of Illinois, Chicago: pp. 65, 72; Kate Ericson and Mel Ziegler, New York: p. 129 (right); Patricia Evans, Chicago: p. 66; Flood, Chicago: p. 94; Hedrich-Blessing, Chicago: pp. 12, 15; Karen I. Hirsch, ©1993, Chicago: p. 70 (top left); Iñigo Manglano-Ovalle, Chicago: pp. 78, 79 (bottom), 84; Jason Meadows, Chicago: p. 70 (bottom left); Robert Mitchell, Chicago: p. 98 (left); Esther Parada, Chicago: p. 68 (top); Antonio Perez Photo, Chicago: pp. 82 (bottom right), 85, 134 (top left, top right, bottom right), 135; Robert Peters, Chicago: pp. 98 (right), 100, 102, 103, 105; Melissa Ann Pinney, Evanston: pp. 67 (bottom), 69; Marc PoKempner ©/Impact Visuals, Chicago: pp. 106, 108, 109; Paula Stewart, Chicago: p. 71; Sharon Zingery, Chicago: p. 70 (bottom right).

Illustrations: Ronald Jones, New York: p. 13; Iñigo Manglano-Ovalle, Chicago: p. 87; Daniel J. Martinez, Los Angeles: pp. 132, 140, 141; Michael Piper, Chicago: p. 133; Skidmore, Owings & Merrill, Chicago: p. 129.